NOESIS

DEFINITION; THE POWER OF THOU

D0791297

The Autobiography of and written by

ALFONZO TUCKER

Note from the author: This work is my autobiography; it contains no composite situations or characters. The accounts that are written about are nonfiction and only the names of a few characters have been changed to preserve and protect their privacy.

Please visit our website at www.alfonzotucker.com

Please write/send comments to
Noesis-3
P.O.BOX 5146 Hercules Ca 94547

I.S.B.N. 0-9741249-0-7

Publishing financed in part by THE R.A.W.ADVANTAGE inc. (Mary B. Morrison owner) for The NOESIS-3 publishing house inc.

Printed in the United States of America

NOESIS

BY ALFONZO TUCKER
Introduction

Every person on this planet, regardless of race, gender, or creed, has the capability of becoming major or minor: major in the sense of positive honesty or minor in the sense of negative choices. For example, anytime one makes a choice related to anything positive, the majority of returns are honest, which merits prosperity. However, when a person chooses to allow negativity to lead decisions, a minor amount of life is understood. Thus, a minor amount of life is lived.

If you're reading this book from a jail cell, it will inspire you. If you're reading this book from a dorm room, it will encourage you. If you're referring to this book from a pulpit, it will help you. If you're sitting in an uncomfortable seat while in commute, my true-life experiences will entertain you. No matter what your economic status, or your ethnic background, you can learn from the mistakes that I have encountered as an African American male who was raised by a Caucasian family in a twenty-first century society that still practices racism.

Funny how a person can recall certain events and block others out. While writing my autobiography, situations I was told about and involved with became frighteningly vivid. However, writing this has been the single most gratifying experience of my life. Of course, I have changed a few names so no controversy comes from this project. Every encounter here is true. I have not embellished any portion of this work.

I truly believe I have a calling, and I am to share my life's experiences with whoever will listen or read this book. According to Merriam Webster's dictionary, Noesis means Comprehension and Understanding. I view that as the power of thought. My desire for security, love, and family have led me to understand and comprehend why, in spite of my short comings, I have developed a high level of self motivation. Noesis has, literally, given me a second and third chance at life with a healthy mentality.

NOESIS

CONTENTS

Message for my reader

(1)The Beginning- Birth in Detroit Michigan

(2) Teachings from an addict

(3) The During – Manhood before childhood

(4) Life with my Caucasian Foster Family

(5) The After – Living life with honesty

(6) Lies and Deceit

(7) We All Deserve

THANK YOU

MY SECURITY WAS GIVEN TO ME BY MY

FAMILY,

THE LOVE I HELD INTERNALLY

WAS ABLE TO BE EXPRESSED BY MY FAMILY

LOVING ME UNCONDITIONALLY

THANK YOU, MIKE

THANK YOU, DANA

THANK YOU, YERO

THANK YOU, ZACK

THANK YOU, KASSIE

I WAS GIVEN A CHANCE TO LIVE

BECAUSE OF YOU, MY FAMILY

I STILL CAN'T UNDERSTAND WHY,

AT THE START, YOU ALL SUPPORTED ME,

CARED FOR ME, JUST PLAIN LOVED ME.

OUR FIRST COUPLE OF YEARS TOGETHER

I WOULD FEEL WEIRD AND UNCOMFORTABLE

WHEN MY FAMILY SHARED

AFFECTION WITH ME.

A KISS FROM DANA,

A HUG FROM MIKE AND KASSIE

NOESIS

I FELT VULNERABLE AND WEAK.

THOSE WERE SURVIVAL TRAITS

TAUGHT TO ME BY PIMPS,

HUSTLERS, AND THIEVES.

I KNEW EMOTIONS WERE COMING OUT OF ME

I COULD NOT EXPLAIN.

AT THE MOST INOPPORTUNE TIME

I WOULD SURPRESS THEM

AND TRY TO REFRAIN

MY SHELTER PROVIDED TO ME BY MY FAMILY

MY CLOTHES, MY FOOD, MY DIGNITY.

THANK YOU

FOR BEING EXACTLY WHO YOU ARE, MY

FAMILY

CHAPTER ONE

The Beginning Life in Detroit, Michigan

My biological mother, Susie Ann Rhymes, was just eighteen years of age when I was brought into this world. I have no memory of my biological mother because my biological father, Thomas Tucker, took me away from her when I was less than six months old. I often wonder what life would have been like if given the opportunity to know Sue Ann. I can now write about the loss of her even though as a child, I was never able to experience the joy of her touch or the sound of her voice. Is having never known a memory of Sue Ann better than having images and glimpses of her? I believe life

would have been more difficult if her vision graced my mind periodically. Yet and still, that emptiness has always haunted me. The loss of Sue Ann has always geared me toward motherly companionship. However, being so afraid of love, the first sign of apprehension and deceit within the actions of my partner destroys my hopes of a relationship. Then, ultimately, I struggle with my own apprehension and hold back any form of feelings for my partner.

In some ways, those very thoughts have saved me from several dysfunctional relationships as well as caused problems in healthy ones. For many years, I felt deprived and lonely for not being able to share in all the joys of a mother and son relationship. Even as a child, I noticed Thomas would introduce me to women who would play a motherly role – at least until they became fed up with Thomas's behavior and left him. Not only did I hate Thomas for being mentally weak and allowing himself to remain hooked on drugs, I despised him for not allowing me to know and love Sue Ann. This affected my ability to love others genuinely. In fact, I was not able to love freely and openly until my last foster placement. This same foster family would become my family. Even then, years passed before I allowed myself to give and accept love.

As a young teenage man, and I state "man" because I've never had the pleasure of being a child, I carried an identification card of my biological mother in my wallet. During my seventh grade year in Jr. High School, while fishing with friends, the car we were traveling in was burglarized and the I.D. card never recovered. On that card was Sue Ann's height, weight, date of birth and social security number. (Now I could have used that information to gain her whereabouts.) To this day I

have never enjoyed fishing.

Thomas, who explained to me in great detail what had taken place, told me this story years ago. Thomas was working for my biological grandfather, Leland Tucker. Leland, a small man who stood five feet six inches and maybe one hundred and thirty pounds, (reminds me of the character "Mouse" in the Eazy Rolins series authored by one of my favorite writers, Walter Mosley.) Anyway, Leland owned a soul food restaurant in Detroit called "Tucker's Place Fine Food". This business was nothing more than a front for his numbers racket (my grandfather ran numbers for an Italian crime family). One of the local hustlers was flirting with Sue Ann while she worked at the restaurant one evening. Thomas showed up, and he and the local hustler got involved in a verbal altercation. Thomas described the hustler as the "super fly" type with high-heel boots and a leisure suit. Mr. Local Hustler threatened Thomas and stated he would return later to "handle his business".

Thomas sent Sue Ann home early to prevent her from being involved in what could possibly be a physical altercation. True to his word, Mr. Local Hustler showed up at closing time and attacked Thomas. Thomas told me this guy was at least six feet tall and more than two hundred pounds. Thomas was just as slim as Leland, however with his youth and a few more pounds, Thomas had a bit more strength than his appearance afforded him. Rather than fight, my butter-skinned father shot his attacker, which turned out to be a benefit, because a knife was found in the hand of Mr. Hustler, who was taken to the hospital. He suffered from five bullet wounds and a collapsed

lung.

 The Detroit Police Department arrested Thomas, yet the District Attorney failed to convict him when several witnesses stated Thomas was defending himself. Mr. Hustler not only lived, but threatened to kill Thomas. One of the investigators working the case told Thomas the injured man was well connected and very capable of having him killed. Thomas, having just gotten out of the Air Force, was trying to change his life and stop using drugs. He had developed an addiction to morphine while in a military hospital during his tour in Vietnam. Thomas stated that while his injured colleagues were given morphine to cope with the pain of their wounds, he and many others continued to use it for pleasure. After his four-year commitment finished, he started using heroin and developed an expensive habit. He and my biological grandfather Leland were not having the best father-and-son relationship, due to his drug use.

 Thomas was also selling his drug of choice, for the same crime family my grandfather ran numbers for. After that family asked Thomas to make some business adjustments and sell in other markets, Thomas decided to leave town and move to California. He and Sue Ann set a date and prepared for the long drive to California. When the date came, Thomas told me he and Sue Ann had been fighting, and she decided to stay in Detroit. Their situation made me question the validity of Thomas and his relationship with Sue Ann. Even though, they were married, Thomas could have embellished his relationship with my biological mother in order to give me the impression they were once in a loving relationship. Yet, how could a woman allow her infant child to leave freely from

her life?

I was not Sue Ann's only child. She had two other sons, Paul, her first born, at age fourteen, and her second, Tourance, at sixteen. Both had different fathers. Thomas married her when she was two months pregnant with Tourance. To avoid conflict, Thomas claimed Tourance as his own, even giving him his last name. While pimping and managing a hotel owned by his employer, Thomas met the chocolate brown Sue Ann while she caught tricks.

Was the splitting of our family consensual or did Thomas take me away from Sue Ann unlawfully? Much later, Thomas explained to me they were all packed and ready to leave, when the young eighteen-year-old Sue Ann took Tourance and left me with Thomas, who was thirty-one at the time. My oldest brother, Paul had been living with Sue Ann's mother since his birth. Thomas stated he looked for Sue Ann, yet was unable to locate her. Who knows whether Thomas was telling the entire truth. The bond between a mother and her child is stronger than any force created by man. How could she allow me to not be a part of her life? Even years later, I never heard from her, never even received a letter or any form of inquiry. A strong possibility exists that I will never have answers to that question or other questions.

While living in the city of Sacramento, California, Thomas would leave me with a young woman, who lived in the same apartment complex. I was two years of age and my Aunt Marie Archie was living in Sacramento along with her husband, Minister James Archie (currently James Archie is a Bishop in the city of Fresno, California, ministering at his church titled "Moments of Blessings House of

Pray" II). One day, while Thomas was at work, the young Hispanic woman, who babysat me, allowed me to crawl out of her sight. I somehow got into the deep end of the apartment complex's pool and drowned. Thomas told me a Hispanic man, living in the area, heard the cries of my babysitter and helped her look for me. After a twenty-minute or so search, I was located at the bottom of the pool, unconscious and in a coma. Emergency medical service was called, and the Hispanic man, who found me, attempted C.P.R. The physician caring for me told Thomas that, if I were to live through the incident, I would be a vegetable. Having faith in a higher power, Thomas called Bishop James Archie, who held overnight prayer vigils with his congregation. In the Intensive Care Unit at the hospital, against doctor's wishes, Bishop Archie laid hands on me. I came out of that coma and was known for many years, after that, as the miracle baby.

About a year later, Thomas was in a relationship with a woman who we lived with in Stockton, California. Josephine was the mother of five other children from several different men, three girls and two boys. Josephine taught me how to tie my shoes. She was actually my first mother figure. But many arguments ensued between the two, and my father often took me to sleep at different motels. Thomas was your stereotypical player. He had many girlfriends and dressed to impress daily for the attraction of his many acquaintances. He could never settle for one woman.

During year four of my life, Thomas and I lived at my uncle's church (Bishop Archie) in hot, without humidity, Fresno, California. We lived in one of the classrooms, sweating for several months. One day, while at the Fresno Welfare Office with

11

Thomas, we met Afro-Centric looking Margo Hawkins and her daughter, Mashona. Mashona would later become a sister, while Margo would give me a few years of much-needed motherly love. Later that same year, Thomas and I went me back to Detroit to help my grandmother, Betty and her husband, John Howell move to Fresno, California. Thomas got his "pretty boy" appearance from my grandmother. She was originally from Louisiana, mixed with Indian heritage and French Canadian. Even at that young age, I wanted to know who my mother was.

On the day we prepared to move, Thomas took me to the park for lunch. While there, we saw a pregnant woman being beaten by a man. Why would someone want to harm a pregnant woman? That was my first experience as a witness to violence. However, it was far from the last. In fact, physical altercations would become nothing more than an everyday occurrence while living in certain areas growing up.

When we got back to California, Thomas and I lived with my biological grandmother and her old fashioned husband. Again, Thomas was struggling with his drug addiction, and John Howell was not going to allow us to live in his home. One night after Betty served dinner, Thomas and John argued at the dinner table. While the short, nappy haired John sat at the head of his throne, he ordered Thomas out of his house. I found myself walking the streets with my father, ending up at a phone booth, then riding in a cab to the home of Margo Hawkins. The relationship between Margo and Thomas lasted five years. For the first year or so of Thomas and Margo's time together, we lived in Clovis, Ca, where I attended T.K (Tiferance Kutner)

Elementary. While in kindergarten, I would fight over anything and had no respect for my peers or teachers. The only person I remember behaving for was Thomas because he scared me. Spankings were given regularly after school. My behavior was so bad that the guidance counselor at T.K had me on a program where my behavior was monitored throughout the day. Each hour or section of study, I was required to have the instructor document my behavior.

Thomas had me angry with him for several reasons. Our living conditions were unsanitary, and he left me at home by myself after he and his Venus shaped lover, Margo, had split up. I remember crying for hours in that Clovis apartment and Thomas coming home angry with me because the neighbors told him I was crying loud enough for them to hear. Thomas was different from the fathers who interacted with their kids at school. At that time, I didn't know his negative behavior was a reflection of his street life and drug addiction. Later, I would be diagnosed as hyperactive. My behavior became so bad at the next school, Jane Adams Elementary in farmland Fresno, California, I failed to do class work.

CHAPTER TWO

Teachings From An Addict

My Teacher, Ms. Gooseman, who I had a crush on, and spoke to disrespectfully, wanted me to be removed from her class. I was sent home several times that year and even received a spanking on two occasions from the principal. Hated that man! Not because I was being punished for my misbehavior. I hated him because he seemed to enjoy spanking and scolding me every chance he got.

On many occasions, I helped my dope fiend daddy because he was either unconscious, lying in the street, or running around scaring the neighbors. Margo, suffering from her own personal issues, would come and go. I found out later that Margo was diagnosed with schizophrenia. And every time

Thomas went off on some type of drug binge, Margo would leave only later to return.

My second-grade year was horrible. On the last day of school, while reading my report card during the bus ride home, the comment section said I was to repeat the second grade. That was my first self-reflection of disappointment. Now as an adult, I think of that bus ride home every time I take an exam.

The following year was just as difficult at home. Thomas was using a drug called PCP. I was forbidden to eat anything with sugar in it because of my hyperactive behavior. Margo's mother passed away, and her sister, Roberta was admitted into a mental institution. Margo's behavior became more bizarre. She would wake me up in the middle of the night, while Thomas was out getting high, and tell me she heard me talking about her. School was nothing more than a break from home life. One day after a writing assignment, my teacher praised me for my work. We were instructed to write a different ending to an old nursery tale. It was liberating to be able to formulate my own thought then write about it. I thought that I could be a writer, but quickly dismissed that notion. Kids like me just got in trouble, all the time.

In third grade, I became one of the better athletes. I could run fast and fight like no other kid on campus. I would always be one of the first kids picked for a team. That actually helped me relieve most of the tension associated with my home life. Thomas had just gotten a new job as a dispatcher for Fresno Valley Alarm. I believe Margo was taking medication, and we even rented a home. The house had three bedrooms, a front and back yard, and was located on Tillman Avenue just

down the street from "Roeding Park". Life was starting to become enjoyable.

One evening, Margo woke me up and told me we had to go to the hospital to see Thomas. Confused. The hospital? I knew Margo's sister was in a mental hospital, and if in a hospital, doctors were trying to save you from dying, as I almost had years earlier.

We arrived at the emergency center and Thomas was lying on a gurney. He was unconscious with blood in his mouth and tubes in his arms. All I could do was cry. I thought he was going to die. Days later when he returned home, he could not eat solid foods because his broken jaw was wired. He could only drink from a straw, and his face was swollen with shades of blue and purple that I'd never seen before.

Thomas had reconciled with John Howell, who was visiting and being told how the incident took place. Apparently, Thomas was at an A.T.M machine and was jumped and beaten for the forty dollars he had withdrawn. Later that story changed a bit. Thomas had another thickly shaped woman on the side. One evening a friend was arrested for some unknown reason, and Thomas, along with his fling (I was never told her name), were followed to the A.T.M. Thomas's plans were to get some money so he could help bail his friend from jail. One of the two guys who followed Thomas that night was the boyfriend of his fling. Those two brutes battered Thomas.

A few people from Fresno Valley Alarm came to the house with gifts and cards for Thomas, and several months later, he returned to work. That same year when Christmas came, my Grandfather Leland sent me a box of clothes. This was the first

time I was given new clothes, and these clothes were suits. I took pictures and even wrote my grandfather a thank-you letter. That's when I developed a fondness for clothes. Unfortunately, times were extremely rough for my family during those holiday seasons. Margo cried Christmas Eve because we could not afford gifts. Thomas was fired from his job for not showing up to work. He went off on more drug binges and couldn't work. Our electricity was cut off, along with the water. For weeks, Thomas would cook meals from the Bar B Q pit so we could have something to eat.

Those types of situations continued to happen off and on until Margo decided to leave for good. Things were different this time because she told me I could leave with her. I chose to stay with Thomas.

Several months later, awakened by Thomas crying, I found him sitting on the toilet naked and holding the phone. The side view of him was thinner than a female super model just before her march down a runway. His eyes were bloodshot, beyond normal, even for him. He usually had white rings around his iris. Next to the burgundy color, I couldn't see any portion of his eyes. With a rabbit paced heart, I asked him what was wrong, and he stated his testicles had somehow twisted themselves around and would not untangle. I called the emergency medical service as Thomas requested and rode in the ambulance with him to the hospital. The nursing staff asked if I had a relative to stay with overnight because Thomas was being admitted. At first, I thought of my aunt Marie Archie; however Thomas and I were the black sheep of the family because of his drug addiction. After giving the nurse Margo's full name, they

somehow contacted her. I stayed with Margo for a few days. For the first time, in a while, I ate full meals and slept comfortably. Even so, I was always being cautious with Margo, thinking she would have another episode. I was happy for a moment; she no longer heard voices and saw things that were not there. Yet that time didn't last but a few days. Soon as Thomas got out of the hospital, I was back at the house on Tillman preparing to move. We were being evicted.

The new apartment complex was located in an area much different from the park neighborhood. The majority of the population was black, whereas before everyone in the neighborhood was Hispanic. Also, the men in the neighborhood came and went. There were no families with a mother, father, brother, and sister. Every kid was being raised by his or her mother. Thomas and I were considered different from day one on Olive and Ninth Avenue across the street from Yosemite middle school, still in the heat of Fresno. My first day at Mayfair Elementary School, I had to undergo curriculum testing so my placement would be in the proper class. Fortunately, my reading and writing were above grade level. Thomas, however, elected to have me continue school at my present grade and not advance me. So my fourth grade year was not difficult. I continued to excel in sports, even though, the kids at school seemed to be growing bigger and bigger. I wished to hit puberty like all the other kids around me.

At home fixing my own meals, when we had food in the house, and dressing myself for school were routine. I had a lot more freedom than the other kids on my block because only a few of us could do what we wanted when we wanted. Thomas

gave me a few dollars here and there, and some of the ladies would show me the differences between wash cycles. Washing my own clothes had me in a position to meet and become friends with most of the women in my apartment complex. Most of them were drug addicts like Thomas, however they had many children, and the women who could even afford to wash their kid's clothes was considered pompous and uppity.

That year was my first time dealing with peer pressure. Kids in my neighborhood were smoking marijuana and having sex, and I was just in the fourth grade. My good friend Norris Yancy, who lived with his mother and three sisters, thought it was a big deal to "cop a feel" on a girl. I refused to do any type of drug or alcohol because Thomas had an addiction, and I needed to take care of him. Norris had many family members who used drugs so it was normal and easy for us to relate. Even though, I was only a couple inches shorter than Norris, he weighed at least twenty more pounds than me. I had a dark skin color while Norris was considered a yellow, hefty, brother. With his build and light complexion, we had no similarities. All of his family members called him "muscle". We hung out after school to break dance with the older kids on the block. Neither one of us was great, but I could hand spin, back spin, knee spin, head spin - you name the spin, and it was spun on my behalf. In spite of his heavy frame, Muscle could pop-lock like a champ. We had no money but only music was needed to form the right setting. At times, the dope dealers on Ninth and Olive Ave would park their lowered cars with candy paint jobs next to us, and we would take turns scuffing our hands and knees on some old cardboard, while they bumped their

system. No one rode on twenty inch rimes in the early eighties. You were the man if you had wire wheels with white walls and fifteen inch speakers in the trunk.

One night Norris and I sat in a circle with many kids who were smoking a marijuana joint. We called it "dank". The older kids would puff and say it was okay weed, not that strong. When my turn came, I was laughed at for not taking a hit. Walking away embarrassed, Norris joined me. I was not going to be a drug addict like Thomas. My phobia of drugs was solidified that very day. Norris told me he thought smoking weed was stupid. I agreed. For fun, Norris and I would go "Door bell Ditching," knocking on a random person's door and running away only to get chased around by our neighbors who knew who we were.

One day Norris and I knocked on this woman's door, who was being beaten by her man. When that angry dude opened the door, he never closed it and literally beat that woman up in front of myself and Norris. I thought she was being beaten because we were knocking on her door. I told myself that day I would never hit on a woman of mine. Norris and I watched the angry man limp down the street when police sirens wailed.

My neighborhood was a lot rougher than most. Many fights were lost because of my size; however I had the respect of my peers because running was not an option for me. Once at Yosemite Middle School, two boys who were about thirteen beat me up because one of them liked the girl I was hanging out with. Wishing to be ten feet tall and enraged I could not defend myself from those older and bigger boys, I went home and got Thomas's baseball bat and a catchers mask so they couldn't

hit me in the face. They were no where to be found. However, several years later as a teenager, I would see both of them together pushing a shopping cart full of old coke and beer cans. After asking them both if they remembered who I was, bang, my right and left fist met the chin of one, then my shoes met the chest of the other after he slipped and fell to the street. While kicking one and shouting slurs, fueling my rage from years prior, the other ran, leaving his brother to absorb the bulk of the wrath. Walking away, I felt revenge was satisfying, yet a new guilt coated my adrenaline rush. Those guys were no longer a threat. My actions were justified by the ignorance of street justice I was desperately running from, yet had not fully escaped.

My love/hate relationship with Thomas was increasing with the level of his drug addiction. He would often be high during my morning ritual of getting ready for school. Years prior, his drug binges were hidden by moonlit rays and the dizziness of my sleepy eyes.

Without a music course or an instructor to brag of, Thomas was very musically inclined playing several instruments. A percussionist, he also played the flute and was very gifted. On many nights, Thomas would have friends over and they would jam. Afterwards, those nights observing him cleaning his instrument, his musical passion was evident. My plan was to help him quit drugs by encouraging him to play more. The more he'd play, the fewer drugs he could do. When Thomas played his flute, he seemed stable. He played in several bands. On occasion before entering my home, Thomas would be playing his flute and my wishes were his music would end his drug use. I began playing the alto saxophone hoping to understand the

positive influence music had with Thomas.

This was my first discovery of "NOESIS". Using thought as a tool, being able to understand Thomas's addiction and comprehend the magnitude of it. I played in school assemblies along with being in the school's chorus. Inviting Thomas to these events seemed to help him. Watching me involve myself in music lifted his spirits. At home we would jam together, and during that brief period music and athletics helped release the stress of home life. I stopped playing the saxophone when he would force me to play for hours after school. His attitude switched, and the musical fire burning down his drug habit was in fact being extinguished by his new drug of choice, "crack". Now if crack cocaine needed a spokesman, Thomas was her man. He pawned his flute and began selling everything he could get his hands on. At that point, the violin became my new instrument, only to be faced with fears of Thomas possibly selling it.

One thing he could not sell was my singing and sports. With chorus rehearsal and football practice occupying my time, hopes of aiding Thomas with his drug addiction was fading. What I discovered was how much my participation in music and sports helped me. Again, I was one of the smaller kids on the "Mclane Pop Warner" football team, yet one of the fastest. As my apartment was several miles away from Mclane High School, the walk to and from practice was dreadful. During my first season, the same shoes worn to school and those long walks were the same shoes worn in practice and games. The kids on the team would laugh at me because of this. Even though that bothered me, I had no other way to relieve the tension and stress of my home life. As an adult, I

now know that physical exertion can help any person release frustration from their life. Back then I just knew it made me feel better.

Due to Thomas's drug use some form of drama was always going on. The apartment was burglarized. The electricity was constantly being turned off, and we seldom had a phone. Thomas received a letter from one of my teachers stating she needed to speak with him concerning my school work. Sitting motionless amongst the filth and stench, watching Thomas speak with my teacher, I gritted my teeth thinking of words to tell him and how to express it without shouting. I asked Thomas why he didn't clean up, knowing that my teacher was coming by. He said, "She's seen dirty houses before". To this day I cannot stand a dirty house.

For the first time that year, I had to live with my Aunt Marie while Thomas served time in county jail. Thomas was involved in a credit-card scam at one of the neighboring gas stations. My Aunt Marie shared the same banana complexion as Thomas. She also gave her husband eleven children. Pictures of her youth, shown to me by Thomas while they grew up together in Detroit, revealed a gorgeous, short in stature, woman with beautiful brown hair and feminine curves. Bishop Archie had bought them a five bedroom home years prior on the east end of Fresno. The backyard was fun to play in along with the front yard. They always had food in the house, however my mischievous cousin Jonathan and I would get in trouble for sneaking into the fridge before dinner time. I was nothing more than another mouth to feed, another body to keep track of. It just so happened I needed more love than they could afford to give. My cousins called me names like "ghetto boy" and talked about

my clothes. In spite of this, I still developed a relationship with most of the boys based on athletics. Jason was someone to be looked up to because he played football for Fresno High School and had the nickname "O.J." He was a small sized tough guy with a pretty boy smile. Cornell was attending Fresno State on a track scholarship, his legs were sculpted perfectly for triple jumping. My other cousins David and Jonathan were around the same age as me. We would wrestle and compete at everything. David was somewhat of a misfit himself because he would ditch church and disrespect my aunt, then my uncle would spank him in front of everyone. David was taller than Jonathan and me. I had not yet started puberty, where David and Jonathan had peach fuzz on their lips.

My uncle was so different from any other man I had known at that point in my life. He was a good man who took care of his wife and he was there for his kids. I even thought because he was a man of God, he could read my thoughts. A dark skinned man with a belly and a beard. He dressed like a rich person always in a suit and tie. He even wore enough jewelry to obtain a second look from people who passed him. Attention was a great need of mine. My aunt had eleven children, her time and then some was given to the church, to my uncle and what little was left, to her kids. My issues would have taken up too much of their time, for those reasons alone I could never be upset with her for not raising me as her own child. The night Thomas got released from Fresno County jail, he came to get me. Not wanting to leave with him that night, we arrived at that cold stale apartment on Ninth and Olive to no electricity. It was like remembering bad times, then awaking and realizing

they weren't memories.

Fortunately, a coach with my same last name "Tucker" came to my elementary school and announced during recess he would be holding wrestling practice after school. I would join! Wrestling was like an organized fight, a physical chess match. I fully expected to participate in these so-called organized fights every day after school. Because of my athletic ability, I was already better than most of the kids who had wrestled before. Coach Tucker had the typical build of a wrestler. Large shoulders with the legs of a distance runner, slim yet muscular. He told everyone about the "Pepsi Classic" wrestling tournament coming up in a few months, and I was determined to wrestle. However, that particular tournament was a freestyle-type wrestling tournament, and that cost money. Coach Tucker bought my first U.S.A wrestling membership card and paid for my first tournament.

My feelings for Thomas were bitter because I wanted to have the money to pay for athletic needs myself. I was tired of being ridiculed for the poor condition of my clothes and shoes. Thomas wasn't working. He collected a welfare check on my behalf along with selling drugs to support his addiction. One day, while talking with a few neighborhood ladies in the laundry center, this white guy came in soliciting people to distribute the Fresno Bee News Paper. Of course, I lied to the guy about my age and started waking up early in the morning, delivering newspapers before school. Now buying wrestling shoes, football cleats, and most of all, being able to pay the entry fee to those weekend freestyle tournaments became reality. Norris was not as excited about wrestling as me. He was strong

for his age, hence his nickname "muscle". However, my hefty friend didn't like to sweat, unlike myself, so physical exertion left him unpleased. We were still friends, yet didn't hang out as much. When the "Pepsi Classic" rolled around, my real wrestling shoes helped me win a third place medal and realize I hated to lose. My hatred for losing led me to explore areas of wrestling that would later help me become a champion. Then, wrestling movement was foreign. My strength and aggression awarded me victory.

The beginning of my sixth grade year was better from an emotional perspective. The attention from singing in the chorus and sports were given to me in bulk. After analyzing my living conditions, drug use was the root to all my problems. If that could be eliminated from my life, then I'd be able to relax and focus on greener pasture with Thomas. Even though drug use with Thomas was evident, I refused to understand and comprehend its hold him. That year, my lips received their first kisses from two girls who both asked me to be their boyfriend (I wish I could remember their names). One was Hispanic with long, straight, black hair, and the other was Caucasian with thick, curly, red hair. Every day after school, I would walk them to the bus stop because they took a different school bus home. One particular day they led me into the bushes, and both girls kissed me.

Funny how certain events can cause one to reflect on past memories because that very incident involving those two girls helped me recall my first attraction to a woman. I must have been about seven years old because Margo and Thomas were still seeing each other. Margo would take me and her daughter shopping in downtown Fresno at the thrift

stores. One day, while Mashona and I, were running around playing between the isles of clothes, infatuation helped me notice a woman wearing a long, light-colored skirt that touched her ankles and a blouse with no sleeves, showing off her shoulders. She was neither Caucasian nor Black. Her complexion was smooth, mid-tone dark, like a deep summer glow she didn't have to bake for. She had extremely long, thick, curly, black hair. Her beauty was to the second power and flaunted the sweet scent of honeysuckle. To this day I think of her and burn honeysuckle candles in my home.

Soon after my first kiss, we prepared to move out of that area. The electricity and phone were off again. My paper route was lost because Thomas took the money I had collected to pay the next month's installments of papers. I couldn't wrestle in that year's "Pepsi" tournament because my hand was broken in a fight with one of the neighborhood kids. Larry was upset because he was much bigger than me, and my wrestling skills were better. Larry started throwing punches, I hit him with a closed fist on his right tibia and fractured my right hand. I had to wear a cast for six weeks.

Anyway, on Thanksgiving Day I had just come back to an unlit apartment from hanging out with Norris. Thomas had scrounged up about one dollar worth of change and told me to go to the grocery store and buy some potatoes. When I returned from the store with a few potatoes, Thomas was fussing with spit flying from his mouth. He told me the grocery store had a sale going on, five pound bag of potatoes for ninety-nine cents. I rushed back to the store, hoping to return before dark. The clerk felt sympathetic and allowed me to exchange the few potatoes originally purchased. When I returned

home, Thomas had an extension cord connected to the neighbor's apartment. The cord was attached to a pot filled with hot grease. When we ran out of daylight, Thomas used a flashlight to finish cooking the potatoes. Thanksgiving 1984, I had the biggest plate of French fries I have ever eaten to this day. I could not finish them all, Thomas asked me, "Boy, do you know where your next meal is coming from?" I had no reply, I forced myself to finish all those fries.

Even though, we had been evicted from that apartment, we lived there for another month or so. When daylight ended, separating myself from friends became routine. They need not know about my living conditions even though, some of them were experiencing similar problems. The apartment we lived in was nothing more than a crack house. Every base head in the neighborhood used that place to smoke dope and sell drugs. The living conditions were becoming harsher before Thomas had gotten arrested again, this time with a warrant after the police knocked on our door. With no struggle, Thomas allowed himself to be handcuffed and hauled off.

This time, I went to live with one of my older cousins, Jimmy, who was named after my Uncle. When we first moved into the apartment on Ninth and Olive, Jimmy worked for the cable company and for a small fee he would hook up your cable. At the time, Jimmy was involved in a little dirt himself. However, he seemed different from Thomas because Jimmy was hustling to provide for his wife and kids. He was not strung-out like Thomas. I feared Thomas would overdose one day where as Jimmy still had hope. He was bright skinned with handsome facial features. Like most of

my relatives, he was less than six feet. While living with Jimmy, all there was to do was take the city bus to school and come home. Being kept indoors all the time was no fun, so when my cast was removed, I tried to find odd jobs around Jimmy's neighborhood. The opportunity arose to work at a farm during Christmas break. The farm was owned by one of the members of my uncle's church. The only stipulation would be having to live at my uncle's house because the rest of my cousins would be working at the farm as well. Ridicule and name-calling would coat my ears, but the money was more important. For the first time I saw a black farmer!

During the first week, my cousins and I were having a dirt rock fight. I accidentally struck an older man in his face. That man wiped the dirt off his mouth and with his long arms hit me hard enough to knock me to the ground. Unable to react he stood over me, yelling, "No one hits me in the face, no one". He was skinny like most of the base-heads in my neighborhood. Fortunately I was not hurt, and no one ever said anything about that incident. Never having been in a physical altercation with a grown man before, confusion spun my thoughts. Thinking to myself if there was a next time, then I'd pick up the closest and biggest object and defend myself. Funny enough, I'd been given the opportunity several times in situations protecting Thomas. After that winter break, my money bought me some clothes for school. As soon as Thomas got out of jail, again, he'd find us a place to live.

Thomas was given subsidized housing at the "Maple Wood" apartments in two seasons either cold or hot Fresno on Shaw and Baker Avenue. I

was attending my fourth elementary school, "Vineland" and would only be for the last half of sixth grade. Vineland had little diversity, only three black kids in my whole class. My teacher was a black heavy-set woman who seemed to have an attitude about her weight rather than embracing her voluptuous beauty. Ms. Manning was mean and right away she didn't like me. I wanted her to care because she was the first black woman outside of my aunt and older cousins who seemed to have respect for herself. No matter how hard I tried she never took a liking to me. Needing her approval as well as her respect, when my question arose she would never give me as much attention as she gave the other students. My level of respect matched hers.

On my second day at Vineland Elementary School, Quinton Gregory became my next neighborhood friend. While we were talking at recess, one of the other six graders from a different classroom came up and took my red dodge ball. I told the kid to give me back my ball, or I would kick his ass. The kid stood over me in challenge. My heart was that of a fighter- with one punch to his nose, the principal and I were having our first conversation.

The principal didn't suspend me; apparently the kid was the school bully, and the administration was waiting for someone to stand up to him. We were both counseled, then sent home early with a note to our parents. Thomas wasn't going to punish me for a fight I did not provoke, he was to busy developing those white rings around his eyes and working on more weight loss. After school let out for the rest of the kids, I went over to Quinton's house where I met his mother and his younger

brother. My new friend lived in a single-parent household and to my knowledge never knew his biological father who was African-American. Quinton's Caucasian mother was a drug addict, just like Thomas. She was receiving disability aid along with welfare for her children. Quinton's mother had lost the lower portion of her left leg (just below the knee) in a car accident. Quinton was tall for a sixth grader, almost five feet eight inches with an Afro that was gold and out of control.

The third addition to our crew was Charles Walton, another tall, slender, black kid from our class. I encouraged them to sign up for sports, chorus and theater, but athletics was the only thing in which they would participate. We had a three-man team during recess and basically controlled the playground. Tall kids like Charles and Quinton were kings on the basketball court, but me being tougher than any other kid allowed me to hold my own and then some.

My responsibilities at home changed. Thomas was trying to win the hustler of the year, selling "crack-rock", powder cocaine, and marijuana in the neighborhood. The "Maple Wood" apartments were across the street from Fresno State, so he was selling Marijuana to some of the college students. After he would make a sale, he would give me enough money to eat and pay bills. Thomas was still manipulating the system collecting welfare and section-eight housing. On the fifth and twentieth of each month, Thomas received a check. If he didn't sell the food stamps, we would buy groceries. I would pay the rent and mail out the electricity and phone bills after obtaining money orders from the local 7/11 on the corner of Shaw and Maple Ave.

In theater, my goal was to play the part of

the "Cheshire Cat" in the play "Alice in Wonderland." I got the part and practiced my lines and added some dancing to my character. We performed that play with Vineland's Elementary theater group all over Fresno. A new outlet had been discovered to release the tension of my home life. The practicing of my lines was difficult because so many people were coming and going from our house. One of their many nick-names was "Clucks". They would ramble around my apartment on their hands and knees in search of crack cocaine, hoping another person who was just as malnourished (resembling a chicken both in stature and movement), might have mistakenly dropped a piece of dope. Along with Thomas selling drugs, different people stayed with us off and on. Reality had not yet sunk in, comprehending and understanding Thomas's addiction was being avoided by me and him. Certain people lived life differently, for me street life was normal. What would seem unreal and scary to some was nothing more than everyday life to me. Watching people smoke rock cocaine from a glass pipe with a bulge in the middle of it was average. If you saw a person smoking from a "straight shooter", a pipe with out a bulge, then you knew they were just that much more addicted (if there is such a term).

One day, a Mexican man (Paisa) sat at our table with a gun boldly showing in his waistband. My question to Thomas was why he needed to show his gun off like that, and Thomas stated most of the guys from Mexico are like that. If he hadn't been in the past, Thomas was involved with some true gangsters now. From time to time after being given a little extra money for clothes, food, and bills, I'd hide the money to use when Thomas was penniless

from spending his cash on drugs.

Thomas's fights were my fights, mostly against other drug addicts. Some were different. At times, the level of altercations were verbal, right away you knew neither party would take a step towards blood, then there were addicts like "Joby". This man was not skinny and weak like the other dope fiends I was used to seeing, he had girth. Thomas had been yelling about how this man named "Joby" had beat him out of some dope. Thomas grabbed a machete and told me he was going to Joby's house, just down the street. I picked up a baseball bat and opted to fight alongside him. We waited in the bushes for Joby to return home. We waited so long that I actually fell asleep. When Joby came walking down the street, Thomas told me if I was going to help him, I better hurt the guy. My heart rate doubled, and I could feel my pulse within the grip of my bat. Not fearing jail or Thomas being hurt, with me there, that wouldn't happen. I was afraid we would kill Joby. I was not a killer. After speaking with Thomas and many of his friends concerning death, in situations such as this, anything was possible. One man named Red, who sent Thomas letters from prison, schooled me to some game. Red had done several years for manslaughter, and when he got out, he lived with us for several months in that stale Olive and Ninth Ave apartment. Red explained to me the difference between a killer and an average tough guy. Red said a killer won't talk shit, he would just kill you if he had to. Also if a person were to disrespect a killer, the man would suffer ten fold before he was given the opportunity to apologize. And most of all, a killer would be able to intimidate with his presence alone. I knew that night I was no killer. And

Thomas was capable of killing Joby.

Violence

VIOLENCE, I UNDERSTAND YOU

YET THAT DOESN'T MAKE YOU RIGHT,

RUN AS FAST AS YOU CAN

HOPEFULLY VIOLENCE WON'T CATCH YOU

TONIGHT.

CAN VIOLENCE BE OUR FRIEND

MAYBE WHEN IT'S YOUR TIME TO DEFEND

YET EVEN THEN IT HAS FOUND YOU AGAIN.

WHY CAN'T WE BOTTLE YOU UP

CAGE YOU AND SEAL YOU IN,

IF I AM NOT MISTAKEN

THAT'S BEEN DONE BEFORE

ONLY TO RELEASE YOU

DURING THE WORST ALCOHOLIC BINGE.

VIOLENCE, I HATE YOU,

IF I CATCH YOU

THAT WILL BE YOUR END.

WAIT, WAS THAT ME OR ARE YOU NOW WITHIN

HOW CAN YOU BE SO POWERFUL

CAN NO ONE DEFEAT YOU

YOU'VE TAKEN HUGHIE, MALCOLM & MARTIN

I WISH YOU WOULD TAKE OSAMA BINLADIN

AN EYE FOR AN EYE, STREET JUSTICE

A POLITICAL VOTE TO WIN

OUR HISTORY OUR PRESENT

YOU WILL LEAD MANKIND TO ITS END

SO BEFORE THAT HAPPENS, LET'S END WITH A

FINAL THOUGHT

DOES ANYONE HAVE AN ANSWER ON HOW

THIS SITUATION CAN BE FOUGHT

When Joby got to his apartment, Thomas and I jumped out of the bushes and attacked him. When Thomas swung that big knife at Joby, he dropped his keys when trying to unlock his door. He cried out for someone to help him. So to prevent Thomas from possibly killing Joby, I would strike him in his hands so he could not make a fist.

Fortunately enough for Joby, he was standing atop his staircase and Thomas could not control the attack. After several minutes, Joby became tired and yelled even louder for any one to come to his aid. When Thomas noticed the onlookers peeking through their windows, he told Joby he would kill him if he ever saw him again. I was glad Joby was still alive, and neither Thomas nor I were hurt.

However, that wasn't the end of our night. Thomas woke me up hours later showing me a portable stereo system he stole from Joby. Thomas's teeth were spread wide showing off the

decay from molar to molar. I recognized pride in his soft tone and those little white rings around his eyes. He was high and retaliation from Joby, imminent.

The front door screamed as if it were being punished for being in the way of an angry man. Thomas grabbed a small hatchet, and I picked up my pellet gun. I refused to have a gun because I knew I couldn't kill anyone. When we entered the living room the door would bow inward with every thud of Joby's force. Thomas asked me, "you ready?" My nod answered his question.

With his left hand raising the hatchet, he reached over to open the door. It literally flew off its hinges. Thomas swung that hatchet beyond sight. Joby was lying on his back looking Thomas in his eyes. Steam rose from Joby's head and glowed on his cheeks. The hatchet was embedded into the ground between Joby's legs. Thomas lay chest first at Joby's feet. Cat-like, Joby was in full stride.

Thomas didn't say a word. He yanked on that hatchet a couple of times before pulling it free. We chased Joby down the street, and every time he slowed down to catch his breath, he caught a hot pellet from my air gun. The whole time, my hopes were not to catch him.

Later when the police came, they already had Joby in the back of their squad car. A female officer questioned me about that night's episode. The only thing said by me was that Joby kicked in our front door. Thomas gave the other officer the stereo he'd stolen from Joby. Thank God, Thomas was not going back to jail. As weird as that night was, Thomas had actually been through much harsher conditions. He was in the Vietnam War, and a few years prior to the Joby incident, Thomas had

shot a man who tried to rob him while using a pay phone in West Fresno. It would surely be only a matter of time before Thomas was either killed or imprisoned for murder.

The summer before seventh grade, I lost my virginity. Elaine Ward was a friend of Thomas's, who had recently moved into the same apartment complex. She had one daughter named Denise, who was about five years older than me. Both of our parents used drugs, yet neither of us would fall into that trap. My view towards Denise was of an awe struck kid. She wore a perm and made her own dresses from material that was colorful and soft. Her apartment was also the spot with cable television. One day after school, I knocked on their door hoping to talk with Denise. Elaine answered the door in a summer dress with no bra. She was thirty-one at the time, and I was just twelve. When Elaine told me Denise was not home, I said thank you and asked her to leave Denise a message. Elaine then grabbed my hand and asked me to come inside. Naïve, my concerns were nonexistent, Elaine was a grown woman, I was a kid. When my friends Charles and Quinton talked about sex, we all thought it took place in high school. Excitement for us was kissing and possible squeezing some hard, lemon size, breast.

Elaine sat me down at her kitchen table and made me a bologna sandwich. While I ate, she boldly asked if I had had any pussy yet. If my complexion were that of butter, my face would have been red like a frozen apple. She then said to me, "I see you looking at my daughter." Elaine had me lost for words. The way she sat in her chair allowed me full view of her thighs. Her voice was direct, yet moist. A knock came at the door; one of her

neighbors had stopped over to borrow something. After the last bite of my sandwich, the restroom became my haven.

After washing my hands, her other visitor had left, Elaine entered the restroom, then with a serene touch led me to her bedroom. My twelve year old pee-pee was so hard it hurt. Elaine took off her dress, then pulled down my pants. Without blinking, I explored her vagina as she lay on her back pulling her knees to her chest. When our eyes met, her expression gave me confidence. Elaine then sat up and pulled me softly toward her by the back of my legs. A moment passed, then she directed me inside her. With my heart still beating a bird's pace, I knew I would be telling my friends about this. Similar to a bath set at the perfect temperature, my mind felt dazed as she directed my movement with her hand gripping my hips. Elaine didn't tell me to keep our actions a secret, she just smiled at me. The whole encounter was surreal, my view of women, "beyond written explanation"

That same summer finding pools to swim in wasn't an issue. Video games over at my buddy's Charles Walton's were fun. Charles, who was soon to be six feet tall, had an allowance and was always eager to spend his money. My pockets didn't know the pleasure of dollars longer than it took to walk to the rental office. However, boredom never needed money to disappear with me in the loop. After pulling up some sprinkler heads, we made blowguns out of P.V.C pipe. With several small- sized nails and construction paper, we had enough darts to stage our own make-believe war. When that got old, we started shooting out all the light bulbs in our neighboring apartment complexes. We raced to see who could get the most at an older

complex just behind the 7/11 off of Marks Avenue at Shaw. One of the light bulbs was big and that thing would not break. Every time we hit it, this ding sound would chime, and the nails would fall in defeat.

After noticing one of the apartment windows was open, my guard was up. That same window was closed when we first arrived. I told Charles, "Let's go." Yet Charles was determined to crack that big light bulb. With another plea for Charles to leave, my attention was towards the street, along with the direction of my stride. Another chime sounded from Charles and his blowgun, and then, screech, a voice not yet manly fueled my pace. Charles was yelling!

When Charles darted out of the parking lot, he was being chased by a young blond-haired white man. We were off to the races. However, this young white guy was relentless. Every car we went around he was right on our tail. We finally lost him by running inside the 7/11 and out the back door. We threw our blowguns away in the bushes before reaching my apartment.

After being in the house for just a few minutes, Charles said he had to get home. Bad idea, "Charles, that white guy who chased us could still be around looking for us." Charles stubbornly insisted on going home. Moments later, Charles was outside screaming, "Alfonzo! Alfonzo!" Thomas was in bed, but I told him what Charles and I had done and that Charles had gotten caught.

Thomas went outside; the blond guy had Charles arms crossed along his lower back, leaning him over the hood of his car.

Charles yelled, "Pops, help me!"(I often referred to Thomas as Pops because I felt

uncomfortable calling him father or dad. Later in life I would just call him by his name). Thomas spoke to the guy and said, "Is all that necessary?" The man just told the woman sitting in the passenger seat of the car to call the police.

Thomas raised his voice and asked the guy to tell him what happened and to let Charles out of his hold.

The guy told Charles not to move. Charles, with an undeveloped tone, said, "I promise sir." Then the white guy told Thomas what we did, and Thomas gave the guy some money (I was surprised he had some). Thomas told Charles to go home and explain to his mother what had happened. After that, my play time was indoors for the rest of the summer!

The start of my seventh grade year was a serious change for me. I had yet to reach puberty, and the other kids were not only more mature, they wore their clothes with style. The in crowd was amongst the cool eighth graders. While sitting in the hallways at lunch, I'd try to do my homework. Even though, I still suffered from test-taking anxiety, my grades improved. Junior high schools had team sports, and this would be truly a life-altering time for me. Thomas was hustling more than ever, his weight was in the "cluck" category, and he was using more dope than he was selling. Responsible for more than just paying the bills, our roles were more clearly reversed. Thomas was being cared for as if he were the child. When his mind was scatterbrained from days and days of heavy drug use, my search for something to keep me strong was found. The power of thought kept me sane. Refusing to participate in anything associated with Thomas and accepting his nature helped me.

Noesis, I now understood the true magnitude of his addiction. My acceptance of Thomas was brighter than fireworks on an evening where stars were nonexistent. Unfortunately at that point of my life, expelling my upbringing was challenging. If there was a problem, my fist went through it. If my stomach was rumbling, food would come up missing out of the school cafeteria. At home, base heads would steal my school clothes and bring me meat from the supermarket. Twenty dollars in food stamps was worth forty, fifty dollars in stolen groceries. I had developed more of a hatred for Thomas, and his opinion didn't mean much to me. We lived under the same ceiling, yet lived virtually separate lives.

The teachers at Tioga Middle School were all different, because students were required to transfer to different classrooms for each subject, we had to adjust to several different styles of instruction. Some of the teachers had to have problems at home because their attitudes would change weekly, some even daily. My health teacher, Mike Darling was down to earth. He was very consistent with his method of instructions and his personality with the students. His stature was very intimidating, standing six feet, five inches tall and weighing close to two hundred and fifty pounds. When Mr. Darling spoke, you listened. He was my health teacher and also the head coach of the wrestling team, and that had me hyped up and more excited to join the squad. Adjusting with the different personalities of all my teachers was work, so the principal's office would eventually become my homeroom class. Principal Dolphas Trotter and I had our share of bad feelings for one another. California law had changed so corporal punishment

was no longer a fear. Besides, the only time we would see one another is when someone else caused an issue for me. Only weighing eighty two pounds gave me many issues with kids until they found out how bitter my heart was. Dolphas Trotter was a positive black man. For me, he exemplified the education and prosperity I desired. Other black men I knew besides my uncle drove nice cars and wore nice clothes from drug profits. Most of the time, I didn't know how to express my admiration for him, so we just butted heads, a lot.

Fortunately, there were several other African American teachers to be admired, like Mrs Means-Ables who was the finest teacher on campus. Her femininity had every boy on campus wanting her as his English teacher. Mr. Jamerson was someone who made me laugh. He had a good job yet dressed like he was broke. His plaid short sleeve shirts with assorted color ties were a joke to see. But most of all Mrs. J. McGinsey had my heart, a dark-skinned woman with a pleasant yet strong demeanor. I often daydreamed about coming home to her as my mother. That atmosphere where so many people of color walked around being nice to one another was foreign. At my house, everyone was plotting on the next guy trying to score some more dope.

Wrestling season soon rolled around, and practice was a place to unleash an incredible amount of frustration and tension, daily. To my surprise, I was the best wrestler in the room. Mr. Darling, now Coach Darling, showed me a double-leg take down, which my teammates would later call the "Fonzie Slam." With an unusual amount of strength, my eighty two pounds would lift my competitors off their feet and literally slam them to

the mat.

Thomas somehow came across a mo-ped, and I rode that back and forth to class. Being on welfare afforded me bus tokens and meal tickets for school. Each week I'd sell my bus tokens and half my lunch tickets. With that money, I'd buy boxes of candy bars at the wholesale grocery store down the street from Tioga Jr. High. After paying four dollars for one box of fifteen candy bars, from my locker I'd charge kids fifty cents a bar with a return profit of three dollars and fifty cents. Selling a box a day was a piece of cake. In-between class kids were lined up at my locker. On Fridays I'd re-up at the grocery store. I'd have a neighborhood base head steal me what ever was needed for school and otherwise. My conscience would not allow me to steal or sell drugs, but my hustle was formed using the same tactics. That mo-ped gave me the freedom to get around like a person much older than thirteen. It was even used for school functions if Thomas was unable to attend. One wrestling match after another I would gain victory. Soon I became team captain, and kids looked up to me even though I competed in the eighty-two pound weight class.

I also made friends with other kids on the wrestling team. Little John Draper, who sold crack, wrestled in the weight class above mine. He eventually got shot while in high school, rendering him paralyzed from the waist down. Then years later he would be shot again, this time dying from his injuries. There were two kids at Tioga named Jermaine Johnson. One had green eyes, and the other looked like a grown, one hundred and fifty pound, hairy chest, man. In junior high school the 150 lb Jermaine was known as a menace. Later, he would be arrested at school for possession of crack

cocaine and expelled. However, before that would take place Jermaine showed me that my attitude was not nearly as tough as his. When he was arrested on campus, two cops, the size of Coach Darling, fought and struggled with him before subduing him. Jermaine became famous in the city of Fresno real quick. He became a "Crip" gang member and killed a Hispanic Fresno "BULL DOG" gang member during a drive-by shooting. As soon as Jermaine became eighteen, he was incarcerated at Pelican Bay state prison.

Several other classmates and teammates of mine would later go to jail or worse, die. One guy, Faruq Darcuil, refrained from robbing people, selling drugs, and joining a gang. We became close friends, sharing the same competitive nature. He had two sisters, one brother, and was supported by his mother Margaret. Extremely developed for his age, Faruq was a year older than me and wrestled in the one hundred and twenty-two pound weight class. Faruq didn't possess the movement I showed on the mat, his gifts were his quickness and his strength, bar none. Every girl at Tioga had a crush on him. His chiseled body and facial features made him a standout.

My first season of junior high school wrestling, undefeated 11-0. At the Fresno city championships, I was seeded second behind a kid from Tenaya Junior High who was also undefeated during regular season, yet at a higher weight class. I wanted to win that championship so badly, to this day it's inspiring to recall. That was the very first match where my ability to out think my opponent awarded me the victory.

There was no score in the first period, and he chose the bottom position to begin

the second round. He's sitting on his knees, butt touching his ankles with his palms flat in front of him, motionless. While positioned on my knees, my left knee at his side and the right knee at his back, my left hand cups his left elbow and my right arm loops his back with my palm covering his navel, the high pitch screech from the referees whistle signals me to react. Holding him down with a simple waist and ankle-ride, he attempts a gramby roll by sitting up then tumbling across his upper back and neck. I let him up before he could score extra points. He was given one point for escaping my grasp. At the end of the second period, I still had not scored. He was ahead 0-1. I chose the bottom position this time; at the whistle, a cheetah could not have matched my movement. As soon as I scored an escape point, he tried a fireman's carry. I had never seen that move before. He controlled my right arm with his left hand by gripping my skinny triceps and positioning the back of his head under my armpit. Placing my right hand on the mat just beside him to maneuver myself around him, he tried to lift my lower body over his head by lifting my right leg at the knee. I used my hips and charged him, knocking him to his butt. He then released my arm to avoid being placed own to his on back. I had scored a defensive takedown and held him down to finish the match with a victory. Happiness couldn't even explain how ecstatic I was. The first person to congratulate me was Coach Darling, and I was glad that he was pleased. Coach Darling and I had developed a unique relationship even then. That victory was so meaningful, and I was so happy to celebrate it with a person who was much more than a coach to me.

My teammate, Faruq, finished

second. He lost his finals match, yet the victory for him was just being eligible to wrestle at the championships. A few weeks prior to the tournament, Faruq's Mom was going to make him quit the team for falling to do his course work. Faruq was intelligent, however he played more than he studied. When Margaret came up to the school and spoke with Coach Darling, a shift in our practice atmosphere left Faruq embarrassed. Coach Darling, bald with a large saddle bag type mustache, required every wrestler to submit a weekly progress report on Friday for eligibility the following week. Your weekend was geared towards completing any unfinished assignments. When he became angry, the wrinkles in his head traveled back to his neck. And those saddle bags shifted from side to side. After Faruq submitted a failing progress report, everyone's attention was directed towards fallings chairs and Coach Darling's long arms circling like a wind mill. After he kicked a few more chairs, underneath those saddle bags came words that forced Faruq out of the gym and off the team.

When wrestling season ended, my focus shifted to the school chorus and the peer-counseling program. Mrs. J McGenzie, who organized and arranged meetings, was our leader. Even though my problems were great, theater, after-school programs, and athletics were my outlet. So when other kids came to the peer-counseling program, their situations seemed minuscule. Our opinion concerning a classmate's problem weren't given. As peer counselors, we were taught to listen and ask questions. That period of schooling was fun, along with Mr. Nygawin's math class. He was East Indian with a thin frame and a stern yet weak voice. He was my academic coach with the school's

46

math team, and Tioga performed well at various city tournaments. I seldom had test anxiety in Mr. Nygawin's and Mr. Darling's classes.

Weeks before school let out for summer break, Faruq and I helped Coach Darling install a fence around his home on 1853 Ashcroft Ave. in Clovis, California. That was the first time little four year old Zachary Darling and I played together. With sticks found in the backyard, we auditioned for every musketeer film ever created. It made me feel like a child myself. Zack resembled a mini-me version of Coach Darling, tall for his age and full of energy. On the way back home before Coach Darling dropped Faruq off, the police stopped us. That was my first time witnessing a person so calm around the police. My views were, Coach Darling was a white man so surely he had nothing to worry about, every encounter the police had with me was negative, so my rigid posture was normal while listening to the officer speak. Coach Darling drove a little white pick-up and was given a fix-it ticket for a broken taillight. He and the officer spoke to each other as though they were old friends. I asked Coach Darling if he knew the guy and, he simply replied, "Never met the guy before in my life."

When Coach Darling dropped me off, he thanked me for helping him with his fence and gave me some money. The memorable part of that conversation was when we talked about how I cut weight for one of my matches that past season. That was my first experience cutting weight. Coach Darling asked me to drop two pounds for a dual meet following Christmas because the weights changed, giving wrestlers a holiday weight allowance. The night before the match, I jogged two miles to the grocery store with Thomas following

me on the mo-ped. We bought a ten-pound bag of potatoes, and I ran back home with that bag of potatoes on my shoulders. The following day after weigh-ins, Coach Darling bumped me up to wrestle the next higher weight class, even though I had just weighed in at the next lowest class. We laughed about that, and he told me he looked forward to seeing me in the eighth grade.

Times seemed to be getting worse, Thomas was bringing various women home claiming that they would be my new "Mom." I'd wash my clothes by hand in the bathroom sink, and when school started, one of his lady friends gave me some white shoe polish so that my shoes would look clean.

The eighth grade was a troublesome year. Thomas's health was fading; he had the appearance of a skeleton and the mind of a zombie. Now when in trouble at school, they would just send Mr. Darling to talk to me. He seemed to be the only person on the planet who would believe and understand me. My living conditions were similar to a greyhound bus station on the eve of any holiday. Thomas had convinced my grandmother to loan him some money to rent an apartment on the corner of Adler Avenue and Kings Canyon Boulevard in Fresno. The media had nicknamed Adler Avenue "Crack" street. Everywhere we lived someone was getting shot and others were selling dope.

Even though we lived in a different district, I refused to transfer schools. Tioga had Coach Darling and the sports programs kept me out of trouble. When wrestling season rolled around, my desire was weaker than the previous year. One of the smallest, yet still the toughest kid on the team, my wrestling division was now the eighty-five pound weight class. I couldn't sleep through the

night in my house because altercations arose on a whim. Either one of the base heads was getting their ass beat for skimming off the mix or traffic was just thick because there was more dope to sell.

Carlos Lazada lived next door to me with his aunt, and we basically kept one another out of trouble. Far from athletic, the only thing Carlos and I had in common was where we lived and the desire not to be jailed. So we befriended one another and watched each others back while hanging out and running the streets. He was a major pretty boy with his Puerto Rican and Black heritage. Carlos went to Kings Canyon Jr. High just down the street from our complex. Every morning I got up early to take the Fresno Area Express to the downtown exchange and transfer to another bus to get to Tioga. Even though my first two losses came that season, Coach Darling believed the city championship was mine. Tioga was ranked number one in the city, and the team captain responsibility belonged to me. With the city tournament one week away, winning was the only thing that concerned me.

While at the downtown bus exchange, sitting atop a bench, this Hispanic kid around my age walked up to me. Posturing with his knees and heels together, left foot north the other east. With his chin poked out, he smartly asked what my jacket stood for. It was 1988, and the Chicago Bears had won the super bowl three years prior. Walter Payton was my favorite running back, and that coat kept the chill off those periods in between buses. My words to the kid, "I don't claim nothing, man."

That kid had nerve enough to yell, "This is Bulldog County, homes."

I jumped off that bench, introducing my forearm to his mouth and commenced to whooping

that boy's ass. A crowd gathered around as we fought. The kid was tough, but my double leg take down slammed him to the street and, unlike a wrestling mat, my head absorbed some of that force. While the kid was catching his breath, this black girl that I had never even met before kicked him in his stomach. The kid didn't want to fight anymore, so without sticking around talking smack, the number nine bus rode me to school.

Every person on the bus was talking about what had just taken place. A couple of the older guys gave me praise and suggested I go home because my clothes were ruffled and dirty. I had never ditched class before and needed all my bus tokens so I wouldn't miss any days of school. In-between classes my teammates talked about the city championship coming up that weekend. One of my friends approached me and said that the kid I had fought that same morning was on campus looking for me. I went looking for him.

He was located near the locker room. Again, no questions, just started fighting. This time I wanted to make sure he would not fight me again. Security broke up the fight, and with blood on my knuckles, we were escorted to the principal's office. On the way there Coach Darling asked me what had happened. I told him that I had gotten into a fight with the same guy earlier at the bus stop, and he came up to the school looking for me so I went and found him.

Dolphas Trotter didn't want to deal with me so, Vice Principal Sherumpshire told me that wrestling in the city wrestling championships was out of the question. That hurt, and even more painful was the look on Coach Darling's face when he was told I was suspended from school for five

days. Tioga placed second at that tournament. We lost to Tenaya Jr. High by three points. All I had to do was win one match at that tournament. A few points would have been easy to score for my team. To this day Coach Darling reminds me of how my suspension cost our team the championship. To this very day, I'm remorseful.

That whole week my apartment became smaller and smaller while different drug addicts came and went. I didn't get to hang out with my girlfriend Stacy. She lived by Fashion Fair Mall which was a good hour and half away by city bus. Being at school was the only time we could see one another. Stacy was white and her mother and father lived in the same house. She seemed to be happy all the time, full of laughter. Stacy would talk about life with me which was a bit serious for kids our age. She played on a private volleyball team, and most weekends her parents escorted her to beauty pageants. We often joked about her being taller than me while our classmates labeled us beauty and the beast. We got along great for over a year, which was forever at that age.

My, "Don Juan", wavy haired friend Carlos would come over when he got out of school, and we would hang out down the street by the Timbers apartments. Ironically, Carlos's aunt attended my uncle's church. Thomas was still an outcast which put me in the same boat, so on Sundays if Carlos's aunt invited me to church, I attended with mixed feelings. On one occasion, Bishop Archie ministered about God helping those who helped themselves. His sermon had me in deep thought concerning Christ and why my life was so difficult. Within thought, my views lead me to believe my ability to think my way through situations, while

others panicked, might afford me a "get out the ghetto free card." All I needed was a plan. As soon as comprehension allowed me a clue, Lord willing, my life would change. So often attending church was to obtain a blessing that would lead to a new life. But after services, it was always back to darkness.

Most of the boys in our neighborhood belonged to a posse called "East Lane." They were thugen, crippen and selling drugs. Half the time Carlos and I hung out over there because they would make base heads sing, rap, even strip naked and run around for drugs. It was always comical, yet heart-breaking, to see men and women degrade themselves for the poison they needed to escape reality. It was stupid to hang out over there for long periods of time because the police patrolled that area frequently, and I wasn't trying to get caught up or placed in Juvenile Hall. Besides, most of the guys in my neighborhood knew I was an athlete who always went to school, so my reputation was of a tough guy, but square and damn serious. Every one also knew that Thomas sold and used dope, the majority of that drug traffic frequented my home. Being a drug hustler was not an option for me, anyone who sold drugs did drugs. Myself and Carlos would talk all the time about having the newest kicks or the tightest ride. However, we always avoided the so-called game (hustling, robbing, stealing, killing people). We didn't have the heart to commit to that lifestyle. Once you became a gangster, you could not predict your future beyond prison and death. With his mixed heritage and curly locks that lay on his shoulders, Carlos was more the player while my sights were in the sports arena.

Conscience

I Can't, I have a conscience

You showed me the life of a thief,

How to rob, how to kill,

And had nerve enough to be impressed by your own

skill.

I pimped my first woman,

At the age of thirteen,

After you taught me how to rock up crack cocaine

And shank a man in his spleen.

She owed you a hundred dollars,

Your advice, be firm stay behind the scene,

Get your money, then the rest was for me,

I Can't, I have a conscience

How many children are raised solely by one male

parent?

You have no heart,

That I did not inherit

You were my daddy and could do no wrong

I thought being a hustle and a drug addict

 were my destiny – when I became grown

I lived with your mentality, far too long.

Lost my virginity at age twelve,

To a friend of yours

She was thirty-one

She told me "you sex like a man"

I was sprung

Son, if you drew your gun

The trigger must be pulled

And if he doesn't go down

No nonsense

Put a couple in his head.

I can't I have a conscience

I watched you smoke cocaine from a glass pipe

Then get upset because I ruined your high!

How was I to know, I was only nine.

Son, you should sell dope,

Then you could provide for yourself,

Have every thing you want in life.

I can't I have a conscience

And if I did who's to say how long I'd live,

Serving poison to kids, base heads, and friends.

I hate you, I love you, I dislike you, I worry about you

Because of my conscience, I am not like you.

Back at school I was on a serious mission to make the baseball team after being cut in the seventh grade. Coach Darling, of all people, was the man who cut me. He coached track, wrestling, and baseball. Everyone respected his coaching ability, but baseball was his specialty. He had never wrestled competitively or ran track. Coach Darling played for the Fresno Rugby Club. Rugby to me was football played by a bunch of big and crazy white men with no pads. Coach Darling's position was Second Row; he often bragged about having to catch all the entry passes. Rugby had to have fueled years of his life. He spoke of meeting his best friend, while playing, even his wife at a Rugby party. For me traveling around Fresno was an experience. In his fourteen seasons Coach Darling used his broad shoulders in clinches and scrums at tournaments in Ireland and England. Like some athletes, my six foot five inch mentor sustained an injury that almost paralyzed him. In 1987, during an anniversary game for club members over thirty, he suffered a blow fracturing several bones in his lower back. That didn't stop him from coaching entirely, and like most athletes he rebounded but with less mobility and constant pain.

My friend Faruq, a baseball phenom who later played in college and the pros, gave me some pointers. However, my little eighty-five pound body had no form whatsoever when it came to swinging a bat or throwing a ball. My ego wouldn't allow me to give in. My goal was to make the team, so

practice was where my energy dwelled until try-outs. From second base, my throw home required a bounce, and even though my legs possessed speed, lack of puberty lost most stolen base attempts.

Coach Darling ran practice like boot camp, he had taken teams over-seas to Japan and beyond. The farthest I had ever been away from home was Los Angeles, and that was for selling the most subscriptions when I had a paper route. When the results were posted in the locker room after the final tryout practice, my name didn't appear on the list. "Not a second time," rung in my thoughts, making my head hurt. I waited for Coach Darling to finish collecting our gear and then approached him for an answer. He had always been honest with me; even when my behavior was bad, Coach Darling would talk to me like an adult. My respect for him couldn't be matched. I asked him why I didn't make the team?

He replied, "Fonzie, your mechanics are not developed in the areas needed for baseball. You have athletic ability yet baseball is a fundamental sport. I am sorry."

Man, my heart was broken. The next day he asked me to be the assistant manager. I accepted and used every opportunity to try and improve my skill. That didn't work. Every time practice started, Coach Darling would give me some kind of assignment as a deterrent.

Every day after school I walked Stacy home, and her mother would feed us. Stacy was winning most of her pageants along with playing volleyball, so at school, I was the man. Stacy's mother could tell I was malnourished so along with feeding me, she would ask questions about my home life. My conversations depicted life as grand as not to cause

alarm. However, I knew she understood. Thomas was headed down a dead-end street, even though his desire to get high was at its apex. He would say things like, "I should just kill myself." Showing no emotion in public wasn't difficult, that was a survival trait. My personal prayer session questioned God's plans for Thomas as well as my future. On one occasion rushing to use the restroom after another long walk from the bus stop, thinking no one was using it, my shoulder bumped the door open while my hands unbuttoned my pants. Thomas had a glass pipe to his mouth, with his cheeks puffed out trying not to exhale. He knew I was standing there yet waited until he finished jonesing before turning to look at me. He had never openly used drugs in my presence with out trying to cover his pipe or conceal his face. On top of all that I heard Thomas was speed balling (injecting cocaine directly into his vein).

Thomas had given up on life when he faced me saying, "You smart, don't smoke shit. Why don't you start selling drugs to provide for yourself?" That was another first. Thomas showed me how to rock up cocaine and determine its value. He showed me tricks, such as how a touch of yeast, to cut the coke, would make the "rock" bigger therefore acquiring more value. I already knew the dope game. What I also knew was how drugs slowly deleted a person from existence. At first an addict looks normal. The untrained eyes can't see their desire, because their desire appears harmless. Similar to an average person's desire for their mate, sexually. Then the addict's behavior changes. They begin to lose interest in issues that were once important. Their mannerisms and grooming habits falter. Their temperament and attitude increases

while their patience becomes somewhat nonexistent. Then before you know it, you convince yourself that your love can cure their habit. Thomas was basically dead, and that was not an option for me.

Without telling anyone what Thomas had suggested, my mind was in limbo, going to school and back was a daze. My hatred for Thomas was overwhelming because he was mentally weak; he was a "Base Head." Couldn't believe that he had asked me to hustle, and if I agreed then death was certain. So for the most part I felt as if he were asking me to die with him.

Shortly after that night, Stacy had a birthday, and her mother asked me to help her organize a surprise party. The party was a success. We all laughed, joked and played, had a wonderful evening. When the time came to leave, I called Thomas for a ride home and heard weakness in his voice. His obligation as a parent was smoked away. He said, "Why don't you stay with them for a few days." With no reply my first notion was to call a cab and ditch the fare.

However, when Stacy's mom entered the room, it was like she already knew. I told her that Thomas had given up. Nothing else was said, she just made me a bed on the couch. A couple of days later I found myself sitting at their kitchen table speaking to a woman from the Fresno County Social Service Department. The woman questioned my cleanliness, commenting on how well kept I appeared. With pride I told her that sometimes my clothes were washed in the sink to keep them clean. After a few more interviews and several visits with counselors, I was placed into my first of four different foster care homes.

THOMAS, MY FATHER

THE LOVE I RECEIVED FROM AN ADDICT

WAS TAINTED YET STILL LOVE,

A WARPED SENSE OF GIVING

FROM A THIEVE'S HAND

AND A LIAR'S TONGUE.

I KNEW YOU WANTED TO PROVIDE FOR ME

HELP ME GROW, WATCH ME SUCCEED,

BUT THAT DRUG COULD NOT LET YOU BE---

----COME A FATHER TO ME.

WITH HATE I STILL LOVE YOU

WITH ANGER I'M STILL THERE

HOWEVER, I COULD NOT DIE MYSELF

ALLOWING US BOTH TO DESPAIR.

YOU BECAME MY FATHER

WHEN YOUR JOB YOU COULD NOT COMPLETE

KNOWING YOUR WEAKNESS

THEN ALLOWING ME TO PROCEED.

YOUR JOB WAS GIVEN TO A MAN

THAT YOU CHOSE

MAYBE NOT FROM A SOBER MIND STATE

BUT AFTER A CRACK PIPE TOAST.

ALFONZO TUCKER

I WILL ALWAYS LOVE YOU AS YOU LOVE ME

AND I AM GLAD I LEFT YOU AS THAT DRUG

TOOK YOU FROM ME

SO BEFORE YOU JUDGE WITH POSSIBLE ANGER

AND SEVERAL YEARS OF NONSPEAK

I RESPECT YOUR GIFT TO LET ME SEEK

AND NOW I HAVE BECOME THE MAN

YOU ALWAYS WANTED ME TO BE!

CHAPTER THREE

The During-Man Hood Before Childhood

Linda Reaves, my first foster mother. Beautiful black woman and an elementary school teacher. Her son Desmond, who I would later refer to as "Bishop" (after Bishop Desmond Tutu, an African religious leader and activist), was twelve, just a couple of years younger than me. Linda's house had fresh smells, my own room with clean sheets, and a long list of chores. Other than Coach Darling, I had yet to meet a more organized person. Linda drove a Mercedes Benz and corrected my speech. She was worthy to look to as being the first strong black woman with whom I had ever lived. Without waiting, I got a job working down the street at Show Biz Pizza Parlor. Linda, a thick

woman, all hips and backside, had strict rules, and I broke most of them, regularly. No person had ever given me a curfew. Linda ran a structured home. Instead of me feeling happy and grateful, my first few months were spent being defiant. Linda's family was huge and all of them seemed successful. I was a ghetto kid with a hood mentality, and I felt out of place around my own people. The black folks where I came from were quick to get loud in public and rarely lived in the same place year after year. Linda's family owned homes and businesses. At family functions, they spoke about younger siblings away at college and future opportunities education would afford them.

On my fifteenth birthday, Linda helped me buy a Spree brand Moped. This time my bike would have registration and insurance. Along with working at the pizza parlor, I delivered papers to pay Linda back the $600 for the Spree. My social worker took me to visit Thomas in-between sessions of his drug rehabilitation program. His attitude was increasing in a positive fashion along with his weight. On my first outing with Thomas he and my grandmother took me to the D.M.V to take the driver's test for my permit. The white rings around Thomas's eyes were clearing up, giving him a more sober appearance. He offered me advice about driving, however the driver's test was a joke. Even though I practiced regularly with an instructor provided by Linda, the practical application was nothing. After placing my seat belt on and adjusting the mirrors, all before starting the car, my D.M.V instructor asked me if I had any dope. That older white man didn't look like a drug user to me. Yet his conversation was of a knowledgeable person who knew the game and smoked dope. With no

hesitation in his voice, he asked me if I could "Hook him up with some pure shit, something that hadn't been stepped on", One trip around the block and he scored me a ninety-two. He didn't even appear ashamed when I told him, "I don't sell drugs nor do I know where you could get some." I was offended that this nerdy, pale, off white colored man with a little pot belly that gave curve to his tie, would assume I'd hook him up. At the time, working class white people didn't fit into the equation of drugs and its associated life style. That incident opened my eyes to drug users outside the hood. For some reason, I thought that all people affiliated with drugs were either hurt-poor or ghetto rich from selling drugs.

Stacy and I were still seeing each other and by then behaving a little grown for our age. One day when Stacy was at Linda's home with me visiting, we decided to walk to the park. My dark skinned foster mother knew we went to the park to be alone, possibly sneak a few kisses. On the way back having planned it out, we snuck around the side of the house where I hid a wooden stool so we could crawl through my bedroom window. Once inside the room, we went into the closet which was spacious enough to lay down in and did what kids back then called, "The Nasty."

Not too long after Stacy and I were into it, Linda opened the door and yelled at the both of us to get up, dressed and in the living room! Scared and embarrassed, my fears were Stacy's Dad and getting kicked out of Linda's house. The only thing that seemed frazzled with Stacy was her long blond hair. She and Linda were actually laughing, having a pleasant conversation before Linda called Stacy's mother, who must have flown over. Fortunately we

used condoms, but Stacy's mom never treated me the same after that. We were forbidden to see each other for a while, and Stacy started seeing my friend Quinton. That was the last of my friendship with both of them. Quinton told Stacy about a time we had gone over to another girls' house and fooled around with them. Next thing I knew we were in our first month of high school, and she had given me back all the little memorabilia from our relationship. She was still playing boyfriend, girlfriend with my boy Quinton, who had been a side kick since sixth grade, so ignoring her became routine.

Bored and sitting in a crowded classroom, listening to another monotone lecture, my mind was on collecting money from late paying customers on my paper route. With sunglasses on, Stacy's mother entered the class apologizing to and asking the teacher if she could speak with me. With my fingers twitching, apprehension coated my pass following her down the hall. Stacy's mother had been the parent from which Stacy inherited her beauty. However, now her shades hid bags under her eyes and the puffy big hair, she wore so proudly, was flat, and pulled back into a pony tail.

"Alfonzo, my husband, Jerry has passed away." My first thought was of him loving and providing for his family. Then my eyes fluttered, trying to prevent the abrupt news from sliding down my cheeks. She stated, "Because we were once close, it is best you know."

Fortunately, football season had started and the Hoover Patriots were considered a top notch program to play for. Every football coach in the county knew our varsity coach, Pat Plummer, who started his career in Tulare, California, before

transferring to the Fresno Unified School District. His long time assistant, Coach Lyons, was even more popular. Hoover had turned out some superstar athletes. Henry Ellared, one of the most notable, played at Fresno State then with the N.F.L's. Los Angles Rams and Washington Redskins. Every aspiring athlete played on Coach Plummer's football team, whether they aspired to play in college ball or not. My years in the Pop Warner leagues gave me the advantage of experience, however my size kept coaches from noticing me. My 115 lbs wasn't enough to compete with kids who were growing hair on their faces. So once again, puberty was interfering with my plans. Even though the freshman, Jr. Varsity and Varsity teams practiced in the same area, all the attention focused on Pat Plummer's star varsity players. My freshman year big Gary Williams was the man. He wore the number #54 and played defensive line. Big Gary signed his letter of intent to the University of Oregon. He was a man among boys, six feet tall, two hundred fifty pounds, a mean looking brotha who walked around the locker room with a bully's demeanor. Being the smallest athlete around was nothing new, however now in high school, kids looked like adults. An adult who had homework, chores and answered to their mothers and fathers. It didn't matter how tiny I was, being disrespected was like damnation, and every day some older jock would test me.

Coby, a junior who played linebacker on the varsity team, had an ego that was faster than his forty yard dash time and bigger than the two hundred pounds he used to tackle halfbacks. All freshmen, J.V. and Varsity teams saw the trainers after workouts. While picking up a bag of ice to

treat my groin pull, Coby noticed that the last bag was in my hand. Not looking directly at him, I could sense Coby staring at me as a few of us freshmen walked to the city bus stop. While sitting at the bus bench, Coby and a couple of his varsity teammates, literally, moved my freshmen teammates for their seats. "Please," in a sarcastic tone was what I said to Coby when he stood over me insinuating that my seat was his. My bag of ice had melted, and the cold water was refreshing as I tilted my head back, watching Coby and drinking in a taunting fashion. He snatched the ice bag from my grip. With in a blink, his ankles pointed to the clouds, and his back was hugging the pavement. Surprised, his ego was hurt more than the scuff marks on his back. While his varsity level friends laughed, he struggled to his feet with both eyebrows struggling just as hard to touch. Coby put me in a headlock and punched me in the chin too many times to count. Teary-eyed trying to hold back emotion, I walked over to use the public phone, hoping Linda would pick me up. Normally, rage would have had me ready for blood, but after suffering a serious ass kicking, my jaw ached and revenge another day dulled the pain. The conversation with Linda was brief. She was not coming to my rescue. So, Mr. Tough Guy varsity linebacker with a mean right hook rode the same bus as me. Coby said nothing to me, not even on campus or at practice. Was it the fact that he was stood up to or the possibility of him losing a round two that detoured him and earned me respect? However it played out, my name ran through the hallways at school, and others knew they had their hands full, if they were in an altercation with me.

No matter how tough I was, my size carried no weight in the category of intimidation. It was me

against the world. My prayers thanked God daily for my living arrangements with foster care, but puberty was a blessing that had yet to be received.

Fortunately my new wrestling coach, Rick Arnold, had us on his own weight lifting program. Our intensity in practice was a testament to Coach Arnold's, competitive days at Cal. Poly University. His reputation was hard, just like his attitude. A good looking older white man, Coach Arnold always got whistled at by the girls on campus. After a couple weeks into my freshmen season, the 112 lbs varsity weight division was mine. Those joys were over quickly, after my body finally started to sprout. Coach Arnold chewed me out for not being able to make weight. Dumbfounded, concerning my weight gain, I began starving myself, weighing only 116 lbs. The scale was no longer a friend of mine as my spirit faded and my hope of a varsity letter diminished. While sitting at the foot of our team scale, not knowing what to do, Coach Darling walked up to me and asked what was wrong. Elated that he was there, my slumped posture became vertical. The words "too big for the weight class" exited my mouth. Watching those saddle bags shift up and down was relieving to see. However, the wrinkles in his forehead weakened the reunion.

"The weight loss is so I remain on the varsity team."

Coach Darling asked me how important my health was.

"It's basically all I've got."

Then he told me, "Don't worry about your weight right now, you're still a growing boy." Coach Darling wouldn't lie to me, I trusted him. He would always come over to the school and check up on me. My varsity letter was not earned that year.

Unchallenged, the 119 pound J.V. position was mine. Wrestling for Coach Arnold was a learning experience, and he would still allow me to practice with the varsity squad. He would have helped me become a champion if not for his arrest for statutory rape.

Televised by the local news, most of the wrestlers attended his trial, some even testified on his behalf. He was married and truly seemed to love his wife, so my prayers were for him to be innocent. The stories that swept through the hallways at school depicted Coach Arnold as innocent, however he was convicted and sentenced to six years state prison.

After only one year of living with Linda, she stopped teaching elementary school and opened her own child care business. Since my foster care placement was considered a division 300-child award of the state welfare case and Linda was now taking care of division 600 children, juvenile delinquents, I could no longer live in her home. My social worker sent me to Detroit to visit my grandfather, Leland Tucker. With hopes that he would finish raising me, my return flight was reluctantly scheduled for two weeks after my arrival.

The East Coast neighborhoods were so different from the California streets that Thomas seemed to love more than me. Detroit was dirty. The street lights hung from cables, and trash covered more areas than the grass. My grandfather's block had small trees planted in cement pots that gave green life to the neighborhood. Leland Tucker reminded me of a horse jockey with style. His hair was slicked back, a lot thinner with more gray than the pictures I'd seen. He still had his restaurant but

in a different location. He and his wife Mattie lived in a tiny apartment, about 600 square feet, just above *Tucker's Place Fine Foods*. From all the stories that Thomas told me, nothing had changed. Leland was still running numbers for that Italian Family. He was seventy-two and still changed his clothes mid-day, just to wear a fresh outfit. My step-Grandmother Mattie was just as thin as Leland. Her complexion was dark with thin narrow legs and straight hips. Not minutes after my grandfather paid the cabbie, Mattie was cooking me pork chops in the restaurant's kitchen. While seated at the booth nearest the stove, stomach barking, my grandfather laid out the rules for my stay. He spoke to me as if my physical being was some place else. Maybe the grandson he remembered years earlier during my infant years.

"Now if grandson steal from me, then grandson going to catch the next flight back the California. If I tell grandson to be quite and let grown folk talk, then grandson is to be seen and not heard. And if grandson hear or see something he ain't know nothing about, then he keep his mouth shut until he get home."

"Understood?"

"Yes Sir."

Not only was I Tucker's grandson from California, I was the Prince of the neighborhood. People who didn't know me treated me with respect. Not the kind of respect one receives from being generous, but of fear because of who my grandfather was. My job was the daily local number's pick up. All the local businesses owners seemed to know me. They called me "Little Tucker." Detroit neighborhoods have every thing you need, and every store to get it from was within

a couple blocks. Grocery stores, pawnshops, liquor mart, dry cleaners, mechanics, McDonalds, and even the Bank of America. All those businesses were on the same street with apartments right above. My numbers collection introduced me to all the shop owners. Leland was a slicker, older version of Thomas without the drug habit. Another job of mine was to drive him around when he did his business in other neighborhoods. He also took me shopping, introducing me to stylish slacks and wingtips rather than tennis shoes and jeans. I couldn't wear anything other than pleated pants when we road together. Leland even tried to give me a gun to carry. However, all he had to offer me was his pearl handle .38, a large .44 magnum, and a shotgun. The .38 was his personal piece and the .44 magnum was entirely too big for my waist. He told me that if my stay were any longer, he would get me my own gun. My hopes were to stay forever beyond the boyish desire to own a hand gun.

Weak bladder and all, Leland was still a player. He told me a man always has at least two main women. Your bottom bitch, she takes care of your kids and your meals. The other would be your sugar. When you had a sweet tooth, she'd hook you up with a piece of candy. He was teaching me all the things Thomas taught me, just at a higher level.

A few days before my flight, my desperation finally overflowed and I asked if I could live with him and Mattie for good. Leland was quick to tell me no and why. He said that he was too old for raising kids, and Mattie had her hands full taking care of him since his bout with lung cancer. Leland stated that several years prior, a portion of his right lung was removed after discovering cancerous growths. His health could not permit him to keep

me. He then said that he would take me by to see my mother Sue Ann if she still lived in the same house where her own mother lived. My eyes passed the ceiling all night, not knowing whether to be disappointed about having to leave my grandfather or scared about the possibility of meeting Sue Ann.

Deflation- not even the people who lived in Sue Ann's old house knew of her. Leland tried to cheer me up by taking me to one of his ladies' houses. Not knowing why we were there, my mouth was going to stay shut until we got back to his 600 square feet living space. Leland asked me openly if I had had a woman yet. Embarrassed, my answer was a muffled "Yes". He told me if not, then today would have been my last day as a virgin. Leland took me back to his little home above his restaurant, and we called information for Sue Ann's phone number. Unbelievably, the operator gave me a number. After dialing, a woman answered and identified herself as Ann. I then asked if she had a child by the name of Tourance (my half brother). The woman said yes, and excitedly I said, "My name is Alfonzo!"

Then came a dial tone. Beep, beep, beep-beep-beep, then redial, trying to reach her back but no one would answer. Then buzzzz, that busy signal stood out in my mind more than her voice. If that was my mother, then she didn't want anything to do with me. A day later, back on the plane to Fresno, California, this time to live in my second foster-care placement.

West Fresno near Carver Middle School, territory of the most prominent hustlers in the county. The "U", just around the corner from my new place of rest. Down the way were other hoods, "The Villa Posses" and "Fink White". All these

areas had ghetto superstars that robbed, sold dope and killed, earning their reputation. The men that rose to fame out of these neighborhoods were role models to most of us who dreamed of a lavish life style. My reality was these streets that would never go away. However, temptation was not going to reel me in like most of the young veterans in the game, despite the riches that rode past me during my walks to the bus stop and the girls who only smiled at you if your ride had beat (high price music system) and your clothes shined. My heart could not bear the burden of a death, whether it came from selling someone drugs or killing someone for the piece of a corner drug spot. Ms. Krast lived in the middle of all that, and she faked sincerity for her foster kids.

My social worker helped me get an inter-district transfer, so Hoover would remain my school for another year. My grades were average, however, I performed well in the majority of my classes until test time. Anxiety and poor test scores came hand in hand. Ms. Krast carried a scowl that added an unattractive view to an already unpleasant demeanor. Her braids always had new growth, and she smelled of stale perfume that reminded me of my apartment on Ninth and Olive after "Renuzit" was sprayed to kill the stench. Ms. Krast worked for the I.R.S and came home every night after work as though she had just gotten fired. I never knew a person other than myself that didn't have a drug habit yet seemed so stressed out and fed up with life. Her conversations were order based. Rules of the house were you hung out in your room and never broke curfew. Ms.Krast cared about the check more than any child that lived with here. The money Social Services would give us for clothes

and hygiene was never seen. My room was shared with another boy a couple years younger than me. Kevin, taller than me by a couple inches and the same shade of dark, showed no remorse for his actions. His mother was a drug addict and his daddy a hustler out in Los Angles, Kevin wore blue Pendleton coats, broke curfew and cursed out Ms. Krast on the regular. Even though I believed she deserved it, I could never bring myself to disrespect her. I was afraid of having to live on the streets. As long as there was a bed and a way to school and practice, hope was not lost. My journey from a good foster home to an amazingly bad one was complete.

After high school Social Service cut you loose. To prevent kids from struggling as adults, foster care provided work shops on job interview techniques and bill paying. In these classes, everyone would goof-off and tease me for being so serious. Those classes taught me that polite conversation could earn you a job. After about six months of living with Ms. Krast, every square inch of my room was memorized like most convicts know their own cell.

During those times I would look forward to seeing Thomas. Still living with my grandmother, he had graduated the drug rehabilitation program at the Fresno Veterans Hospital and was attempting to gain custody of me again.

Wrestling season would soon start and our new head coach came from Hanford High School just an hour or so outside Fresno. Coach Dennis Bardsly had wrestled in college at California Poly Technical just like Coach Arnold. His style of coaching was completely different from any other coach I had before. Coach Bardsley was easy going and never seemed to be dealing with anything

major. He laughed and joked just as much in practice as he did outside on the quad. When wrestling practice started, the fight was on. Coach Arnold taught me how to wrestle with a fighter's mentality. Coach Bardsley was calmer, he taught wrestling with an emphasis on developing one's natural ability as opposed to team similarity. Like most wrestlers, Coach Bardsley had a work-out regimen that lasted year round. His lunch time runs were as routine as his playful demeanor and chipper voice. Standing about five-ten with the legs of a distance runner, you'd notice his hairy arms and chest before his muscularity.

The practice room was close to being mine. Every one on the mat near my weight class was either getting pinned or doubled legged on a consistent basis. All except for David Gobely, a senior who had me by a couple weight divisions. The first time I took him down, we literally fought more than wrestled. I ran around the room with my hands in the air as if I had just won a championship. My fighter's mentality gave me an edge over everyone else. Now the next ingredient was skill. At 126 pounds my body looked more warped than attractive. My arms and legs were long, while my torso was short. At that point, the majority of my weight rested in my stomach and chest. Puberty wasn't everything I'd been praying for, my face was developing acne, and my appearance was that of a muscular ant.

Coach Bardsly was easy going. He would allow us to joke with him like he was just one of the guys. Unlike his predecessor, Coach Bardsly would not have me cut major weight at all. When the year ended, my point total earned me my first varsity letter, yet my money total couldn't afford the jacket.

My complexion was at the top of every joke list on campus. However, my bite was much bigger than my bark so most of the time my classmates teased me while my back was turned. Weekend fights were routine. Between my spotted face and Ms. Krast, anger lay rest in my expression even when joy should have showed the world my teeth. Hardly ever fought at school- the police were on campus regularly, and they took students to jail like a two for one sale. Most of my fights happened after school, and my reputation around town grew with most of the other athletes at Hoover High. Mr. Baseball, Faruq was a member of our weekend fight crew. His arms were as thick as his head so most of his opponents were either intimidated or in college. Fraternity Row on Bulldog Lane was home base to our masquerade. All the Fresno State Caucasian Fraternity and Sororities had their house parties every weekend. Being in high school and living in Fresno, most white kids just got drunk every weekend, whereas most black kids hung out at the park, hoopin, and looking for a party. When I hung out with my teammates, we started most of the fights everywhere we went. Every now and then, we would catch another group or team from another school. If they were game, then fist fighting was played like Nintendo. The meanest altercation I had thus far was with another wrestler who was on Fresno State's team. This guy wrestled in the upper weights, around 180 pounds. A white guy with short brown hair and a build different from most wrestlers, he was tall with long legs. He challenged me outright with no build up or argument. I didn't even know why he wanted to fight, there was no real reason, he hadn't said anything to me other than "come on, let's fight". Looking around, my boys

were there and so were his. We were high schoolers, they were all in college. His crew had combat ready for smiles, and my crew was not as experienced. I wasn't about to take the first punch, so my Fonzie slam was discharged. With both my hands cupping the back of his knees, he sprawled, pressing his hips into me and kicked his legs back completely off the ground. When my face hit the gravel it felt cold, along with the smell of oil because we were fighting in the middle of the street. When he began to lift my body, I planted both elbows in his mouth rotating from left to right trying to build more force with each swing. When my toes touched the ground, I noticed every one around me just watching. No one from either side was fighting. A bright flash on the right side of my face alerted me that my eye had taken a serious blow. Again I had bit off a little more than I could chew, but he approached me. Minutes into punches, grunts and shape stings, his sweat smelled of beer. I wasn't winning, and he was not whooping my ass. As he inhaled, someone from the audience held a knife high enough for everyone to see. "Cut his ass", came from another spectator. His whole crew got lost in the wind. Chasing him wasn't a concern of mine, where did that knife come from? The dude brandishing the knife was neither friend nor foe, just some Hispanic guy that was being entertained by the fight. He said to me, "Man, you'd be a bad dude if you had some size." With my clothes ruffled and stained, I thought about all the fights I'd been involved in before and limped away thinking am I a tough guy or a fool?

After several group meetings with my social worker, Thomas regained legal custody of me. We lived in a three bedroom apartment with my

grandmother on Bullard Ave and Maroa. Just down the street from Blackstone Ave and Auto Center Drive. Having a woman in the home who would cook regularly, adding more structure to our lives, was a major change. My grandmother let it be known from the beginning, no problems in her house. She was the Queen, and her rules were to be followed without exception. My smile became clear again along with my complexion. Thomas was looking for work, and I received the Most Valuable Player award on my junior varsity football team. After the season, my interview went well with Pizza and Pipes around the corner from our apartment. My own money, my own room and my own family, happiness was visiting on a regular basis. A few dollars of my check was given to my grandmother for miscellaneous things. She loved to cook, and her Creole dishes were putting a few pounds on me. She often told me that Thomas would have accomplished more in life if he had never been involved with my mother. Those comments seemed to progress when he would come home late, missing dinner, claiming to have been job hunting.

That honeymoon period was over. Thomas didn't have a job and slowly his old drug characteristics returned. He would leave with my grandmother's car and be gone for days. Betty would vent, and her frustrations would hit me like a punching bag. Do you know that your father is a drug addict? With saliva boiling in her mouth, she told me that Sue Ann should have never run off and left me, with Thomas not knowing. Afraid to ask what those remarks meant, with a little thought, her insinuation was that Thomas may not have been my biological father. Thomas would come in the house after being in the streets smelling of urine and

telling Betty that he was looking for work. My grandmother's warped solution was buying Thomas a car so he would stop taking hers, then her health started to fade. She began using an oxygen tank for normal daily breathing. Despite her cantankerous demeanor, I feared for her safety.

Just when joy began to visit me on a regular basis, my power of thought faded along with my desire to live. Understanding every life situation had been a positive in my quest for security and peace, now my grandmother was a factor in this equation and comprehending the outcome was fatal. "What if" ran through my thoughts, and every scenario led to a physical altercation that started with Thomas. Just like years prior, at some point violence would find him. Be it over a woman, dope or debt, my grandmother would be involved. With her living in the same house, Thomas and his issues could not be avoided. After several conversations trying to convince her to kick Thomas out or the two of us move, she told me I'd have to move out before Thomas. On my sixteenth birthday I scratched my face and the scabs flaked off like dandruff. No matter how hard I tried, Thomas was just pulling me down with him. My life was lived as an adult ever since walking became a daily occurrence, so my focus became leaving, living life on my own.

Then to make things worse, I witnessed my friend Andre Singleton murdered. Faruq called and invited me to a house party on the east side. Skeptical, "no" was my answer because East Fresno was notorious for "Fresno Bulldogs" starting fights and worse. (The Fresno Bulldogs, a predominantly Hispanic Gang, claim northern California in region and red in color). When Faruq told me most of the members from our football team were going, that

changed my answer.

The party was huge, girls were in short skirts and most of the guys looked like they just came off the set of a "Snoop Dog" video. Typical Fresno house party, D.J., couple of kegs, and every one holding a red plastic cup. Drinking was still on the no-no list, so while my boys got drunk, my hopes were to find a girl that saw past the extra pepperoni my face held. If something was going on in Fresno, then everyone was there. Cars parked around the block, the dance floor extended from living room carpet to back yard grass. With the D.J booth set up under the stars, the night breeze would allow all of M.C. Hammer's back up dances to break a sweat and still look cool. Before the D.J. was given the chance to warm up his turntables, a group of Hispanic guys started pushing and punching one of their own homeboys. Why were they treating him that way? I was not about to stand around and find out. After motioning to Faruq to meet me in the back, the Hispanic kid that was being shoved pulled a gun from his groin and started pointing it at the crowd. Pulse doubling, I maneuvered towards the front door. Female screams alerted those who were still freakin and doing the running man. The crowd split. Andre was the only person in the middle of the dance floor. That Bulldog held his gun to Andre's head, and they began wrestling. Indecisive, my weight shifted from foot to foot. Rush the Bulldog? Try to grab his weapon? A gold flash came from the barrel. That shot clearly missed Andre as he continued to fight. Strikes heated the back of my head as if someone was hitting me. I kept an eye on that gun. A fist was my least fear. The crowd was fickle, both front and back exits were packed.

Andre ended up on his back. Another gold flash roared from that Bulldog's gun. As Andre lay on his side, a few of my teammates and I watched the rest of those Bulldogs lead their gunman out of the house. Standing there numb looking at Andre, searching for a wound. His body started to shake, and his eyelids opened and closed rapidly. One of the bystanders pointed at Andre's right eye. When his eyelid opened his eye seemed to protrude from its socket. Andre's dark black skin showed no other bullet wounds. Every one around began yelling, all high school age. Some screamed as a release of fear, others called for their friends. The only voice that held my attention was the Mexican kid on the phone with medical services. "He's not moving, he doesn't have a pulse, the address here is?" He stops talking, looking around for an answer. The screams build again, everyone asking the next person what the address is. Moments passed, and I saw flashing lights and people dressed in blue uniforms with medical patches on their shoulders. They cut the clothes off Andre's body exposing his genitals. While one member pumped on his chest, two others extend the gurney and wheeled him away.

At the University Medical Centers Emergency room, the doctor told us that the bullet had penetrated Andre's eye and settled in his brain. Andre was brain dead and living on life support. Investigators from the Fresno Police Department took pictures of everyone at the hospital and questioned us about that night's events. I told the cops that my friend was shot, and he had done nothing to become the victim. Andre was not gang banging nor was he a troublemaker. He was no saint either, yet he had done absolutely nothing to his attacker. Andre was chosen at random being the last

person to clear off the dance floor.

I had seen people get stabbed and shot over drug deals and arguments before, but the shooting death of my friend was different. He was a true victim and had no right to die. For years nightmares haunted me, watching him being shot over and over in my dreams. The nightmares didn't stop until I visited Andre's grave and apologized to him for not helping him while he was struggling with that Bulldog before he was shot.

The following weekend after Andre's death, I tried marijuana and alcohol for the first time. For me that was giving up. My hopes and prayers seemed to be nothing more than wishes. All the thought invested into achieving my goals of a secure and peaceful life were shattered. School was a place I went to be away from Thomas and my grandmother. Hoover was a predominantly White high school, and I had a wide assortment of friends. Most of my Black classmates smoked "weed," while most of the White kids drank beer. Everyone knew me as an advocate for non-alcohol and non-drug use. Even though my temper was high and fight rumors echoed my name, no one ever offered me drugs, cigarettes or alcohol. It was common knowledge that peer pressure wouldn't get me. Yet after years and years of frustration, my soul was numb. My life was basically over. I would end up dead from participating in something stupid with Thomas. Or become a random victim like Andre. I went to what we called "a White-boy keg party" and got drunk off about four red eight-ounce cups of beer, give or take a cup. My memories come in flashes, my boys laughing at me while I vomited in the kitchen sink of who's ever house. That same weekend I drank some wine called Cisco. I must

have passed out because my memory recalls the flavor of that drink as peach and nothing else. The next morning alcohol had taken over my body and punished me for running from it for so long. My every movement was reminiscent of its bitter taste. While in the shower, the steam had the aroma of peach. Sick was an understatement; dry heaves and red eyes made me promise myself to never get drunk again.

Later that day, one of my friends from the old neighborhood picked me up from the apartment. Thomas wasn't there. He was probably out getting high. My grandmother had stopped talking to me all together. As we were driving south bound on Hwy 41, "Bucky" was smoking a joint. Bucky had graduated from Hoover High school in 1990. It was 1991, my junior year. Bucky was known in the city of Fresno as a teenage pimp. He had a woman for every day of the week and twice on Sundays. Standing at an even six feet tall, Bucky had green eyes and light yellow skin. For a young, non-athletic African American, Bucky had "Mouth Piece" (slang term meaning he could talk the panties off a virgin). Even though Bucky didn't offer me a hit, I asked him for the joint.

The car's speed dropped about ten mph. With his chin tilted and his shoulders hunched up Bucky asked, "Tuck, you sure, man? This isn't you." Holding that burning zigzag between my index and thumb, tilted my head east, and puffed. One hit then passed it back. As I sat back waiting to feel the effects, nothing happened.

Bucky's reply was "Man you need to take it to the head, one puff isn't going to get you blown."

I felt like crying, I had done things I'd run from my whole life. My faith in God was virtually

non-existent and the motivation that drove me, gone. Bucky told me he was sorry for smoking around me and tried to apologize for giving me the joint. My reply was, "I'm my own man, making my own decision."

We talked and drove around for hours. Buck asked me if we could partner up, hustling, selling dope. Normally I would have gotten upset if anyone asked me to sell drugs with them but my mind was lost. We then drove to Antwon's house. Antwon was a major hustler over on the west side of Fresno. Everyone knew Antwon, his main lady at the time was my friend's sister. That night it was me knocking on the door with Bucky waiting in the car because he owed Antwon some money.

After a few minutes of conversation Antwon told me, "Tuck, you need to keep your head on straight. You different man. Cats respect you because you don't be out in these streets. You have a chance to do whatever you want in life."

Dazed within depression, I went home and let the comfort of my bed guide me to sleep. Athletics was not motivating, there were no theater arts program or chorus that allowed me escape. What sparked thought was getting away from Thomas, however my grandmother couldn't be left by herself. After a few days of contemplation, I asked my grandmother how she felt about Thomas and if she knew what he was involved with. She told me that I was out of line and not in a child's place. I respectfully told her that Thomas was using drugs again and was headed for death. She chastised me and went to her room.

Why was she ignoring Thomas's behavior, believing all his lies? Then I realized that Thomas was her only son and all she had since her husband

died a couple years earlier. She was holding onto Thomas as if he were a child, hoping he would become someone sober she once knew. My aunt still lived in Fresno, however she had a large family to tend to. My grandmother needed companionship and the feeling of being needed. Thomas provided that for her no matter how much dirt he involved himself in. I, on the other hand, was no longer willing to suffer for Thomas. Moving out would somehow come, sooner or later.

After speaking to a few friends, I hoped they would consider the idea and share living expenses. The average sixteen year old was struggling to get the trash out on time and keep their rooms clean. None of my friends could even consider the offer. The ones who would were living a lifestyle that I would not involve myself in. Frustration battled with me more than ever; there was no way out.

December 19th, 1990, Thomas really outdid himself. Some crazed man with a deep voice called the house threatening to kill Thomas if he didn't pay him his money. After pleading with the man, explaining that my grandmother was home and in bad health, with that baritone voice he boldly stated, "I'm on my way to collect payment!" Buzz, that dial tone lead to a long stare into Thomas's eye. He wasn't ready for this situation, his bone structure showed through his clothing. He lost that familiar glare that used to scare me, thinking his death total was soon to increase. A quick call and fifty dollars later, my hands held an old 25-caliber pistol. The money was saved in preparation to leave Thomas. While I waited for this unknown man to kick in the door, my grandmother appeared so innocent. Her massive attitude didn't fit her five foot stature. Fair skinned, she would sun burn like a Caucasian

person. Thomas had chosen his path, he could not be helped, but I could not bear the thought of my grandmother getting hurt because of him and his drug- related behavior. We needed to prepare for the worst, this situation wasn't new nor was the possibility that Thomas or I could be killed. When I asked Betty to go to her room, she became red faced, shouting "Thomas, whoop his ass, he ain't too old for spanking"

"Grandma, you don't understand, men are coming here to harm us!"

Thomas tried to argue with me. No backing down on my part. Even though we were the same height my weight had him beat, and I was only one hundred and forty pounds. "Thomas, years of drug use had destroyed your body, I'm a young man. Fight me and you'll lose." Back and forth, back and forth I shouted asking him to tell his mother openly that he was using drugs and that some man was coming to the house to "collect payment." Tears clouted my eyes without permission. You're destroying me, I can't live like you, my conscience won't allow me to be like you. Why are you bringing me down with you? The top portion of my collar is wet, tears dripping from my chin, fist clinched tight enough to free water from steel.

He had no words to match my rage, my grandmother called the police. I went into my bedroom, sitting atop my comfortable bed hoping the police would come and detour whoever was on his way to "collect payment." While sitting there contemplating how to handle the door being kicked in, I held the little .25 automatic in my palm.

Thomas walked into the room and in shock asked me where the gun came from. I just stared at him. When my grandmother walked into the room,

Thomas directed her out and shut the door behind them. For the first time thoughts of suicide crossed my mind. No longer living on this planet seemed like the perfect solution to all my problems. The pain from my gun blast would be temporary. All that was needed was a quick trigger pull. Thinking of my uncle's sermons, they were vague yet something about Christ not allowing people who commit suicide into heaven. But why would God allow me and others to go through hell on earth? Maybe there is no GOD? The doorbell rang, and I looked out the window. Parked in front of the apartment was a Fresno P.D. squad car. No one was in the car. I paused, stared at the gun, lifted it to my temple. This living nightmare could end. I paused, then used my wrist to wipe the tears from my eyes. I exited through the window and hid the gun in the bushes across the street. While climbing back into my room, one of the two officers was knocking on the door asking me to put down the gun. "Gun, there ain't no guns in here." Then the door opened.

With a quick peek and his gun drawn, the blond haired young looking officer cautiously entered the room and asked me where the gun was. I told him that I never had a gun, that it was a silver butter knife that was sitting on the dresser. After the officer checked my waistband, he put his gun in his holster and led me into the front room. The other officer, darker brown hair, thicker build with a receding hair line, entered my room and remained there as we walked into the kitchen.

I said to Thomas, "You told them I had a gun, that was a butter knife in my hand."

Thomas responded, while looking me directly in the eyes, "Maybe I was wrong."

Then my grandmother stated, "I thought you

said he had a gun, I told them he had a gun." My grandmother never saw the .25 auto.

I told my grandmother, "I never had a gun." She didn't even look my way.

The officer then asked Thomas questions about what had taken place before they arrived.

Thomas said that I had challenged him physically and was out of control, shouting and disrespecting him.

The police arrested me placing my wrists in handcuffs. While seated in the backseat of their squad car, the two officers were telling me that kids could get lost in jail paperwork for years. Those statements were made to scare me. "What am I being charged with?" Their response was vague. They kept telling me there were so many crimes, they could not count them all. That meant they had given up on the gun theory.

To my surprise juvenile hall was crowded. After a lengthy strip search, fear to the second power was my only visitor, they put me in an observation cell where one of the counselors would come by periodically and check on me. They must have thought I was suicidal, that particular unit had rubber walls and nothing else. Sleep comforted me-maybe tomorrow all my issues would be gone.

In the morning another counselor came and spoke with me. She asked me about my health and what my thoughts were. "Suicide is no longer an option, my own clothes back would be nice, the jeans they gave me are too small." I was immediately transferred to another area with more juveniles. Most of the kids had kind of the same look in their eyes. That glare of survival. I knew the feeling and offered the same stare back. There would be no problems as long as I kept to myself.

After meals, most of the kids talked about what they had on the streets and how much more when they got back to hustling. How could they want to live in that mind state? Constantly watching your back, in fear of the next hustler or crew trying to take what you got. The drug addicts were even predators who would cut your throat if you were not alert. Yet most of all, why would anyone want to contribute to the demise of another human being. While one man lay in the gutter, covered in stench and depression, the hustler rode around in a nice vehicle smelling of cologne and worshiped by kids who need a positive role model.

Another day passed and being in kid jail was somewhere I didn't belong. One of the counselors had a mean basketball game, she scored at will on everyone. NeNe, was about five feet six inches tall, booty like a track star with a masculine demeanor. She asked me why I kept to myself and didn't play ball with the others. Basketball season was during wrestling season and my hoop game was weak anyway. Avoiding the question, then asking her when I was due for release. NeNe gave me some acne cream, then told me that there hadn't been a charge on me and she didn't know why I was in custody. After confiding in her, telling her about the gun, Thomas and my plans to have my own place, the sun darkened my face while two probation officers and I rode to the spot where my pistol was hidden. After showing the officers where the gun was, they told me that I could have been picked up twenty four hours after my incarceration, because there was no criminal charge. My behavior was being monitored for safety reasons. Two plus two equals Thomas either on the pipe or not wanting me to come home or both. On the way back they let me

use their phone. My first call was to Pat Plummer my football coach, hoping to get a ride back to my grandmother's apartment. The authorities wouldn't allow me to leave without supervision. Coach Plummer was unavailable. The next call was to my junior high school mentor and wrestling coach, Mike Darling. We spoke for the first time in almost a year.

After our conversation, he knew about everything. Coach Darling asked to speak with a supervisor and then told me he would see me soon and to not worry about things so much. Christmas was a couple days away, and the events of my past week were far from the loving, caring holiday spirit portrayed on television. Collect calls to my grandmother's phone weren't accepted, who knew what was going on with her. If Thomas were in the same room with me, I'd have a more legitimate reason to be jailed. He had put his own mother in jeopardy. How could a drug be so powerful that one would risk the life of his own mother? Thomas was beyond weak, soft wasn't even a descriptive enough word to use. Thomas was dead! Even though he breathed air and used his street knowledge in search of that next high, he was no longer alive. His total disregard for the only person on the planet that still loved him unconditionally was inconceivable. I was haunted by the longing for my biological mother, and Thomas was contributing to an early grave for his mother. Hating him was an understatement.

CHAPTER FOUR

Life With My Caucasian Foster Family

The following night, December 24th, 1990, Coach Darling picked me up from Juvenile hall in his mother's blue 1989 Cadillac. On the way to 1853 Ashcroft in Clovis, he laid down the rules. His voice carried a strict tone that reminded me of Leland back in Detroit. My grandfather had passed away about one year after my visit to Michigan. Unlike my grandfather, Coach Darling's rules were based on family living rather than making sure the numbers pick up was on time. At first staying with his family was planned as a temporary situation. I'd most likely live at another foster home before the end of winter break. Coach Darling's back was still

giving him problems from that blow he received a couple years prior in that Rugby game. When he sat down into the black leather seats of that plush Caddy, it took him a full minute, with his back facing the center console, his head never bent forward nor did his spine curve as he lowered his torso trying, to manipulate all six foot five inches of himself into a drivers position. With a quiet tone, my questions received answers that let me know his health was worse than he let on during our phone conversation. The drive was long and that Clovis neighborhood seemed peaceful, no one hanging on the corner, drinking from a brown paper bag. All the street lights worked. From their dining room window shined Christmas lights and Santa Claus décor. They had a mid-size Christmas tree, no frost, yet covered with multi-colored ornaments next to a real fireplace with real huge red stockings hanging from the mantel.

Zachary greeted me with "What's up Fonzie!" His little blonde hair was spiked and he still had that playful spirit. All he wanted to do was roll around and wrestle. That was cool with me. We had fun playing swords when I helped his father build their backyard fence. Dana was scurrying around as though she were late for something. With a glassy look, Dana stated she was not prepared and had no gifts for me Christmas morning.

Just being in their home was the best possible gift imagined. Watching them interact with each other was a treat, comedy at first yet still sweet. They would laugh at the corniest of jokes and Janice (Coach Darling's mother) stood on top of a chair to look Mr. Darling eye to eye and scold him. I had never seen anyone speak to Coach Darling that way, and he had my respect for

standing there listening to what his mother had told him.

That Christmas Eve night, Coach Plummer came to the Darling's home and brought me some gifts. Overjoyed but curious, "Why was everyone being so nice to me?" While basking in all the attention, Coach Darling asked me how I felt. My answer, "feels as if I'm on vacation." When the door bell rang, there was no cause for alarm. While eating dinner, mostly everyone left food on their plate. Life was a lot different under this family's roof. Zachary and I played every day like it was going out of style, and Kassandra, Coach Darling's four-year-old daughter, wouldn't even speak to me. Her eyes would brighten, then she would place her chin into her chest and refuse to talk. Kassie was so tiny and Dana always curled her thin, bright, blond hair, so she looked like the little girl from that play Annie.

Weeks later when school started, Social Services spoke with Coach Darling, and he told them he wanted me to stay with his family. The situation was extremely intimidating. Coach Darling's family was beautiful, not corny in that "Leave it to Beaver" fashion, but a genuine family. My thoughts were dreams of living on my own, working a regular job and paying my bills without having to hustle for rent money. I cared for Coach Darling, he was the only white man I knew who didn't seem racist. He never held his tongue in a fashion that indicated a prejudiced thought. He behaved as if he loved his wife, always concerned about her health and happiness, even though he could only sit upright for minutes. His long limbs were always stretched out on the floor in front of the television. One night over dinner, Dana asked

Zack and Kassie if they were enjoying their presents or had they forgotten them so soon after Christmas.

Zack spoke up loudly, "I like my new brother!"

Looking at Zack, his expression seemed so sincere. The little guy was expressing emotion with a grin, sporting his two large front teeth.

Helping with the dishes didn't seem like a chore, it was my way of thanking them for another meal. Dana asked if I would always be so helpful. My reply was, "Yes, ma'am," and she told me I didn't have to refer to her as ma'am, they weren't that formal.

The following Monday, I moved to a temporary/emergency foster home for the purpose of paper work and the social services investigation of Thomas and his drug usage. After a few days of emergency housing, the Darlings became my temporary foster family, and Zachary was excited about sharing a room with me. My complexion was still pizza like and my hair had fallen out in several areas. Coach Darling took me to see a dermatologist. On the way to and from the doctor's office, Coach laid down the rules of the house. He told me that as long as school and practice was a part of my daily routine, an allowance would be given to me. The doctor gave me a prescription for tetracycline, which eventually helped my facial issues.

After missing a few weeks of wrestling practice, Coach Bardsley allowed me back on the team. My desire to win was strong, and the North Yosemite League Title was my first tournament win. After becoming a Valley Champion and a week later a Divisional Champion, I was on a roll

and became All-State, by placing seventh, at the California Interscholastic Federation where the whole state of California competes for the State title.

Even though things were going great with my home life, new challenges at school and in our community were difficult to understand. My foster parents lived in the city of Clovis however, I continued going to Hoover High School in Fresno. In 1990, the city of Clovis contained seventy-two thousand people and two percent of the population was Black. The first time we went out to eat, everyone in the restaurant stared at us.

Dana, who always seemed energetic, never thought twice about the color difference and would give me kisses in public stating, "We can give them something to stare at, Fonzie."

One day after football practice when "Mr. Baseball" Faruq and another friend of mine, Willie Montgomery, gave me a ride home, we were stopped by the Clovis Police Department. A white female officer and an Asian male officer approached both sides of Faruq's car. I asked him if he had not signaled a lane change or anything. Angrily, Faruq stated, "No, man we haven't done anything wrong". Willie said, "Tuck, what I say about living out here with all these white folks." After Willie finished chastising me, I told them I would do the talking.

The short, beefy, Asian officer standing at the driver's side window asked for Faruq's driver's license, registration, and proof of insurance. Faruq asked the cop why we were stopped, and the thick Asian officer didn't respond. We were three Black men in a predominantly white city, driving while Black was invoked. Over my right shoulder stood

the taller White female officer, "Ma'am my friends were just dropping me off at home, and I live right up the street."

The female officer asked, "Where at exactly?"

I told her, "1853 Ashcroft."

The Asian officer then gave Faruq his paper work back, and they followed us back to my parent's house, then drove away after we entered the home. I didn't know if they followed us out of caution or spite.

Coach Darling never told me to act a certain way or speak with a different tone. He understood my personality, and we began to connect on a level much greater than mentor. My demeanor was always polite, until threatened or disrespected. So at home my comfort level was at an atmosphere unknown. No late night screams from base heads fighting over a hit. No fear of the electricity or phone being cut off. Every time the refrigerator was open, fresh smells filled the air along with being able to reach in and find a snack. Life was just being lived easy, when the bills came, they were paid without me knowing or figuring out a payment arrangement.

One day, an older neighbor approached me while I was mowing the lawn. His eyes would avoid mine, and his voice had an unsure pitch shifting from medium to low. Trying to make him feel comfortable by engaging in small talk about how hot the valley is, he asked what he could refer to me as.

I told him, "My name is Alfonzo Tucker, you can call me Alfonzo or Tucker whichever you prefer."

He said okay and explained he had grown up

referring to my people as "colored." I got the impression that he was trying to be polite by asking me his question. I explained to him "colored" was a term that had never been used in reference to me directly, in my entire life. I also said that "colored" was a term used by white people during the "Jim Crow Era." Times have changed and some people of color could possibly take offense, depending on your tone and the context in which you used it. I then stated that I was comfortable with "Black or African American," and he could use either when referring to me.

He thanked me for being polite (I thought I was just being myself) and went on his way. The color of my skin alone was intimidating for the people in my new community. A few reasons White people and Black people have issues with one another is because we don't know one another. That lack of knowledge alone can lead one to believe in different stereotypes and myths. My new White family was corny, not rich like I thought all white people were who lived in the suburbs. Coach earned a school teacher's salary, and Dana had to work as a secretary or they wouldn't be able to provide for themselves. Smiling was easier, and my understanding of White people was increasing on a daily basis.

Even though my complexion was improving, my social skills at school were fading. There was no longer a need for regular weekend brawls. I hadn't drunk alcohol since that first time, and drugs weren't even a thought. I was so used to dealing with problems with my home life that, socially, my behavior reflected that of a stress release. Without the stress, my motivation to act out was dull. My only desire was to graduate from high

school and possibly compete in football and wrestling in college. My focus on school work improved, there were no distractions that kept me from finishing assignments. Test anxiety hadn't left me yet, so on exam days I'd pray hoping to do well. My faith in God had been renewed after conversations with Coach Darling during our rides to court and back. Coach often said, "God has a plan for you, Fonzie, you shouldn't question his existence." Those conversations reminded me of my trips to my uncle's Church. I asked Coach why so many people suffered and how could the Lord allow it? Again, Coach would speak to me in an adult fashion. "Fonzie, I don't have all the answers, but I believe in our higher power, and God sent you to me for reasons I don't understand. I wanted to raise you years ago when you were in junior high, but things didn't work out. It's like I've been given a second chance, and you're here with me now so there must be a higher power involved."

My foster parents were still in the transition from temporary to full time, and every so often we had to appear in court to discuss my behavior. At these hearings, Thomas would request visits and I would deny them. Street life coated every word that crept from his mouth when we spoke on the phone, so the less he saw me and knew about my foster family, the better. He couldn't be trusted, so the last thing I needed was him bringing confusion into the Darlings home.

Judge Nancy Cisneros, who would become another mother figure, made counseling mandatory. Sharing my feelings with a stranger wasn't like my peer counseling days in junior high school. Focusing on me would open wounds that hadn't even healed yet. My argument to Coach Darling

was that counseling was for crazy people. Even though I had problems growing up, I was not crazy. Coach convinced me to attend sessions with a psychologist who played on his rugby team. I agreed, yet thought that if this guy plays rugby, he must be a little off-center himself. Dave Hill was cool. He helped me understand why my feelings concerning drugs prevented me from forgiving Thomas. To this day, I will often give Dave Hill a call when I've come to a crossroad on anything I'm analyzing. We spoke once a week, and Judge Cisneros inquired about every session. She would sit atop her bench in her black gown and speak so intelligently. She looked every person in their eyes when she spoke with them, and her blond hair would flow across her shoulders with every turn of her neck. She seemed sincere within her concern for me, why? Why were the people around being so helpful, with these caring and sensitive attitudes? In my old neighborhoods, you were weak if you showed any compassion. Half the time my, anger got the best of me in any emotional situation because weakness was not a survival trait expressed in my upbringing.

Girls began showing interest in me, even asking me out, and that was a major boost to my ego. My weight was around 150 pounds, still small however, the muscular ant look had passed. For years, even my early adult years, I thought girls were just attracted to my body. Later, I would understand that my sincerity and attentive nature was attractive. That side of my personality was developed while searching for clues to cope with not knowing my biological mother. This was the beginning of my "player" stage, which would bring me just as much heartache as struggling through life

with Thomas.

Having several girlfriends and dating regularly every weekend was starting to interfere with my growth as a person. More than school work, my attention was spent getting girls' phone numbers. One evening after hanging out with Megumi, an Asian exchange-student from Japan, Coach asked me where my new shoes came from. He gave me an allowance weekly, yet these were an expensive pair of sneakers that weren't affordable with my allowance. My passion for shopping had developed beyond that of the average male. He knew the money he gave me was spent on clothes from Ross, Marshalls, places affordable. I was honest with Coach Darling, never had a reason to not tell him the truth. "Megumi bought them for me." He asked if she was the foreign girl from Japan, the one with her own apartment. "Yes."

"Alfonzo, do you love this girl or is she just sport?"

"She's not my girlfriend, and there isn't going to be a future beyond us hanging out sometimes. But what do you mean by sport?"

"So you don't love her?"

"No, what is this sport business you're talking about?"

"Alfonzo, I'm not going to tell you to abstain from sex until marriage, I didn't. But women view sex differently than men. If she is sport, some one you're having sex with for the fun of it, then she should know. Don't take advantage of her. Before you know it, women are buying you expensive shoes and-"

I cut him off, "Okay, I don't use women. Megumi bought me these shoes because she likes me, not because I'm trying to use her."

"Fonzie, can you afford those shoes?"

"No."

"If you can't afford them yourself and they weren't a gift from a loved one, then I don't think you should accept them. What happens in the future? You start living off the gifts of women you're just hanging out with?" Coach Darling was right. I didn't care for Megumi in a loving sense. She could have taken me shopping daily, and I would have accepted everything she bought me. Admiring and respecting his comments, Megumi was given back the cost of those shoes after several weeks of saving. I stopped seeing her after feeling that she, knowingly, wanted me to take advantage of her financial prowess.

My senior year in high school, we moved into a new house that Coach Darling contracted and built with the help of his friend, Mike Ellis. Coach Darling had been seeing a physical therapist, who had him walking around regularly again. Prior to my coming to live with Coach Darling, he had broken his back in a rugby game and was still suffering complications from a partially healed disc (but I mentioned that earlier). Some days Dana and us kids would have to perform assigned tasks because Coach Darling was bedridden. So being able to move into this new house was a joy for him. Every time conversation sprouted about the new house, he pulled up his pants and tucked in his shirt as if he were getting ready to move that moment. His pride showed in the inflection of his voice and the widening of his smile. He moved more freely, less grunts before sitting or changing positions.

Zack and I still shared a room, and our relationship had grown into an older and younger brother tag-team. We spoke about Thomas and how

drugs can damage your life. Being a big brother was enjoyable and playfully beating him up occurred on a regular basis. Kassie had grown out of her shy stage and would talk to me as though she'd known me her whole life. Our relationship as a family was evolving, and I knew that Coach Darling loved me because he would discipline me within conversation and explain to me in detail why he had made certain decisions.

During one of Fresno's famous 100 plus degree days, with a zero percentage of humidity, my right ear clogged. I had been swimming at school, and my hearing was muffled along with my eardrum being sore. Coach Darling suggested a drop of alcohol in the ear would clear it out. Hesitant because alcohol burns, my first thought was to take a nap. Maybe it would just go away. Coach Darling was quick to explain how his days competing in triathlons would always end with him having to clear out his ears with alcohol drops. Trusting him, he placed a single drop into my right ear. Pain shocked me like a lighting bolt. Not wanting Zack to see me cry, with my head leaning over hoping the alcohol would seep, in a full sprint I was out the front door. Coach Darling called me back then rushed me to the doctor's offices. On the way there, he explained he was only trying to help me and he would never hurt me intentionally. Out the corner of my eye, I saw sincerity in his expression and heard the bass free itself from his tone.

My weakened voice spoke, "Coach, you were only trying to help, its okay I'll be fine."

Even though my ear was killing me, my thoughts revolved around happiness because he showed so much emotion concerning my welfare.

That was the first time I knew for sure that this White man, who was being a father to me "loved me." My home wasn't just a foster care placement, this was my family!

Before football season began, I'd be allowed to work a few hours here and there at the Pizza Parlor near my grandmother's old apartment. One evening after being fired, I was afraid to tell Coach and Dana what had happened. Coach sat with me at the kitchen table and asked me how and why? While working the gift-ticket counter where kids exchanged tickets for various prizes, I'd let them slide when they were a few tickets short. I was also eating the candy on the display counter and hooking people up with free tokens. That was common behavior amongst all employees. However, that day my manager called me into the office and asked me to explain why I was so generous with his company's goods. With no excuse, he fired me.

Expecting Coach Darling to be angry, he told me, "Fonzie, if you behave that way as an adult, you won't be able to support a family. The decision you made was wrong, it was against company policy. If you make this same mistake at age thirty and forty, then you'll have learned nothing from being fired." I took heed and accepted my mistake.

Showing up to school with a smile on my face and a cocky attitude was nothing different. I had finally gotten a letterman's jacket and several of us athletes called ourselves the "Pate Town Posse." Healthier mentally and living life free of stress, a few of my friends stated that I was changing. My personality was changing for the better so I wanted everyone to meet my foster parents. One guy in

particular labeled me a sell-out because I stopped rough housing and fighting after school and on the weekends. Not caring entirely about rumors, my stress level was nearly gone. I couldn't be anyone other than myself and thankful to be intelligent enough to know that certain stereotypes were made by persons who hadn't had the opportunity of living with a Caucasian family. Being naive, I tried to bring some of my friends around the house. The very first time I brought that certain person over, he went straight into the kitchen and opened the refrigerator. Ashamed that he had no respect for me or my parent's home, I never brought him back. In fact bringing friends home was seldom unless they, for sure, would respect my parent's home.

Football season started and zero-period P.E. weight lifting was helping me develop some muscularity. My football coach, Pat Plummer, would pick me up at 6:15 am. He also lived in Clovis and taught that fitness class. My body was developing slowly with the weight lifting and constant practices, soon my weight was one hundred and fifty-six pounds. My heart was bigger than my physical prowess and showing it every time I touched the football was exhilarating. Due to my size, I suffered a lot of punishment playing running back and showed no interest in playing defense. Tackling hurt more than rushing the ball. Plus all my competitors were much heavier than me. That along with a bad right quadricep held me back from gaining major scholarship offers. I refused to tell the athletic trainers about my left wrist; to this day, there is no full range of motion. My right quadricep slowed me down the whole season, afraid to tell anyone in fear that I would lose my starting position. The coaching staff never heard a

complaint from me. Even though my face appeared regularly in the sport section of the Fresno Bee newspaper, my full potential was not seen. I rushed for over a thousand yards and scored five touchdowns in a single game, however my forty-yard dash time is faster now than when I was in high school.

My parents were the greatest supporters one could ever have. They would come to my wrestling matches and football games. Dana would cheer loud enough to have other parents ask her who her son was. When she would reply number two, most of them knew that I was a "Black kid." Dana either got a funny look or someone helping her root me on.

Because of my athletic prowess, different elementary and junior high schools would ask me to speak at assemblies and individual classes. Coach Darling encouraged me saying that I was in a unique position to communicate with many people of color in the Fresno Area, inspiring people who were in the same situation as me, living in foster care and having a drug addicted father. Surprisingly, speaking in front of crowds was very easy for me. There was no pressure, and every topic discussed was relieving to know that someone else was or had experienced the same situation. The only significant difference was that most kids had issues with their mothers and mine were not knowing who my biological mother was. Coach Darling asked me to speak at Martin Luther King Jr. Elementary School where he got his first teaching job. At first it seemed like no big deal, just another group of kids to speak with. Then emotions exploded, holding back tears. Part of me wanted to run away and hide as if I were back living in that stale roach infested, cold with no electricity, apartment on Olive and

Ninth Ave. I literally smelled the stench different woman left behind after turning tricks in our bathroom while on their menstruation. Looking at the faces of those young kids, the connection was unspoken. I wanted to do more than just leave them with a hand shake and words of encouragement. My prayers were, hopefully, they would be able to set their goals high and have the motivation to see them through.

Dana hugged me after I shared my experience with her. Even though the hug was accepted, part of me was uncomfortable about sharing affection with my new family. At times guilt coated my sincerity, and I couldn't understand why guilt would tease me. Then more times the joys were breathtaking, other times initiating affection was like being choked. But my family was a blessing and the fact that our ethnicity was different made our living situation unique. From our perspective, we felt special because our family shared a great deal of love and support for one another.

Periodically, Coach Darling and I would have to appear in court, where Judge N. Cisneros would check on my progress with counselor Dave Hill, and Thomas concerning his drug program. During those meetings words never left my mouth for Thomas. Coach Darling would encourage me to visit with him, yet I'd refuse every time. He still carried a demeanor of drug user, there was no way he would end my happiness. Coach Darling explained that Thomas made most of his mistakes because drugs ruled his thoughts. I knew and basically hated Thomas for that. The time had come to better myself, for a secure livelihood and not deal with the pressure of caring for my biological father,

so that he would not feel guilty for using drugs. Thomas would show up to court only to be informed on my progress, and afterward he would hit the streets hustling, then smoke up half his profits. I knew Thomas better than he knew himself, and if I showed him affection, then he'd feel no need to clean himself up. Hood life is a small world, so keeping tabs on him was easy.

When my final year of high school wrestling rolled around, I was ranked number two in all of California and had spoken with Coach Paul Cotton at Howard University about attending school there. I was setting records for wins and pins until I wrestled in the Morro Bay Classic near Santa Cruz, California. I had won the O.W, Outstanding Wrestler Award, at every tournament, thus far. Yet in the finals of this tournament my opponent just plain out wrestled me. At the start of the match all was well. My conditioning was good and no fear existed within my thoughts. As soon as the referee blew his whistle, I lowered my stance at knee level and lunged towards my competitor's lead leg. With his right leg in my grasp, I stood straight up then attempted to sweep him off his feet by raising his right knee higher and grasping his left leg just above the knee. My momentum should have continued during my attempt. To much hesitation, as soon as I reached for his left knee, he laced his right foot in-between my legs, then threw me to my back by under-hooking my right arm and over-hooking my left arm. I fought off my back for a good minute reading every light in that gym. Down five to nothing, I wrestled with hope more than skill. At the end of that match, I lost 12 to zero.

Disgusted with my performance, Coach Darling helped me train to prepare myself for a run

at the California State title. He would put his truck in neutral and I would push it around the block several times. We would even travel down to the city of Reedley to train on his friend's property. Clark Mello and Coach Darling were and still are best friends, they were even best man in each other's wedding. Both were avid hunters. Clark was a Junior high school principal along with refereeing wrestling matches on the side. His property was huge, a few acres with hills and a shooting range. We began by me pushing a wheel barrow up hill, carrying a load of rocks, unloading the rocks, then shooting a thirty-auto-six rifle at a target before rushing down the hill to obtain more rock. Towards the end of the regular season, my ability was terrifying my competitors. At times some coaches would forfeit the match, not allowing me to wrestle their kid.

My next tournament, the Clovis Invitational had me salivating. Mr. BeBout of Ponderosa High School, the guy who beat me months earlier at the Morro Bay Classic, was there, and we wrestled in the semi-finals. No hesitation, my positioning was too precise. He couldn't set me up. It just wasn't his day. To prevent him from countering, I finished quickly or switched moves all in stride. When the match was over, I hadn't given up a single point and won 9-0, a major decision.

My foster parents had a get-together before the final championship matches. Nerves led me to nap an hour before leaving with Coach Bardsley just before the finals started. My opponent was a guy from Bakersfield, California. Plummer, he was tough and strong, yet I felt he could not handle my pressure. At times during the match, after a long scramble, he would get winded and render himself

to poor positioning. I scored every time he was in bad position. After the matches, they awarded the victor a "Cow Boy Hat" and I won the "Outstanding Wrestler" award, which was a belt buckle. My season was going great. My only loss was avenged and my ranking was at the number two spot. The only thing bothering me was preparation for the Scholastic Aptitude Test. The anxiety build up for this exam was haunting me. If my scores were low, then no scholarship offers could be expected.

After the Valley tournament, all of my teammates were finished with their season, due to elimination. Myself and Coach Bardsley were the only guys working out in my wrestling room. Unlike my junior year, a state title and getting recruited was possible. Fresno State's Coach Dennis Dillido was thinking of me, but my plans were to leave California. My drill partner was my coach. We couldn't compete against one another because he was so much bigger and stronger than me. My 153 pound weight division was no match for his 180 pound of experience. There was never a chance of me scoring against him, let alone obtaining good position. Out of frustration, I threatened to return once I'd become an adult and pound him like he pounded me. At the divisional tournament, my wrestling was poor but good enough to win it.

This is when I met Yero Washington. His ability drew admiration. He was extremely active on the mat, even more so than his 130 pound competitors. His personality was similar to mine when it came to competition. However, Yero was even more aggressive than me. When he drove you to the mat with a firemen's carry, it appeared as if he was trying to permanently plant you into the ground. He never seemed intimidated and wrestled

without caution. Yero wrestled out of Porterville High School and had an ex-Olympian for a coach, Tim Vanni. He and Yero stood about five feet three inches tall, however Vanni was several pounds lighter.

The first day of competition I lost a match and the whole world seemed to stop moving. Every time my opponent's legs were in my grasp, I had trouble finishing. Every wrestler was able to defend themselves by countering and bumping me off balance with their hips. Defeated, I knew standing on the number one spot atop the winner's podium would never happen. Yero, on the other hand, had California buzzing with his style. He was an unranked wrestler who made it to the finals. My seventh place finish for the second straight year had me questioning my ability and wondering if colleges would even recruit me. Pouting like a child who wasn't given desert after finishing all his food, my lips poked out while Coach Darling and Coach Bardsley congratulated me for accumulating a record of 47-3. My whole existence was based on becoming a State Champion, with that I'd be given a choice at scholarships and the opportunity to be more than a drug addicts abandoned child. Not realizing that my self esteem was based on my athletic prowess, depression set in and all hope was again lost.

Yero's final's match turned out to be one of the most exciting wrestling matches in California high school history. Yero, with his short, stocky build, used his eighteen inch neck for leverage during scrambles. The score traded position every time he and his competitor scored against one another. Yero would take him down with a double leg or firemen's carry, then release him with a free

escape point. When Yero was taken down, he'd fight like a wet cat for his escape point. They both traded take downs to the applause and screams of the crowd. It seemed like the last wrestler to score would win! Eight points to nine, then nine points to ten. Yero wrestled with a passion for the sport combined with pure aggression. In an arena that held over ten thousand cheering fans, Yero never held a panicked facial expression. The crowed seemed to provoke Yero and his taller opponent into a continued take down battle rather than stalling or riding the back of one another keeping his stomach pinned to the mat. The arena roared as the match's apex approached. Yero hunched over in good position facing his lanky competitor. Both on their feet along with every opened mouth fan shouting advice standing stomping their heels. As if they were gun slingers, Yero shot last and when the smoke cleared, the ref raised Yero's hand to a deafening octave. Not knowing Yero well, I was proud of him.

At school, a hero's welcome was given for having become All State. However, disgusted with my performance, studying for the S.A.T was more challenging than winning a match. For the second year in a row, the most outstanding wrestler award was given to me at the winter sports awards banquet. Along with my athletic accomplishments, I was also awarded the U.S. Army Scholastic Athlete of the year for my public speaking at different elementary and junior high schools. To be given such an honor was inspiring, especially with Dana in the audience smiling at me.

Even though I had studied for the S.A.T.'s, dreading that exam had me unprepared. I could not sleep days prior and was in a daze before taking the

test. When the examiner gave us permission to start reading, daydreaming and dozing off took up most of my time. After each section it got worse until there was no hope. Time had expired, and for the first moment since sitting in that observation room at the juvenile detention center, life seemed over. My frustrations and self pity scored the winning take down. No college would recruit me unless it was under Proposition Forty-Eight, which allowed you to attend school but not compete your first year to prove yourself as a student. No one was interested.

It was during this time that I experienced a falling out with my new family. Laziness pinned me to the couch daily after school and hopelessness was written across my forehead. Coach tried to cheer me up asking me about my plans for the future. Before we would have had a discussion about continuing my education, but frankly, school had me intimidated. My work ethic was not an issue, sitting down studying and doing homework at times was to an extent enjoyable. However, the mental break down came at test time. Maybe it was tough love because Coach Darling yelled at me for the first time outside of competition. Watching those saddle bags shift up and down reduced me to junior high again and him being the only person I'd speak to when in trouble. Loud, his voice still carrying a sincere tone free of bass, as he stated. "What are you going to do, Fonzie? You have a choice. Either you can live pouting your way through life or you can keep trying to succeed as you've always done. Whatever you decide to do won't be from that couch!" I walked out the front door, thinking to myself that returning to his house would not happen. Coach picked me up a couple blocks away.

No words were spoken between us for several weeks.

As the end of the year approached, so did the Hoover High School Prom. At the time, two girls had my interest and deciding which one to take was hard. During this time, each girl was a refuge and a physical release. Girlfriend number one, "Asa", was another foreign exchange student from Sweden. Amazing body, phat ass with the softest blond wavy hair, she stood five feet eight inches without shoes. We started dating during our home-economics class where we were paired as a married couple assigned to care for an egg as if it were our child. Girlfriend number two, "Karen", was an American-Japanese girl that I had actually been in a committed relationship with following her invitation to the "Sadie Hawkins Dance" several months prior. Karen was a little tiny girl, pretty, standing just over five feet tall. She was extremely independent, living on her own with two female roommates that attended Fresno State University. I was running from girl to girl more or less relieving the frustration that chased me. When the flyers posted the deadline for Prom tickets, I wasn't prepared to pay for any of the cost and wasn't about to let either of the two girls pay for me. Conversations with Asa about not going to the Prom led her to question me about Karen. Asa always knew about Karen because I openly answered all her questions. Karen never discussed Asa, yet often asked me why I continued to hang out with her knowing that I liked other girls. Karen went to the prom with another guy, so did Asa, and they both told me all about their experience afterwards. It was nice to know they had a good time, and my fear of love and commitment wasn't stopping them from

enjoying their high school prom. My regret was a struggle too great for a person my age to challenge. My next smile came at graduation, it was a time that often seemed impossible to fathom because of my childhood. Coach attended, and we broke the ice about our discussion months earlier. My love for him was developing more and more, but my fear of life had no answers, and Coach Darling believed in me when belief in myself was non-existent.

When school ended, my job became construction work for Coach Darling and the red headed, Mike Ellis. Framing walls and pounding nails in the hot sun for ten hours a day made me never want to do labor work again. Being active and enjoying working out was fun but labor was work. The only gratification was the paycheck. College was a possibility, yet my test-taking ability was haunting me. Coach Darling introduced me to one of the ladies at our church, Family Community. She showed me some study techniques and told me that I was intelligent, just behind, therefore afraid of schoolwork. I needed to get over the hump of test taking so I could get on with my life. Remembering thoughts of years prior and how thinking my way through situations prevented me from getting caught up in the streets, I promised myself to attend college and earn a degree. My motivation was security and to support a family of my own someday.

Coach Music, the Fresno City College wrestling coach who came to a lot of my wrestling matches, stopped by my parents' house one evening. While sitting on the couch, staring at Coach Music and searching for sincerity in his voice, he reminded me more of an ex-football jock. With his aging white hair and thick chest, he seemed to be speaking from the heart, which I

respected. Coach Music had been coaching at Fresno City College for close to thirty years and had a highly respected reputation. He told me the potential was mine to be a great wrestler. I had heard this before from Lee Kemp, a man that I met at the Colorado Springs Olympic Training Center's wrestling camp for grade schools. A legend in the sport of wrestling, Lee Kemp is in the wrestling hall of fame. He won three N.C.A.A. titles and several world championships. In 1980 when the U.S. boycotted the Olympic games, Lee was one of the team members projected to win a Gold medal in the 163 pound weight division. The following year, Lee Kemp won the world title, beating the Olympic champion from Bulgaria in the finals. Lee Kemp was the best wrestler known to me. So when Coach Music made that exact statement, I knew I would wrestle for him.

That summer, May the twelfth, I fought my fear of love and asked Dana to be my mother. I brought her into the room Zach and I shared then spoke to her in the kindest most sincere tone. With tears in my eyes, I told Dana that not knowing my biological mother left an empty space in my heart and that she had filled that void. With an extreme amount of tears softening her cheeks, Dana said "Yes" and hugged me like never before. Welcoming her affection, "I Love You" was more than just spoken, it was evident. A couple of months later, we celebrated my nineteenth birthday and me moving out of the house. From July the twentieth until the beginning of September, I lived with Faruq, who was playing baseball for Fresno State, and with another one of our high school buddies, Robert House. For a little over a month, we "apartment" sat for one of Faruq's sisters while she was away.

While Robert and Faruq bought groceries, my side of the cabinet was filled with canned goods. Unwilling to spend a great deal of money on food that had to be cooked, my plans were to save funds. Robert, who was the kicker on our high school football team, laughed at me, along with Faruq. We used that one bedroom apartment like a party house, defining our freedom. Robert was in summer school at Fresno City College, while studying he would wear his ball cap tight and low to his eyebrows. He often stated that the cap helped him focus, that made me think of something to use while studying for my future exams during wrestling seasons with Coach Music. Right before the summer ended, Coach Music, with his laid back demeanor, met with me again at my parents house for Sunday dinner. During this meeting, he helped me fill out the application for school and financial aid. The exciting part of our meeting was him telling me that Yero Washington was also going to attend Fresno City College and wrestle for the "Rams". Yero and I were to be roommates, and Coach Darling co-signed for our apartment. Yero came down from the city of Porterville to give me his share of the rent, and we talked about how we wanted to become champion wrestlers for Coach Music. Still living in that tiny one bedroom with Robert and Faruq, Yero and I drove around the block to Bulldog Lane where the Village Apartments were located. Yero handed me 185 dollars in crumpled up ones and five dollar bills. Observing him pull money out of both front pockets and laughing about it, the accounting duties were destined to be my responsibility. We joked about it and became very close, very quickly. We were basically from the same place, different ghetto, same hood problems. He lived in a crack

house growing up in Oakland, California's, Sabrany Park with his mother who lived the same type of lifestyle as Thomas. In high school, he moved to Porterville and lived with his brother Leon Hilliard, a Correctional Officer. For me it was never meeting my biological mother. Yero never met his biological father. He said that he was a member of the Black Panther Party and was killed within the struggle. We would have a third roommate to even out the bills, John Stevens. Ironically, I had wrestled against John before, once in the valley championships my, senior year of high school and again for seventh and eighth place at the state championships.

Yero had surgery to repair a damaged ligament to his left knee and walked around in a cast for the first couple of months we lived together. Our apartment was a war zone, in a fun way. Jerry Abas lived upstairs from us with Ian Booker and John Pevler; they all wrestled for Fresno State. Everyday, we would have water fights and invade the others' house. Every time we had to settle an argument in the apartment, we would just go take downs. There were so many holes in the walls and damages to the appliances, that when management found out, we had to pay 1,500 dollars in fines. Jerry Abas was the man at Fresno State, national division one runner up. He competed in the 142 pound weight class. While Booker competed at the 119 weight class, Pevler floated between 142 and 150. We were all around the same size so wrestling matches jumped off on a whim, whenever, however for a full year. One evening close to 2a.m., while both my roommates were sleeping, a light loomed through the patio. My bedroom, even though several feet down the hall, was located directly in

front of the sliding glass patio door. After a long dull screech, the light now entered through the sliding glass. My heart rate boomed and lifted me to my feet. Attack was the only thing that entered my mind, so a few steps later with my fingers curled against my palms, a stiff stream of warm water stroke me in the face. Abas, Booker and Pevler had broken into the apartment and fired water guns upon us. It was on! After that, none of them were safe. If they had a party, their door was shoved in and anybody in the way was drenched. That went on until I fought with two of my teammates in Abas's apartment. Even though my presence brought calmness to my surroundings, the fighter in me never left. After wetting a couple guys on my team that weren't involved in the water wars, they both tried to double team me in a challenge that was pure entertainment at first. They were both smaller than me and now my body had grown to about one hundred and sixty pounds. Like rag dolls, I'd toss their one-hundred twenty-five pound bodies around and shout, "Do you know who I am?" laughing the whole time, until my vision blurred, while one of them hit me repeatedly. This wasn't a hood fight, but the hood came out of me, and a few guys had to hold me down. Later, Yero got into an argument with one of the guys I was tussling with and fought him, breaking Abas's dress mirror in the process, all while I bloodied the nose of the second guy involved. My entire fault, if it were not for my explosive decisions to put my fist through every threat, half the team would not have been fighting that night. My serious, yet calm demeanor hadn't fully taken over my choices to end every altercation with clenched teeth and a lead right hand.

Trying to keep out of trouble, most of my

free time was spent with a girl from my old high school, Hanna Weldamuska. Hanna had immigrated from Ethiopia with her family just a couple years prior. She stood about five feet five inches tall and was just as thin and fine as she could be. Every so often she'd have to shave hair growth that connected her eye brows, but that didn't affect her beauty. She was the woman that introduced me to poetry. Every time she visited me at our three bedroom mad house, we would discuss her writing and she would encourage me to write. Those conversations brought back memories of the second grade when I thought kids like me just got into trouble mostly. We shared some interesting times reading one another's work, however her father forbid her to have a boyfriend and that ultimately broke us up. Being in college living on my own, my roommates had other students over all the time. When Hanna would leave to make her curfew, she would tell me that some college girl would steal my heart because she was only a senior in high school and had to run home to daddy. I never told her that my fear of loving, period, was more to worry about. Even though drinking alcohol wasn't my thing, my roommates did, and we had some crazy first-year college experiences.

My African American studies class with Kahinda Suwalze was off the hook. This African American man defined black pride and every class with him was an experience. He held no qualms about White America and often discussed his dislikes during class. American born, Kahinda was not his given birth name. He was a self-made lukewarm radical. Certain discussion within his class made clear since, however there was a few lectures that were questionable just because of my

relationship with my Caucasian family. During Kahinda's class, I read the autobiography of Malcolm X (as told by Alex Haley) and could not understand why Kahinda didn't focus on the Malcolm X after his "Hajj pilgrimage to Mecca" as opposed to the pre-pilgrimage Malcolm X and his changed views of the White man. There was a clear difference between the two, which led me to believe hatred of another race was pure stupidity. While analyzing and trying to understanding prejudice and racists views, it was difficult to debate them from an intellectual stand point. But, that is what I liked about Kahinda's classes, they also drew debate. He was an instructor of mine almost every semester.

My advanced English-B course was a mistake. However, in that class sitting directly behind me was Monique Williamson-Frazier. Far from my type, she didn't have a sprinter's body or a butt that made you follow her around, dazed and mumbling to yourself. She was built more like a Caucasian woman, so most of the white guys were checking her out. Her dark skin was attractive though, and she pronounced her words with a east-coast accent.

Now, that English-B class was tough, and Monique offered to help. She became my tutor, helping me in all of my courses. Our friendship blossomed, and Monique became the person who would help me battle test anxiety. Even though, my athletic prowess shined above my academic ability, Monique gave me the confidence to read and ultimately pursue writing. We studied together at her aunt and uncle's house, and it was a pleasure for me seeing a black couple together raising three kids. Monique was from New Haven, Connecticut, and was the most intelligent woman I'd met thus far.

She designated times for our tutorial sessions. In the library, on the quad near the fountain that was the pride of Fresno City College.

At my apartment was where we shared a kiss and more. Confused because my attraction wasn't physical, yet my emotions gave me an erection when she'd hug me. Not knowing how to accept our plutonic friendship, we talked about the possibility of engaging in sex. Monique was a virgin, and I didn't feel comfortable accepting that from her. Her beauty, mentally and physically, was to be shared with someone who loved her, not some guy she was tutoring. In time, I told her more and more about me, my childhood with Thomas, my family and my goal to graduate from college and have security for myself and a family of my own someday. Monique shared her experience concerning the loss of her mother and choosing to attend school in California. Her family often referred to her as Nicky, I called her Nicole. She told me how rough high school was, being overweight and how she'd lost major pounds in the Fresno heat. It was hard to believe she had been overweight. Nicole had become my friend and caring for her was easy because I expected nothing in return. My love issues were still lingering, but Nicole was not a love interest. Weird was the fact that I could care for her from an emotional perspective, yet from a physical standpoint, she would not be my type. My relationship with Nicole would help me understand the importance of friendship and how precious it is to the human psyche. After a year, her out of state tuition dropped, and she transferred to Fresno State, pursuing a degree in English.

Wrestling was more of a physical strain. In

order to make the one hundred and fifty pound class, I couldn't lift weights and put in several miles daily before practice. Similar to my freshman year in high school, the weight loss was taxing my body. My training schedule had me weak and wrestling tired. My technique improved allowing me to become a true wrestler as opposed to a brawler. My four losses out of thirty-seven matches wasn't something to be proud of. Two of my losses were to Byron Cambel, once at the California All-Star match and the other in the finals of the California State Junior College Championships. I had the talent and the work ethic to become a champion, yet I needed to give myself and the sport more respect. The weight loss would never propel me to champion status. The fact that wrestling had provided an outlet for me, relieving most of my stress associated with my childhood was a blessing. Wrestling ultimately helped me maintain my sanity, I had to respect that. Even though, I was awarded All-American status, those four losses kept me awake at night.

The off-season came, and I was hired as a group-home counselor for the Fresno Unity Group Crop, owned by Linda Reaves. Other than being my boss, Linda was my first foster parent. Just five years prior she opened her first home. Now she had five with her own charter school. Working in her care homes taught me how to communicate with people in a business setting and how to give direction to clients who lived there. Being only two years older than the oldest client was challenging; they often questioned my authority until conversations, similar to my lectures at speaking events, earned me respect. My confidence heightened and personality was continuing to

develop in a positive fashion. Most of the decisions the group home kids made I understood. Even though I didn't agree, being in that atmosphere helped me understand myself more and how I survived my childhood. My new thoughts were whether my college goals would be accomplished. That job helped pay my bills and kept me from hanging out on the weekend because my shift went from 7pm to 7am. I even helped Yero get a job there, but he quit after a few months. While laughing Yero would say, "Tuck a job ain't nothing but work." But he always worked enough to pay his share of the bills.

My other roommate, John, didn't make the starting line-up that year and he was having issues with his girlfriend. His personality was changing and his behavior was similar to someone using something more than a recreational drug. I'd wake up 3:30 am to use the restroom and he'd be up moving posters around in his room. Paranoid that John was doing drugs on the down low, he had my attention with a negative glare every time he exited his room locking the door behind himself. Ian Booker, the little brother from upstairs, needed a place to live for the summer. With me having the master bedroom, Ian moved his stuff in with mine. He and John never got along. Booker was a small black man with a Napoleon complex. Even though he dressed with style, his racial comments made him appear ugly around John. Booker didn't have to cut but a few pounds for his one hundred and nineteen pound weight class. He lived wild, smoking weed on a regular basis along with a lot of other athletes running around Fresno at the time. While getting ready for a work out, John and Booker started arguing as though fighting were the

next step. On this occasion Booker called John a "Cracker." Trying to intervene, I told Booker not to speak to John that way because he, along with Yero and myself, were allowing him to stay in our apartment rent-free. Booker's behavior was unusual, he could not control his emotions. He seemed cool one minute, then shaky the next. It didn't matter though, he stepped out of line by using racial slurs with John.

Only a few brothers wrestled in Fresno at the time, so we were the minority in a Caucasian dominated sport. We stuck together, Yero and I agreed to house him without payment. John didn't even have issues with him not helping with the bills. John hadn't provoked Bookers comments and stated, "Tuck, Yero, if I were to use the N-word to you in your own home, what would you do?" Without answering his question, I asked Booker to apologize considering he was a guest in our home. Booker's reply was, "Hell No!"

Later, when Booker was more relaxed, we spoke about the incident. He stumbled within his speech, not stuttering, just jumping from one topic to another. Booker refused to apologize and later went home to visit his father in Alameda, California. Booker never came back. He quit the wrestling team, school and wasn't heard from for years. Every now and then I would hear stories about Booker leaving messages on our teammates' answering machines.

That summer before my sophomore year at Fresno city, we had to move out of the Village Apartments. With so many damages to the unit and complaints from management, it was better that we moved anyway. Living further away from the Fresno State campus helped me concentrate more

on school and less with the ladies. Learning how to live with Yero and John was still a challenge. My conservative behavior (besides socializing with girls) added a balance to the house.

Being a neat freak, order was a must. To irritate me, John and Yero would turn wall pictures off center and leave their shoes in the living room. My neatness was bizarre, and my attitude a bit serious for my age, so they took it upon themselves to help loosen me up. But every time the house got dirty, it reminded me of that stale roach infested apartment on Olive and Ninth Ave.

Lifting weights and speaking to Lee Kemp regularly had me dreaming about being a champion. When wrestling season rolled around, Lee told me that my competition weight would be one hundred and seventy-seven pounds someday. That was hard to believe. Even though my body was becoming more muscular, I still felt undeveloped. After my first match of the year, Coach Music told me, "Tuck, if you wrestle to the best of your ability in every match, absolutely no one can beat you." My number one ranking went to every tournament and dual meet as though I had something to prove. My offense was unstoppable, every takedown, I saw before it happened. I made a vow of celibacy and eliminated all my favorite foods and drinks from my diet. Focused was an understatement.

Before every match a smile dwelled within but to an onlooker, my eyebrows were twisted south. "Give up your wallet," was what they most likely thought was ringing in my head. Yero had come out of his red-shirt year and was proving that the state title he won his senior year in high school was no fluke. Detrane Gant, a brother with a phenomenal high school career placing third as a

sophomore, first as a junior, and second as a senior in the California High School championships, was now wrestling at Fresno City College. Detrane had to sit out his second year at City for academic reasons. Now, Detrane was a thug to the heart. He would roll joints in the back of the bus on the way to different tournaments. He would brag, stating that Marijuana made him wrestle better. Detrane also represented "Six Deuce Diamond Crip." He was so serious about his gang status that we would have to deter him from fighting at different tournaments if the neighborhood housed a rival set. Detrane had the longest arms I'd ever seen on a man of his height. He would shoot double legs then throw you to your back with a head and arm, from his knees.

The sun was going down just outside Fresno in the city of Sanger. The heat was still making its presence felt, and one of our wrestling buddies Stan Greene was hosting Yero's going away party. Stan's house was huge, sitting on a couple acres, pool, several car garage, the whole nine. Stan was an All American himself at Fresno State. Short white guy, long torso with a thick head we often teased him about. The party was packed with almost every wrestler who ever competed at Fresno City and or State. My parents were there along with other parents. The crowd was packed, Steven Abas fresh off his third N.C.A.A championship was in the back-ground showing off his Capoeira skills. Detrane and Yero were running around the party talking to folks with a slurred speech and drooping eyes. Half the crowd was inside watching the De La Hoya vs. Vargas fight, while I'm at the buffet eating some free finger food.

"Tucker! Tucker! You bad motherfu-"

"Yo! De, not in front of my mother. Man, there are too many women around here for you to be cussing like that, dog."

"You right Tuck, you right man. I was just asking your parents if Zack has got some pussy yet!" Dana's face was red and Coach was laughing with his forehead wrinkled up!

"Tuck, Zack is big as fuc-oops my bad Dana, I mean Zack – look at the size man! What he six-two, six-three now?"

"De, its all good man, don't trip. Come holler at me right quick."

"What's up Tuck? You know I got you dog! What you need?"

"Nothing serious De, I just want to interview you for my book."

"Ah, Tuck I got you. You never stop amazing me man! You really writing a book dog?"

"Yeah, man and you're going to be in it!"

"What you want me to say?"

"Detrane, just be yourself and speak your mind. I got a tape recorder in my car. Let's talk over there."

(The following is quoted verbatim from my interview with Detrane at Yero Washington's going away party on September 14th, 2002. Yero would be moving to New York to become an assistant coach at Columbia University working for our ex-teammate, Head Coach Brandon Buckley.)

"Okay Tuck, the first time that I met you, we were at Hoover, and I didn't like you. It was a thing that we had against each other because we both wanted to be champions and I didn't like you, and when we'd wrestle I was upset because I couldn't win all the time because I was a champion. Then after that, when we began to know each other,

we became cool, and especially when we went to City College everything changed, we were teammates. There were a lot of things, you were at a different weight, I was at a certain weight. You were at a higher weight, but I still felt that I could beat you. But, the bottom line is you were always stronger than me, so when we wrestled I was more of a competitor to anybody else than to you, and it didn't matter if you were stronger, I was a good wrestler and just like the homeboy, Yero, nobody could fuck with us."

Stan Green's father interrupted our conversation and said, "The most important thing to me is that none of you get hurt. You know what I'm talking about, tonight's a great time and I just want everyone to get home safe." Stan's father was a little intoxicated himself. Yet he was very sincere.

Detrane said, "I love, I Love." Detrane slaps my steering wheel with both hands, looking out the corner of his eyes at Stan's Father.

Detrane said, "Nobody will come between my friends."

I thought that my interview was going to end before Detrane got a chance to finish speaking his mind.

Detrane then asked, "Do we have to get out? I'm down, I'm down for whatever." What Detrane was saying (mind you he was drunk) was that he was ready to tell Mr. Green, not in a polite way, to allow us to finish our conversation.

Yero walked around the corner yelling, "Tuck, Tuck, you ready to leave?"

I motioned to Yero, hoping that he will persuade Mr. Green to leave.

Detrane then spoke into the recorder and said, "Tuck will always be my friend, Yero will

always be my friend."

Yero again asked if I was ready to leave.

I motioned to him again, hoping he'd catch the hint.

Detrane stated, "Tuck is always my friend, Yero is always my friend and we will always be the baddest wrestlers ever to touch ground and the future will be the future but people don't want us in the future. If I ever touch ground on wrestling again, it will be lavish. It's the same with my boy Tuck and it's the same with my boy Yero, yet Yero is doing his thing right now, but it's the same for all three of us. We are too good to be forgotten, we are the best. So if anybody doesn't understand that, Fuck'em, Detrane Gant peace out." I quoted Detrane not because he and I were the only wrestlers to become State Champions that year, like me, Detrane had an outlet in wrestling. If not for his Roosevelt High School teammates and Coach Music, there is no telling what would have become of Detrane. No matter how much of a thug Detrane Gant is or how much weed he smokes, Detrane has those wrestling memories to feel accomplished. That alone will help him maintain some level of sanity while he runs the streets.

I was doing well in my classes and exceptionally well on the mat. My foster parents were no longer the "Foster Family." We had developed a tradition of Sunday dinners where Coach Darling would cook from Patti Labelle's cook book (LaBelle Cuisine Recipes to Sing About, with Laura B. Randolph). Yero and I would soon be arguing over who got the best Christmas gifts. Coach Darling often made fun of the fact that he had to attempt soul- food cooking even though he had no soul or rhythm to aid him with his dishes.

The fact that he would even try was amazing. Coach had done all the cooking ever since I could recall, and even though it was nothing like my Grandmother Betty's dishes, Coach was teaching me how to provide for a family of my own someday.

My second undefeated season since junior high, I achieved a 37-0 record. My only disappointment was giving up six takedowns the whole year. Coach Jake Spates, from Oklahoma University, called me regularly along with Mark Shultz from Brigham Young University. A couple of other schools were courting me as well, however I wasn't going to waste anyone's time, especially if I hadn't thought of attending their University. My relationship with my family had developed to the point that the excitement of leaving town had dulled. I felt like an older brother to Kassandra and Zachary, and Yero was more than a friend to me, he was my brother who had experienced the same childhood as me. Coach Darling was like a mentor; he would educate me in a fashion that was different from most adult-minor relationships. Coach Darling would tell me openly that racial prejudice still existed in White America and what to look for to recognize it. Deciding to remain in Fresno was easy being blessed with a family that would love me under all conditions. When Coach Deliddo met with me at my parent's home, I signed my letter of intent to attend Fresno State. Soon, I'd be wrestling for an older Italian man that was more anal about things than myself. I heard that Coach Deliddo was a stickler for organized practices and had no qualms about fussing to get his point across. Awarded the team captain and Most Outstanding Wrestler award from Fresno City's College team had me on an

emotional high. The studying wasn't over, a couple of calls to Monique and summer school helped me receive my Associate's Degree in Liberal Arts Studies.

When school started at Fresno State, I felt empowered. The students walking around seemed more focused and mature. Fraternities and sororities set up informational booths in the free-speech area. Class sessions seemed to involve more discussion. Even though the Black student population was less than it was at Fresno City College, the Black students had a much tighter bond with each other. My goal of a bachelor's degree was in sight.

Two weeks into classes, Coach Deliddo approached me with his air-filled voice that sounds like Marlon Brando's version of "The Godfather" and explained that one more class was needed before they could release my Associate's Degree from Fresno City. My eligibility for division-one wrestling wasn't completed. Heartbroken, I wanted to travel around the county competing against other Universities with my new teammates. My competitive fire was blazing, wrestling was on my mind consistently. So that last class was my only obstacle. After that, I made it a point to calculate my own credits and courses needed for graduation. Coach Deliddo asked if I wanted to set out the year (red shirt), my decision was "No." Stubborn and eager to wrestle division-one, my mistake was allowing my ego to make that decision for me. Plus, Bryon Cambel, the guy who beat me in my freshmen season at the Cal. State J.R College Championships, was on my team and competing in the same weight class. I wanted to beat him out for the 158-pound weight class so bad that red shirting was not an option.

By not competing that first semester, socializing was much easier. When the team was out of town, chasing girls was the thing to do. I wore my state champion ring on my wedding-ring finger and told everyone, "I'm married to school and wrestling until I graduate." Remaining focused for a couple more years until my degree rested on my wall seemed logical. Campus life was different for me, my attitude was a little more serious than the average college student. At noon, the free-speech area was full of young ladies to admire, so that was my rest stop every day for lunch. Sitting there one afternoon, I was asked to play in a co-ed intramural football league after practice. A young lady named Janisha Richardson who ran track asked me to play on her team. The quarterback was also a girl, Tina Ackerson, who was on the track team as well. She had so much athletic ability and the competitive spirit to match. Her attitude was a major turn on, not to mention she had an amazing body. Just my type, so my nose was open before she said hello.

One night at a party off campus, we would exchange numbers and not too long after that I was sprung. Tina had all the qualities needed in a woman. She seemed ambitious, athletic, had a fear of Christ and understood her feminine power. Wow! I was sprung. As a young adult, she was the first girl I met who had conversation and a competitive drive. There was no reason to even think of another woman. Tina had me on cloud nine and we became boyfriend and girlfriend not long after we met.

Back at the apartment, John was having issues and had dropped out of school. Yero was shining again for Fresno city's wrestling team with hopes of being recruited himself. After

conversations with Yero about John, we agreed that if his behavior didn't change, we would ask him to move out. John was working construction during the day and bartending at night. How did he have the energy to work all those hours? John's girlfriend left him and found a new boyfriend, and to top it off, Yero walked in on John snorting a line of crank.

My first reaction was, "Kick his ass out!"

Yero said we should try and help him, encourage him to go back to school, and maybe continue wrestling. I didn't know much at all about crank and thought, if it were as addictive as crack, then John was hopeless.

One evening, John asked me to hang out with him at his bartending job. Explaining that he knew I didn't drink alcohol nor would I enjoy that atmosphere, John wouldn't take no for an answer. I figured this was his attempt to reconcile. Remembering what Yero suggested, I befriended John and tried to encourage him, while tagging along doing the bar scene. As soon as we walked in elbows and shoulders shifted, the crowd reminding me how much I hated that atmosphere. The whole night John talked about buying some jet skies and the three of us renting a big house.

My reply was, "John, you know I have expensive taste, but we're in college man, my plastic shoes are treated like leather."

John would repeat himself the majority of the night, stating that we were visiting his world, and in his world he was "The Man." While we danced with a couple girls, John held his arms around his partner's shoulders, not holding her, just positioning his elbows to create space between them and everyone else. As the strobe-light kissed its dancers, John looked at me with the most intense

eyes. Unable to see his pupils, being the bar's lighting was so dim, a vision of Thomas and the white rings around his eyes came to mind. "If this fool got me up in this bar and he's high, ah-hell-naw!"

"John it's time to go! Right now!"

When we got back to the house, I told John that he was folding under the pressures of life and drugs would only make things worse. John got mad and accused me of referring to him as a "drug addict." "I know you're using crank John, you're behaving like an addict right now!" We were both in the kitchen standing by the refrigerator. I reach in to get some Kool-Aid, and he rushed me, attempting to take me down like we were at practice. I grabbed him by his neck and threw him up against the table. Like a puma, he leaped up with a chair in his grasp, holding it over his head.

Staring John directly in his eyes, I asked him, "Do you really want to fight me?"

With a vegetable red face and his chest heaving, we stood there for a moment. I reminded John about the time our wrestling team had gotten into a fight over Yero play-strangling some girl's cat at a house party. I reminded him how we had each other's back, fighting to protect one another and Yero's crazy ass for messing with that damn cat. When I started talking about our wrestling each other for seventh and eighth place at the high school state meet, John broke down. Tears covered his face along with embarrassment. "Don't be ashamed John, just get off that dope!" He would later move back in with his parents.

It took Yero and me no time at all to find another roommate. Mike Sasolino, a Porto Rican dude who was in a relationship with one of Faruq's

sister, moved in with us.

My relationship with Tina was still in that cloud-nine status, and we were even training together. One evening while at her apartment, she got a call from her blue and white sorority sisters requesting that she join them for a night on the town. Far from jealous, I wanted to support her friendships. The way she accepted my friendship with Monique was difficult, often questioning why we were so close. So I always let her know that she was my woman and Monique was a platonic friend who helped me study. Before her friends picked her up, she changed outfits several different times. Finally, asking for my opinion. "Dress sexy, I don't have a problem with that. You know how you enjoy showing off your physique, if you're comfortable wearing it, put it on." Tina was helping me overcome my fear of loving. We had been seeing each other for three months and enjoying her company was so liberating.

Christmas break came and my eligibility was restored. Bryon Cambel and I would beat each other up in practice daily. Surprisingly enough when wrestle-offs were set, the media and newspaper journalist covered our competition against one another. This was personal for me. After losing to him as a freshman, he was the only wrestler in the past couple of years that I hadn't avenged a loss. The media depicted the match as an in-house rivalry, stating that my choice to attend Fresno State University was to challenge Bryon Cambel for his starting spot. That wasn't entirely true. Dana, who was now my mother, and the rest of my family was the reason. If Bryon wrestled any other weight rather than 158 lbs, we would not have challenged each other. I told the reporter the

challenge was enjoyable, but Mr. Fussy Coach Deliddo would not allow two good wrestlers to battle over one weight class. The winner would have his choice between two different weight classes, 150 lbs or 158 lbs.

Low scoring match, extremely strong, Bryon was tough to score on. The camera being there made it more exciting. Coach Deliddo growled, sending the team off to the gym with our trainer. Four padded walls, thirty-five yards of faded blue and red mats. While Bryon and I butted heads, the mats reeked of bleach. They were mopped daily at the start of practice to prevent the spread of rashes and bacteria. Controlling his left leg allowed me to scramble towards his back side and grasp his right ankle. His strong legs prevented me from scoring, so I worked my way up and gained control of his torso. Slowly lifting Bryon off his feet, then shifting him to his side, his right shoulder hit the mat. Holding him down long enough to gain control, the match was mine! Competing in the Western Athletic Conference Championships, in the hundred fifty-eight pound division was more than a prize.

Before my team, the Fresno State Bulldogs, went to compete in those matches, Yero and I would discover that our roommate Mike had gotten fired from his job working for Airborne Express, for stealing goods and selling them. Mike got so far behind on his bills that Yero and I had to help him. Yero had just finished his second season at Fresno City College with a State Champion ring to brag of. He even beat my undefeated record by one match. Teasing me as much as possible, Yero involved humor in every situation he faced. Good, bad, happy or sad, Yero had a joke for everything. Now, my weight was about 170 lbs and Yero, with his

eighteen inch neck and five-foot three-inch frame, was still wrestling around the 130 lbs weight classes, so all those holes in the walls from our freshman year weren't as easy to duplicate from his perspective. Every time we wrestled in the house, I'd just lift him off his feet and slam him on the couch. Every time Mike got involved in our antics, he was labeled a fish more than a threat. Because Mike wasn't paying his bills, I wouldn't play fight with him in fear that my disappointment would lead to me really whoop his ass.

The W.A.C. tournament was hosted by the Air Force Academy in Colorado that year. My confidence level was up, however missing half the season was discouraging most of my competitors were faces that I'd never seen. The elevation wasn't an issue and my stamina was good. After a few tough matches, I found myself competing against a taller white guy from the University of Wyoming, Brandon Alderman. His offense wasn't threatening, but his defense was phenomenal. Never in all my years of wrestling, did I have such a difficult time scoring. My technique was far from limited, yet I relied on my strength too much. Whenever caught in a poor position, if my skill couldn't help, muscle would. Alderman would challenge me openly, leaving his lead leg vulnerable. Every time I shot in deep, securing a leg, he tried to leg in by hooking a thigh. Disappointed, that plane ride home and the next few days were spent in silence. Trying to cheer me up, Yero would tell me that I'd better perk up or he was going to invite Alderman down from Wyoming to beat-up on me. Comments like that had us breaking chairs and chasing each other around the apartment. The pouting didn't last long, final exams were approaching and when Tina

wasn't acting jealous, we studied together and played house. My first season as a Bulldog was disappointing. Losing in the finals of the Western Athletic Conference was still haunting, but I had made it to the N.C.A.A tournament, hosted by the University of Iowa, ironically losing to an Iowa wrestler named D. Webber. Double elimination tournament, I wrestled back with one match to win All-American status and lost again.

One evening while helping one of Tina's sorority sister's move, we argued for the first time. While driving Tina's truck back to her apartment, I'd unintentionally jab her side while shifting gears. Tina's sorority sister was in the cab as well, so there was no room for comfort. It was a half ton pick up that was meant to seat only two passengers. With each nudge, Tina sucked her teeth and rolled her eyes. Driving north on First St. a few miles away from her apartment, she blew up.

After Tina cussed a few times, telling me that she was about to lose it in front of her girl, I stopped the truck, got out, and started to walk home. Tina leaning over her girlfriend's lap began fussing through the cab window, "Why are you embarrassing me like this, get your ass in this car!" Tina, resembling a mad woman with her hair all tangled, still sweating from moving all day and sitting in the tight cab.

"Girl, who you think you talking to? You know I'm not the arguing type. Go home, call me later!"

"Alfonzo, let's not make a scene, please get in the car." After shutting the cab door, with a calm voice I told her that she was going to feel me shifting gears, there was no other way to drive.

A moment passed, Tina apologized, and we

drove her soror back to their apartment. Once inside, Tina directed me into her room. While I stood at the foot of her bed watching her place her permed hair into a bun and take off her earrings and bracelets, she was breathing heavy. If her skin wasn't so dark she would have been flaming red. The woman was quick and with a right cross she struck me in the jaw.

As she threw more punches, I gained control of her wrists and stepped into her bathroom closing the door before she could enter. My first thought was, "This Bitch Gone Crazy." Sitting on her stool, yelling through her door that held two blue and white towels covered with white doves, "Calm your ass down so we could talk!"

She shouted, "Let's talk."

When I walked out of the bathroom, Tina rushed me again. This time I blocked her punches and positioned myself on top of her.

"Girl, why are you hitting me?"

She replied, "Don't you ever embarrass me in front of anyone!" She continued to struggle trying to release herself from my hold. I told her to calm down.

"Fuck you. If you let me up, so help me!"

I placed her on her stomach with her arms pinned to her butt so I could use the phone.

"Yero! You got to come get me man, Tina's over here swinging on me!"

All he could do was laugh.

"Man, this is serious, come get me!"

"Tuck, where is she?"

"Yero, I'm holding her down. Stop playing, come on man!"

He rushed over just to get a closer look at the drama.

I heard Yero's car pull up outside Tina's window. "Alfonzo, please don't let him see me like this."

"Ask your girlfriend to untie you after we leave!"

"Tuck, Tuck, you alright?" Her bedroom door opened, there stood Yero with a huge grin.

Still laughing the whole ride home, Yero said, "I've heard of men beating their women, but I never heard of a woman beating on her man." Yero had jokes for quite some time after that. Every time we talked smack to each other, I was referred to as the "battered boyfriend."

So much for love. Staring at my ceiling every day was wearing me down. Not knowing how to act or what to say. I spoke with Coach Darling and Dana about what had happened and they said she was no longer welcome over the house anymore.

Tina apologized a thousand times, begging me to forgive her. She said she would take anger-management classes if we got back together. She brought balloons to one of my classes with a card and even met with my parents and apologized to them.

After forgiving her, we became a couple again. Only this time around she seemed more jealous and insecure. Yero was dating this Hispanic hottie named Mary Lou, who would bring her girlfriend, Tonya by the house at times. Mary Lou was a tiny little girl about an inch shorter than Yero, maybe 115 pounds. She even had a little three year old boy named "J.J." One day when Tina met Tonya, Tina didn't want me to be in the same room with Tonya, ever. Though Tonya was attractive, I had no plans on stepping outside of my relationship.

Still sprung, Tina was entirely all the woman I needed. When she wasn't acting jealous and insecure, our house playing days were great.

Around this time I joined the M.I.K program, "Men Interested in Kappa." I had read this book called, "Days of Grace", a Memoir, authored by Arthur Ashe and Arnold Rampersad. The book covered the life of the late tennis champion Arthur Ashe and his struggle with the AIDS virus after contracting the deadly disease from a blood transfusion. Arthur Ashe discovered in 1988 that he had AIDS and even within that time he still lived the life of a champion. He never stopped his crusade for racial and social justice. He was also an intelligent man who competed at a world-class level in a sport dominated by Caucasians. Arthur Ashe was a U.C.L.A graduate as well as the 1975 Wimbledon champion.

While researching the different African American Greek fraternal organizations, I discovered that Arthur Ashe was a member of Kappa Alpha Psi Fraternity, Inc. The more I educated myself on fraternities, becoming a member of "Kappa" was more than a goal, it was a promise to myself. Wanting to experience what made men such as Arthur Ashe and Tom Bradley so great. I admired these men and looked up to them as role models. I had questions concerning where Ashe got his cool, collected personality and drive for excellence. My calmness came from having experienced tragedy, as a youth, nothing violent seemed to rattle me, but when my fists were clinched, all hell broke loose and I needed to control that. While growing up, my role models were literally the pimps, hustlers and killers in my neighborhood. My personality was calm until I

engaged in competition, unlike Mr. Ashe, who from what I've read, was always calm. From what I read, he was the calmest person everywhere he went. My determination to succeed in life was more apparent than any other person I knew. Yero wanted success, but for him it would come when he decided to invest the time. Kappa Alpha Psi was an organization that best fit my personality and my desire to achieve. While going to the M.I.K meetings, I met those who would later become my line brothers.

One of the members of my M.I.K program who seemed to share my passion for success was Oliver Baines. Even though, I mostly hung out with my woman and the guys on the wrestling team, Oliver would become one of my closest friends. Our conversations were analytical, challenging each other for hours. Tina even began to act jealous with Oliver. Trying to prove my love, my friendship with Monique was virtually non-existent. My mentality was still developing; it had only been a few years since I moved out of my parents' home. I had some middle-class knowledge mixed with some hood demeanor. Oliver was blessed with a Mother, Father, Brother, and Sister: all in the same household. He was actually the first friend I had that wasn't from a broken home. I would later meet his mother while she came up from Los Angeles to visit her son. I was drawn to the fact that Oliver had such a strong relationship with his mother and I had never even known mine. Dana loved me phenomenally, always there with a mother's opinion. She even held my hand in public.

Oliver and I began to make plans and formulate ideas for programs we wanted to implement as members of Kappa. We would talk

late into the evening about school functions concerning Kappa even before we pledged. Little did I know how difficult it would be to survive being on line. All the members in my M.I.K program would have to wait a year before being given the opportunity of becoming members.

Our roommate, Mike was still several months behind in his bills, and Tina was showing more signs of dysfunction regarding her temper. The fact that the electricity and phone were in jeopardy of being cut off, had me ready to whoop Mike's ass. He acted like it was no big deal and the money would just somehow appear. On the way home from practice, I decided to call Mike instead of confronting him in person for his share of the rent and bills totaling $681.00. When Mike answered the phone, he stumbled within the conversation, basically telling me he didn't have his share of the bill money. I told Mike when I got home, either he would have the bill money or I would have his ass. Speeding back to the apartment in hopes of catching him penniless, Mike was gone.

Later that evening, Mike showed up with all $681.00 and no car. Yero and I inquired about the whereabouts of his car. Mike said he borrowed the money and left his car as collateral. When he first moved in with Yero and me, he had inherited $10,000 from the death of his father and blew it all in less than two months. Mike was a major player, with women on every side of town. If he wasn't treating one of them to dinner, he was squandering cash on jewelry and clothes. He had blown his money foolishly, so I had no remorse for his situation.

What angered me most was when Coach

Darling called the house and asked to speak with Mike about the car. "Coach, were you the one that loaned Mike $681.00?"

Coach Darling said, "It has been agreed that if Mike doesn't pay me back in exactly thirty days, then his car goes on the market for $681.00 and not a penny more." Cussing Mike out was hard not to do. Relying on my parents to bail him out of his bill situation had me hot. He showed me no respect, why he didn't ask me for permission to speak with my family felt like a slap in the face. I even became more upset when in that month's time, Mike never got a job or worked anywhere to earn money. He was the type that relied on women for his livelihood, to me he was less than a man.

Upset with Mike, the last thing I needed was for me to have issues with Tina. She lost her mind again and hit me during an argument. Why was she having so many issues and taking her frustrations out on me? I left her once more and planned to date other women. The next time Mary Lou came by to visit Yero, I told her to bring her long curly, dark-haired friend by so she could be given some attention. During this time Monique and I became even closer, spending more time together outside of studying. While I was on a date with a tall dark sister named Sharon, Monique called me with some personal issues. My lady friend and I picked her up, brought her back to my apartment, and we all socialized together. Sharon was just as tall as Monique, both women while wearing heels, could look down at me. Sharon's pretty face allowed her to shine in a crowd, but her work ethic woke her up at noon daily and helped her party until all hours of the night. With Tina's antics, love was nothing

more than a word that had no definition. My state champion ring went right back on my left ring finger. School and wrestling buzzed over and over in my thoughts any time relationships were discussed. Monique, Sharon and myself laughed for a while talking about Yero and how dirty his room was. When he walked into our three bedroom pad, decorated with one green couch and one orange couch, the first thing he said was, "All tall women have to leave." Monique often flirted with Yero, stating if he were two feet taller and a few shades darker he might have a chance.

Thirty days had passed, and Coach Darling sold Mike's car as promised. Why was Mike upset for no longer having a car? He still had no job. He was even behind on that month's rent. I took Mike's house keys and threatened him with an ass beating if he returned to the house without his share of the bills. Later, I saw, what looked like Mike on campus, relaxing near the free speech area. Not thinking it was him, because Mike wasn't in school and plus this dude had some beefy shoulders and thick arms. The Mike I knew was at times chubby in the mid-section, far from having an athletic build. Word traveled around that Mike had hooked up with a friend, and they started using and selling steroids. I let it be known that if he was to, "Try and Catch me Slipping," he would need more than just those big arms he was carrying around.

Monique and I screwed-up and shared an intimate moment one evening. This was different from the kiss we had four years prior. The best way to describe it would possibly be love-making between friends. I didn't want a relationship with her and she didn't give me the impression that a relationship was what she wanted. While spread out

on my full size bed, she explored my body as if it were a puzzle. Not even Tina had touched me with such passion. Her hands trembled along with her lips. Confused about our friendship, we never asked each other what was happening. It felt long overdue and needed by both of us. When she moaned, her tone held an octave I didn't know she could make. "How are you?" As she smiled, her tension weakened and allowed me further. Time was non-existent, yet her ecstasy was felt quickly, then again and again and again. I thought we would have a lifetime friendship and she would forever be my tutor. But after we made love, everything changed. Tina was constantly calling, and I felt guilty for having made love to another woman even though we were not together.

Weeks later Tonya showed up with Mary Lou and I would do more than visually admire her beauty. She had no shame in expressing herself physically, and I felt as though I was playing the field more than being focused on school and wrestling. Tonya's sexual energy was unbelievable. At no time was she not expressing her attraction for me, which turned me on and then some. Her father is Hispanic and her mother is White, but to look at her you'd think she was a mixed sister. Weak in the flesh, weak in the mind, Tonya had put a spell on me and to hear her voice at times excited me. Tina took this as a challenge and would stop by the apartment unannounced. During these episodes, Tina didn't have the same physical appeal but the emotions were still there. I missed being in love more than actually missing her. Off and on with Tina, my parents again banned her from the house. Coach Darling liked Tonya and so did Dana but love was something that was only going to be given

to my family. The emotional pain was horrid, different from my psychological down falls with Thomas, but just as painful.

Monique and I were still going through a major falling out that hampered our friendship with one another. I blamed the fact that we had taken the friendship to a sexual level for its confusion-were we dating or just friends?

Coach Deliddo recruited Yero and we were again teammates. His decision to stay and attend Fresno State would ultimately solidify our brotherhood. However, Yero would explain to me that he was his own man and I could not direct him as I did my own life.

"We are different Tuck, you're an organized neat freak, and I'm just the opposite. I know you mean well, but I can make my own decisions regarding life's choices."

I often treated Yero like a younger brother rather than someone my own age. Since we cared for each other like brothers, I took it upon myself to make most of the decisions in the house and just told him how much money he owed at bill time. I cared for Yero whether he was right or wrong. I also respected the fact that he was capable of accomplishing his goals without my direction, only needing my support. With all those conversations, I learned how to be a true friend. We continued to live together in search of a new roommate.

Summertime came and working at Fresno Unity Group Homes for Linda Reaves again was planned. The M.I.K program was prosperous that summer. I organized a couple of speaking engagements and Oliver helped at both events. While Yero was like my brother, Oliver was becoming my best friend. We organized more

events together and he was voted in President of our M.I.K program. Towards the end of the summer, Monique and I were still not talking. I was upset and still confused about my feelings for her. How could I care for a woman as a friend and have sex with her at the same time? I didn't want a relationship with Monique outside anything platonic, that confusion kept us apart. Tonya and I were seeing each other regularly, however I was afraid of committing to a relationship.

Sunday dinners at my parent's house were comedy. Everybody had to have thick skin eating at our table. Coach would often tell us to take it easy because Zack and Kassie were trying to talk as much trash as myself and Yero. It was all in fun so we continued with ease. Coach Darling began shaving his head completely so we were limited on the bald jokes. Dana couldn't keep up with Yero's wit so being eighteen inches shorter than Coach left her an open target. Kassie and Zack were now taller than Yero so they had many short jokes to tell.

After those Sunday dinners, while beating Zack up, Yero and I taught him a series of arm-drags and single leg take downs. Eventually it paid off; joining the tough guy crew, Zack placed fifth in his age group at the California Freestyle State wrestling tournament. My family was taking me places and showing me sights that I had never seen. We had been to Hawaii a couple summers prior. But traveling up and down California was a annual summer time event. Dillons Beach near Stockton, California., was always fun, Bodega Bay up by San Rafael, and my favorite Tulloch Lake. Our annual summer vacations were an experience. Most of the time, there were no other Black folks running around in a speed boat or on jet skis, so when other

people of color were seen enjoying the water and waves, I made it a point to introduce myself and speak. Coach Darling would often tease me and ask if the nod was restricted to Black people only. I told him to try it and see for himself, most of the time he got a nod back. On most of these trips came Coach Darling's best friend, Clark Mello, his wife Lynne, and their children Collin and Whitney. They all had become like cousins to me. We've shared years of summer trips together and even have a special Christmas celebration the day after Christmas so our families could get together.

Foolishly, I accepted Tina back into my life after my parents, Yero and Oliver encouraged me to stop seeing her. I told her about my relations with Tonya, but refrained from saying anything about Monique. Even though, Monique and I were struggling in the friendship department, we still knew we would support the other in times of need. It was wrong for me not to say anything to Tina about my episodes with Monique. But she was just a friend and I wanted Tina to still view her in that way. In love with the feeling of being loved, my attention moved away from school and everything else that was important to me. In order to let Tina know I cared about her, I applied for a credit card and started to put myself in debt buying her gifts. My parents helped me buy a 1983 Cadillac Coup Deville, white with a burgundy interior. I kept that car so clean that it was the envy of every hustler who knew me.

When school started my senior year, I was team captain and Yero made the starting line up. We were traveling together on road trips, and soon I was ranked fifth in the country.

I had my last falling out with Tina when she

attempted to exert her frustrations by moving her furniture to the side, one day while arguing at her house, and challenging me to fight. I told her she had mental issues and walked out of her life. This time the cards and notes on my windshield didn't work. We spoke occasionally, but my heart had turned cold and bitter from being disappointed by her so many times. I compromised myself to the point that I believed her over my parents, Yero, and Oliver. My focus shifted from school and wrestling to the security of a relationship with Tina. Hurt, bitter, I felt like a fool and most of all, I figured out I was living a naive and co-dependent lifestyle with Tina, similar to my childhood with Thomas. I had to stay away from her. Through rumors it was said she had other guys on the side. That made me ashamed to show my face on campus. I was caught up with the image of being this star athlete to continue impressing Tina, I had forgotten who I was and what my goals were. I was not living healthy, mentally. I had survived my younger years by constantly seeking physical and mental outlets. Now, I felt haunted again with nowhere to relieve my frustrations at relationships. Again, my state championship ring went back on my wedding ring finger vowing only to replace it with an actual wedding ring. Again dating but denying anyone a serious chance to get to know me.

After submitting my application and interviewing to become a member of Kappa Alpha Psi, my concentration shifted to school, wrestling, Sunday dinners with my family, and becoming a member of Kappa Alpha Psi Fraternity, Inc.

On the mat I felt that, within my weight class, I was one of the better wrestlers in the country. After returning from a road trip where I



lost to Hardel Moore of Oklahoma State, I promised myself to wrestle more aggressively. He bullied me with a strong single leg shoot and disregarded my offense. I knew I could beat him even though he felt strong for my weight class. While in my restroom cutting my hair, pondering wrestling and how to improve, the phone rang, a call from Nic McCray. He sounded different from the times he spoke at our M.I.K meetings. With attitude and bass, he told me to report to his house immediately, then hung up in my ear.

Halfway through cutting my hair, I was hot, driving quickly, weaving in traffic to Nic's apartment expecting to hear some remorse in his voice. Nic was the current president of Kappa, so he best have reason for speaking to me like a chump. When I knocked on the door, a different voice yelled, "Get Yo Ass In Here!"

I flung the door open defiantly, thinking I had some words for whoever thought they could speak to me in that fashion. When I entered the living room, there were members of Kappa everywhere. All the brothers in my M.I.K. program were lined up against the wall with Rick McCaster first in line. Each one of the brothers had their chins pointed at the ceiling, with their shoulders aligned perfectly. All I could focus on was everyone's throat.

I knew what was happening and joined my brothers in line. School was tough, wrestling practice was hard, but pledging was humbling. My hood mentality would not allow me to be disrespected. That first session was spent with an attitude not knowing if I would make it through the night. As the process became more in-depth, I felt as if I had made a mistake by trying to join during

my final wrestling season in division one. I was tired during practice, tired during classes and just tired period. The times that I thought about dropping led me back to Arthur Ashe and wanting to experience what he had. Those thoughts gave me a sense of humility, and maybe that is what was needed for me to survive in the real world without flashing and whooping someone's ass for disrespecting me. Also, the other brothers going through the process needed my help just as much as I needed theirs when the heat was on.

My parents were in disbelief that I was putting my body through so much. At one point Coach Darling came over to the "Hole" with his redheaded friend Mike Ellis, who is just as big, with demands to send me home. Fortunately, I was in study hall. My line brothers laughed that a huge white man with that big mustache had come to the house and demanded I be sent home. From my perspective, Coach Darling was just being my father, thinking he was protecting me from a bad decision. My choice to finish what was started had been made, so dropping for any reason wasn't possible. It would have been fun to see him at the hole that day, banging on the door with those saddle bags shifting side to side demanding his son return home. That would have been a good laugh, after the fact.

Yero told me several times that I was crazy. Crazy for risking the opportunity to become an All-American and crazy for accepting the belittlement from people who were already members of Kappa. I told him about wanting to know what made Arthur Ashe such a great man,

Yero said to me "Tuck, you trippin."

Monique and I would talk at odd hours and

places so my big brothers would not catch me. We reconciled, I needed someone to talk to during these times. She had become a member of "Delta Sigma Theta" two years prior, so she could relate. Monique was always there like a true friend, at times I felt as if sex between us was a gift. I cared for her, she was my friend. When I looked at her she didn't spark that desire like Tonya or Tina (before she started trippin). The fact it was physically satisfying made it easier. Our situation taught me how some women could fall in love with a man and not be sexually attracted to him from a sole physical perspective. For me, I was afraid to admit my love for Monique because I couldn't label it. She wasn't a booty call, I didn't view her as someone who just satisfied me whenever. There was no potential for a relationship. Then it hit me! I had missed years of learning how to love, by a woman, with a woman. There was no mother raising me with that warmth and security before manhood. Dana had a late start, at seventeen I was too old to be caressed and tucked away at night. During every difficult time in my life, I used athletics, chorus, theater and women as a release. Half the time engaging in the act of sex wasn't the issue, just a woman's presence, period, was satisfying. However, as I matured physically and discovered the physical gratification of sex then it became easy to indulge myself. Monique was a friend years before we had sex, our hormones and youthful antics were excuses for lovemaking. The attention I received as an athlete allowed me to have several other partners as well. Was this new revelation a good thing or a bad thing? Not knowing the answer, I was just happy to be understanding myself better.

While trying to become a "Kappa," I had my first conversation with Dajia. Hoping to keep the encounter brief, scared one of my big brothers would see me speaking with her, I asked her if she wouldn't mind sitting down and having a conversation the next time we bumped into one another. Beauty had blessed her, to me she was the finest girl on campus. She had a light honey-brown complexion with distinct African-American features. Her thick lips were the center of my attention every time I saw her. Her long dark hair was down (a hair style she seldom wore because it was to difficult to manage while training with her team), and she wore a zebra-print skirt that lay on her ankles. Her body had the attention of every guy on campus that admired the feminine physique of a woman athlete. Not to sound crass, her butt was shaped like two volleyballs. When she walked, confidence lifted her every step, and her thin neck, reminiscent of a pedestal, held the portrait of her eyes, nose and lips. When she spoke, intelligence was evident, free from arrogance and strife.

After sneaking into the R.D.H. (resident dinning hall) one afternoon for lunch with a few of my line brothers, Jeremy Guidry, Damien Ruffen, and Ruben Parish, I noticed Dajia eating with one of the guys on the basketball team. That year was 1996 and famed basketball coach "Tark the Shark, Jerry Tarkanain" was coaching the Fresno State Men's basketball team. Dajia had such energy while talking to the Afro-wearing hoop star from Los Angles I, on the other hand, looked all dehydrated from wrestling practice and late nights with no sleep. I daydreamed she was sitting across from me looking into my eyes while smiling and eating her lunch.

Later that day I had practice, and even though I wrestled every match tired, with a few of them going into overtime, I hadn't lost a match. The media caught wind of my success on the mat and did a cover story on my family, "Tucker has Family in the Truest Sense" by Ron Orozco of the Fresno Bee. The story went into detail about my childhood and how my parents became my legal guardians during my junior year of high school. The Sports section carried a full page layout, a picture of me in the middle of my family. Part of me hoped that Dajia would see it.

Burning the candle at both ends, yet happier than I had ever felt in my life, Dana put a smile on my face every time I thought of her. Zack, Kassie, and Yero were my siblings in every sense. We'd laugh together one minute, then fuss with each other the next. When Coach Darling wasn't complaining about me trying to become a Kappa, our conversations were teaching me a great deal about life and manhood.

On March 9th, 1996, I won the Western Athletic Conference Championships along with us capturing the team title for the fifth consecutive year. Not even celebrating with my teammates, I rushed off to help my line brothers in session. That same night at 10:04 and forty three seconds, I became Big Brother Heart Throb, the third person on my line to become a member of Kappa Alpha Psi Fraternity, Inc. At first, I was expecting my questions to be answered immediately concerning Tom Bradley, Arthur Ashe, and other African American men who had also become NUPE's. Those answers wouldn't find me for years.

After finishing that process, my fists were not clenched as much during situations that would

have earlier made me barbaric. Learning more about myself helped me better understand the people around me, allowing me to communicate freely without fear of being hurt. Maybe that is why I feared loving for so long?

When I started college, my intent was to earn a bachelor's degree in Criminology with hopes of becoming a parole agent in order to help families with siblings who are in custody. My reason was wanting to help Thomas get his life on track. Like many students do, my major switched. Physical fitness had always been a part of my life. In fact, I credit my level of sanity to having physical activities to participate in during all those emotionally trying childhood years. Wanting to learn more about my body, becoming a Kinesiology major (which is nothing more than a ten-dollar word for physical education) held my interest during those long monotone lectures. To my surprise, the course work was more difficult than expected. Because Kinesiology falls within the study of science, my biology, physiology, anatomy and health classes were killing me. I even took one of my biology courses twice. But, my decision to change majors was the best thing since becoming a member of Kappa Alpha Psi. My plans were to teach health maybe at the junior high level, because that was when I met Coach Darling, and continued training after college with hopes of becoming a world-class wrestler.

In two weeks time, after winning the W.A.C., I was to compete at the N.C.A.A championships in Minneapolis, Minnesota. After sleeping on my parent's couch for a couple of days, that being the most peaceful place around, I invited all my fraternity brothers to the house for one of our

famous Sunday dinners. When most of the brothers asked what we were eating, I told them the food would be different from what they were used to. However, it would be prepared with the same intent to please, as Patty Labelle intended. During this dinner, my parents would discover how much becoming a member of Kappa meant to me and my brothers would know how much I loved my parents. The dinner turned out great. We borrowed chairs from the neighbors, and Coach encouraged us to do some community service at his school. Dana, with her little five foot frame and a couple of glasses of wine, had my Frat-brothers laughing, teaching her how to step, while they twirled Kanes. Dana was the life of the party.

Now wrestling with more energy, free from those late nights, my body felt rejuvenated, even though, my hamstrings and gluts had suffered strain from training without proper recovery time. Nothing was going to keep me from competing at my best. While holding my right hand over my heart, Yero stood to my left and we focused on our fifty stars with thirteen red and white strips as Ed Aliverti sang the "Star Spangled Banner". Just listening to him hit those difficult notes brought back memories of him doing the same at the California High School Championships. Ed Aliverti is to U.S.A. Wrestling, what Dick Vital is to College Basketball. Mr. Aliverti, with his clean shaven style, glasses and so much animation within his commentary, allowed me to ponder victory as he once praised me two years earlier after winning the California. Jr. College Championships. His voice could inspire anyone.

The N.C.A.A tournament brought in the toughest competition in division-one wrestling.

Every match was a battle. My mental strength was at its apex, yet physically, months of late nights trying to become a Kappa were taking its toll. With no time for condition and technique camp, my coaches Jerry Abs and Deliddo were encouraging me to wrestle with aggression.

The first day after three matches, no losses were suffered on my part, just a black eye and bruised hips. Far from the regular season, number one ranked guys were getting beat in the first round of competition. Upsets were happening like mad! New wrestlers were making names for themselves, while others were curled up in solitude facing an auditorium filed with thousands of roaring fans. Ed Aliverti started every session with the spectator count and directed their attention to certain matches that brought cheers to some wrestlers and elimination to others. The second day, I lost an overtime match to Jackson from Ohio State. This would only make my goal of becoming an All-American that much harder. Even though, I was proud to be participating in a weight class stacked with returning All-Americans (the majority of them African American), they treated me like bait. I received no respect in every second of every match. That helped me realize how significant becoming a Division I N.C.A.A. tournament winner is. Some wrestlers don't even make it through their league or conference to qualify.

The year prior, I was happy just to have competed. The two guys I lost to would ultimately become N.C.A.A champions, respectively in separate, but higher weight classes. That small amount of insight helped me to victories in some very close matches. I wrestled with an extreme amount of athleticism and knew I needed more

training and experience before I could legitimately challenge a national title. Some athletes are capable at a younger age; I was one who needed more time. Mr. Hardel Moore of Oklahoma State and I would meet again in a match that would send the winner into the All-American placement rounds. With every intense scramble, Aliverti's voice screeched, fueling my need to hear him call me the victor. Scoring with a sloppy duck under to his lead leg, I won the match. Feeling the rush of victory and seeing my family up in the stands had me euphoric. Looking over at my opponent brought me back to reality. On twelve mats laid out side by side in rows of two that stretched about sixty yards, my goal was met. Walking through the University of Minnesota's basketball tunnel back to the stands, the first person to congratulate me was Yero. As we hugged I screamed, "All-Americans! We are both All-Americans."

Day three and the war was not over. Ironically, I wrestled Jackson of Ohio State again and avenged an earlier loss. Later that night, while standing atop the number-four space being applauded by that massive crowd, I felt a sense of accomplishment and wanted more. Becoming an All-American was an amazing achievement, yet my peak as a wrestler had not been accomplished. Looking around at the tons of wrestlers who had not made the awards platform helped me realize why so many athletes continue to search for that perfect match, that perfect season or that perfect ending to a career. For some it becomes an obsession that leads them from other accomplishments in life, while for others, it clarifies thought enough to understand other possibilities one may pursue.

My fourth year of college was coming to a

close, but before that year would end, I would have that conversation with Dajia. Different doesn't explain how unique she was. She was the most well-rounded and self-assured young lady I had ever met. A student whose plans ventured well past being a college athlete. Intimidated at first, yet her challenge was not of a sexual nature, more of an intellectual feint. I was somewhat discouraged thinking about how my ghetto past could not compare to her prosperous future. Dajia had the kind of self-esteem most people wished for. When she woke, her attire for the day represented her mind state, fashion queen to grunge, but never layers. Dajia shared thoughts with me that only solidified her inner person.

"Why should I care what the next person thinks of me! I'm the only person studying for my classes, taking my exams and getting out of bed before the moon downs for early practice. I respect myself and everyone who respects me!"

College was just a stepping stone, a few years of her life spent to accomplish an undergraduate degree, while for me it was life itself. Not graduating would mean I failed, and jail or death would be my ending. So, structure and a serious demeanor were my tools. Those thoughts were unhealthy, as I was while pursuing her. Recovering from my last relationship and childhood memories should have been my focus. Instead my baggage carried an unhealthy mind state that was damaging for any person to come behind. We kept in touch over the summer, and I looked forward to seeing her in the fall.

That summer was "off the hook!" My sands (fraternity brothers) and I tried to attend every Kappa function in California. Our bond was and

still is very strong. We argued like brothers and contributed to one another like family. The only time I had ever experienced rejection from girls was during my high school years when my acne was out of control. As soon as my face cleared up, I had more options than most. Even the attention I received as an athlete afforded me more dates than average. Now, by becoming a NUPE, girls were throwing it at me from all directions. Fortunately, I played catcher with a glove. The attention gained was a reality check for the type of woman I wanted to spend my time with. Since changing my major, more requirements were needed to finish my degree. By not red-shirting, my fifth-year scholarship was worth two semesters as a student coach and course requirements to graduate. Finishing college was the answer to my meaning of life question, I was determined to become the owner of a Bachelor's of Science Degree. The diploma would indicate that success had been made without becoming a statistic. Even though test anxiety was still visiting me, the challenge was accepted and most of my classes were enjoyed.

When the fall semester started, my fraternity brother, Nathan Moore became our third roommate. Yero teased him, stating that he was the best roommate we had ever had because he stayed in his room most of the time playing video games and his trumpet. Big Nathan was the tail of our line (the tallest brother in my M.I.K) attending Fresno State on a Band scholarship. I was voted into the office of "Polemarch" and my best friend, Oliver Baines, "Vice Polemarch." That April 23rd, we implemented a "Guide Right" program in the Fresno Unified School District. Coach Darling's best friend, Uncle Clark Mello, helped us by

inviting our group to a Fresno Unified School District directors meeting. That meeting allowed us the opportunity to market our community-service commitment to all of Fresno Unified.

The warm weather in April normally kept people in Fresno indoors, not my fraternity brothers, we started visiting different schools in Fresno twice a month. We spoke to Bullard High School juniors and seniors and helped them fill out college applications and financial-aid forms. Surprisingly, a majority the students we spoke with believed that only the exceptional "A" students went on to attend college. My fraternity brothers and I explained that "A & B" students had more options of what schools to attend, however, every person who wanted to continue his or her education after high school could, in spite of their G.P.A. We spoke at Coach Darling's school Tioga, the same school I was suspended from for fighting as an eighth-grade student. I was a regular at Tioga, speaking to different classes that teachers were having difficulty controlling. When speaking in those setting, I'd figure out their issues then allow students to vent, gearing the discussion towards solutions. Not allowing the conversation to get out of control, we just sat back and talked as if we were not in a school setting. With my soft voice and fit physique, it has always been easy to capture the attention of any audience. While some brothers enjoyed the nightlife more than the community service, Oliver and I made it mandatory that members participated in at least one event each month. When classes got tough, my focus would falter allowing my eyes to sway front and back witnessing the swing in many girl's hips during their cat walks across campus.

Hanging out with different women,

organizing different community functions, and studying for classes, my time had to be structured. I would only see certain women when I finished homework and studying. One day while manning our fraternity booth in the free speech area of campus, this young woman with a body that rewarded her with cat calls and major attitude asked me when I was going to give her the time of day. Flattered, yet not trying to show my excitement, I told her she could have as much of my time as she could handle. Lavia was "bad!" Me being a sucker for a nice butt didn't help. She told me she had forty-five minutes before her next class and to meet her upstairs in the library. My interest was slipping, I was falling asleep at the wheel and losing my direction. Remembering love, my hopes were to hang out with Dajia on a consistent basis ultimately creating a relationship. Even though this contradicted my plans of being uncommitted, free from the possibility of being hurt, my conversations with Dajia lead me to believe our goals wouldn't interfere with each other allowing us both to be focused. She was doing some dating of her own which would soon end.

One evening while my frat brothers and I were hanging out in the free-speech area watching Delta Sigma Theta Sorority, Inc probate their girls, I spoke with Dajia who for some reason was teary-eyed. One of her grunge days, she wore lose fitting jeans and a long sleeve multi-colored blouse. After convincing her to spend the night at our three bedroom college pad, showing off our green and orange couches with a cabinet full of Top Ramen Noodles. She slept the entire night in my arms. She never told me what was troubling her, but our connection had finally been made. A month later,

on September 10th, I asked her to be my girlfriend. We spent a great deal of time together switching from her apartment to mine, never spending the night apart. During the day, she dwelled within my thoughts, her thick lips telling me everything she wanted for herself in the future and the highlight of it all was being able to hold her at nightfall. On occasion when she had A.M. practice, our sleep was interrupted while she hurried off to work out. Every now and then she'd report to an A.M. practice after forgetting her coach had cancelled or changed the time. Her laughter of those situations only solidified her inner beauty. Because I enjoyed shopping as much as she did, we were always at the mall together, often dancing between the isles, while top-forty-music lured buyers into the stores. She would try on every dress I picked out for her, and I openly admired her beauty.

"Dajia, girl what you gone do with all them legs and butt?"

"Well Alfonzo, you might could have me, if you be my baby."

"I might could?"

"Yup."

"Who's my baby?"

" Me."

"Who's my babies, babies, baby?"

"Me."

Dajia had the spirit of a woman well beyond her years and even within play, our conversation was always stimulating. She would even challenge me in debate over different authors and their meaning within scenes of certain novels we'd both read. Her confidence still intimidated me. While I struggled with exams, she seemed to retain information with ease.

As our relationship became stronger and sexual activity became involved, we had some differences. She would explain how strong her attraction was for me, however she felt like she needed to save "something" for marriage and her husband.

"Baby, we're having sex. What more can you hold back?" Foolishly I looked past the true intimacy associated within lovemaking and felt like my job was done when she climaxed. Dajia knew she didn't have all of me and wanted the security of knowing I would always be around to hold her at night and comfort her when life dealt some tough cards.

My first college relationship ended with so much confusion and animosity, I found myself holding back my feelings for Dajia and allowing myself not to care for her as deeply as possible. Every time we had a conversation about completion of undergrad, Dajia would explain how she was looking forward to law school, but not to leaving me in California. I felt like we were on a time schedule and she or I used that to prevent her from having all of my heart. She was holding back sexually which I used as an excuse to further my desire for other women. Selfishly, I disregarded her mature decision for wanting to share levels of intimacy with her future husband. Now when girls offered themselves I accepted, involving myself with other women, without Dajia's knowledge.

She's going to leave me when she graduates, she'll meet some tall handsome guy in law school who'll be passionate enough to wait for her sexually. My teaching salary won't be enough to provide for her the way she is accustomed too. I had excuses for everything and foolishly justified

my lies and infidelity.

The first time I acted upon my lustful desires was when Dajia was out of town at a tournament with her team. Actually nervous during the encounter, I felt horrible for having contradicted myself. Dajia and I stated that, if we were to engage in a sexual encounter with another person, we would tell the other out of respect. Still wanting to enjoy her as my girlfriend, I figured since a condom was used she didn't have to know. Feeling guilty, I attempted to break up with Dajia, yet after a few days I felt lonely and longed to have her sleep next to me again. Selfish was an understatement. My actions defied our trust and knowing she would not forgive me held the potential to end even our friendship. I spoke to the women I had been with and told them that I just wanted to clear my guilty conscience. Momentary relief, they knew I had a girlfriend and we stopped seeing each other.

I was still working at the group home on the weekends and was given the head-coaching job at Clark intermediate in the city of Clovis, California. I would coach the team in hopes of getting a teaching position there with the possibility of continuing wrestling myself. Yero was having another outstanding season; he was a fifth-year senior and a returning All-American. Big Nathan was still our roommate. The bills were getting paid, Sunday dinners at my parent's house were joined by Dajia, Nat, Yero's girl Mary Lou and a couple wrestling buddies, even on occasion, my fraternity brothers.

My first head-coaching season was allowing me to smile outside of my confusion with Dajia. She'd come to our dual meets, yet afterwards my attention was all about the team and graduation. My

rules were easy to follow, break them and you didn't wrestle. Coaches Darling, Music and Deliddo all had the same philosophy. The only difference within my coaching was the structure of practice, every minute had value and every minute you were active. It just so happened that Zack was attending school at Clark Jr. High. His background in wrestling started in the third grade where he wrestled for the "Tony's Tigers" Wrestling Club that I helped coach. Zack's kinesthetic awareness was great; better than any person his age at the time. Every move I demonstrated for the team, Zack could replicate that very same day without instruction. My little brother had potential, his desire was to play as much as possible, yet his ability was far better than everyone on the team.

We continued workouts in our parent's garage, drilling and learning new positions. I thought Zack would immediately be in contention for a state title once he entered high school. Like me, Zack hated to lose, but instead of training harder and learning more, he would throw temper tantrums. They would disrupt practice and dual meets. On one occasion, he got in trouble at school and was given detention. My rules for the team could not be altered for any athlete, especially my little brother. His long, lean, limbs afforded him more leverage in positions, where average wrestlers had give up points. Zack used that to his advantage. Without coaching, he was a natural. But his temper led to the disrespect of his teachers, which led to detention and that led to him missing several team practices. He had to be benched for disciplinary reasons, which upset me because he was my brother. He should have never even contemplated making a mistake.

Zack was my first wrestler who broke the rules. I thought that not all those, after Sunday dinner, conversations about life and true commitment to himself were being understood. I questioned him about his behavior outside of practice and the classroom. He promised to turn down drugs and not succumb to peer pressure.

One evening while hanging out at my parent's home, the door to Zack's room was gone. The hinges were not ripped out, like I'd seen in homes where doors have gotten kicked in during a drug raid or when Joby broke down my front door when I lived with Thomas.

"Coach, what up with the missing door?"

"Fonzie, Zack's behavior is out of control. He runs to his room and slams the door locking it behind him to avoid answering to Dana or myself! I took it out, and he is not getting it back until his attitude changes around here!"

I was surprised that Coach had taken such steps. Zack was getting away with too much, needing a much higher form of punishment in my opinion. While sitting on the couch, I heard Zack raise his voice at Dana; she was in his room helping him with his homework. When Dana came stomping her short self down the hallway angry and fussing, Coach got out of the shower.

Dripping wet and stark naked, all Coach had in hand was a racket ball paddle and a towel covering his private parts. He yelled, "Zack, turn around and take what you got coming!"

Coach Darling was HOT! He had never even raised a hand to his children, preaching and lecturing more than gritting his teeth with bits of spit jumping out his mouth. Was he really going to whoop on Zack? I was hoping so!

Zack cried out, "No, Dad, please don't spank me!"

"Good, he needs his butt kicked!"

The doorbell rang; in two steps, my hand was already turning the knob. When I opened the door, to my surprise, it was Rusty Rassmesen from across the street, there to see Coach. I asked Rusty to wait and went to Zack's room to tell Coach Darling that he had company.

Zack, with his eyes doubled in size, was curled up in the corner by the bed trying to keep away from that paddle. Coach, standing there with no towel, blood-red face with that saddlebag mustache and his wide shoulders rising with every breath, looked like he needed a straight jacket.

"Coach, Your company is here."

Walking back into the living room, laughing at the image I'd just seen and thinking was Zack more frightened of the spanking or Coach Darling standing over him with a paddle and no clothes. Thirty minutes later Coach was gone, Dana was sprawled out on the couch sipping some Napa Valley Merlot, Kassie was on the phone, and Zack was settled in his room underneath his desk light doing his homework.

My relationship with Zack and Kassie was unique. Being their African-American brother who shared his life experience with them had to give them a bit more understanding concerning life than their peers. I would explain situations to them they hadn't yet encountered, hoping they would take heed and develop thought for themselves rather than exploring and experimenting with drugs. While Kassie never seemed to get in trouble, Zack stayed in trouble despite altercations with his dad.

The Clark Intermediate Wrestling Team

placed second in the league that year. Excited about coaching another season, Sherri Hall, the mother of Kassie's best childhood friend, Bryanna, arranged a meeting with Mr. Lindstrom, the director of the Fresno Police Academy.

While passing out promotional flyers to one of our fraternity parties with Oliver, I received a page from an unknown number. While on the payphone, Mr. Lindstrom identified himself as a friend of Sherri Hall and the director of the Police Academy. Flattered that he would even call me, I offered a conversation in person rather than by phone. He spoke very calmly and invited me to interview with him that very hour. Though nervous, I accepted the invitation and drove to the campus where the academy was being held, not realizing how under dressed I was until I stepped out of my car and noticed the current class lining up for roll call. They wore neatly pressed uniforms with nylon holsters and guns with no magazines. I was wearing red shoes with a white windbreaker jacket that had the Greek letters of my fraternity. Wishing I had more time to prepare and change clothes yet determined to impress Mr. Lindstrom, I walked past the cadets.

After a handshake and a few minutes of small talk, Mr. Lindstrom asked me why I wanted to become a cop. I was completely honest with him and told him that my intentions were originally geared toward teaching and continuing wrestling. However, I had spoken with my parents about a career in law enforcement because teaching jobs were limited due to budget cuts within the Fresno County area. Because I had a fascination for the meticulous work of investigation, I was willing to research the profession of police work. A week later

I was in his office again, taking the law-enforcement entrance exam, which freaked me out. When we had our next interview, he told me that the next session (Class 73) would be starting in two months and if one of the already scheduled cadets could not attend, then I would take his or her place. Even though still in school, I only needed one other class to graduate and could take that in the summertime right after graduation. The good news would come and Dajia celebrated with me the opportunity to pursue employment in law enforcement.

When I received the course outline of the six-month academy, I was completely afraid of the exam schedule. The academy was associated with Fresno City College and the cadets were to accumulate over thirty units of Criminology (administrative justice) within a six-month period. We were to take two exams weekly and maintain no less than eighty percent throughout each learning domain. The first day of class, a young thin Caucasian woman complained of asthma and quit. The following week after our first exam, several cadets including myself, scored below the eighty percent minimum. Each cadet was given one opportunity to take a revised form of the exam over and if you failed that particular time, you were finished.

My anxiety level shot through the ceiling. At first I felt that Dajia was in my corner; we would study together and I was scoring well over the minimum allotment. During this time, my behavior was draining her. Being selfish, requiring too much of her attention again was unhealthy. She too had plans of her own. With school, her sport and me, she was bombarded with pressure as well. Even

though, I developed good study skills in college, I never had to perform at this pace. The two exams a week were stressing me, and the physical training portion of the academy was a joke compared to wrestling practice. On occasions, we would have scenario training and have to enact a mock arrest. This was easy for me while others struggled, talking to people was simple. The most important issue was determining the crime and then being able to defuse a potentially violent situation. If the role players acted like criminals and we had probable cause, they were arrested; if they were victims then a report was taken. My childhood was spent on the other side of law enforcement, so recognizing crime was easy.

Dajia and I were having issues. Trying to avoid heartache, I would distance myself from her hoping not to end up heart broken. When she questioned me, I told her she was already thinking of ending the relationship.

"Alfonzo, I'm not."

"Would you tell me if you had?"

When she hesitated, I reminded her of the year prior in which I had gone to visit her back home during our winter break. Her sister was engaged and celebrating a birthday. An old boyfriend stopped by to take Dajia's sister to dinner. He dressed in slacks and fidgeted with his hands as if he was on a first date. I asked Dajia if her sister's fiancé knew she was going out to dinner with her old boyfriend. Dajia looked at me and stated what he doesn't know won't hurt him.

My insecurity led me to read her journal while she was competing out of town. I discovered information that was upsetting yet nothing leading to an affair. Dajia was introduced to a guy while

attending her sister's wedding in Chicago. They had been communicating on a regular basis by phone. Reading about another man giving her the attention she needed had me wanting to find a gym. My love for her was watered down. By not contributing to the relationship in a healthy fashion, I should have been mature enough to tell her the truth and hope for the best. My selfish desire kept her and deterred me from leaving her.

During the shooting portion of our academy, the stress level decreased because there were no exams to take and shooting was not difficult for me at all. However, we lost another female cadet for having scored below the requirement on the "use of force" exam.

She was being sponsored by the Fresno Police department. A representative met with her and confiscated all of her gear, on the spot, she was asked to leave. After investing so much time, not to be graduating from the academy had to be heartbreaking. Some of us tried to encourage her to reapply, to my knowledge she never did. The following week Officer Hamilton, our regional training officer, asked Cadet Campos to report to the office. When that happened, it was common knowledge that someone had failed academically or was being reprimanded for outside activities unbecoming of a future officer. The next thing we knew he was being driven away in handcuffs while in the back seat of a patrol car. R.T.O Hamilton stood in front of our class and told us that ex-cadet Campos had been videotaped stealing money out of our commissary till. We used the honor system to pay for goods during breaks, and every so often, the till would come up short. I heard he was charged with burglary and admitted to taking the money

only after they showed him the tape. Our academy class started with close to sixty cadets and was down to forty-eight.

With two months left in the academy and needing an outlet, I would go to Fresno State's wrestling practice. I had forgotten how enjoyable wrestling is and desired to continue. Trying to maintain motivation, I'd drive around the new housing developments off Herndon and Polk Ave. Walking through the model homes had me wishing and dreaming of some day owning my own home. That inspired me to continue studying.

With a month left in the academy, I had graduation ceremonies at Fresno State. This was going to be the moment that gave my life meaning. Not completely forgiving Thomas, I figured one way to end my dislike of him was sharing my graduation with him. Debating with me, Dajia, suggested that would be a good idea. Even Coach Darling believed it was the right decision to make. I picked up Thomas from a halfway house he was currently in and figured, if he wasn't high then he could set in the crowd with envy and take pride in his biological son graduating from college. He didn't have those heavy white rings around his eyes and smelled like dial soap with clean clothes on. Black Graduation! or as advertised, "The African American Commencement Ceremony," held in Bulldog Stadium. Over ten thousand spectators were either weeping with joy or grinning with pride. That evening, Thomas told me he was proud of the decisions I had made in life and was overjoyed to see me graduate. Not wanting to embrace him, I shifted the conversation and told him I had cheated on my girlfriend Dajia and felt guilty for not having told her.

"Son, do you love Dajia?" Disgusted with him referring to me as his son, made me regret him being there. Just as thin as I remembered him from years past, I introduced him as my biological father to whoever asked.

"Yes, I do love her. But how does one love a woman and remain faithful?"

"Son, I don't know but you shouldn't tell Dajia. It might be better off unspoken."

For the first time in several years he sounded sober, however, was his advice good or bad?

I walked that stage with Thomas and several people whom I loved, my family, Dajia, Monique, Nancy Cisineros, Yero and my fraternity brothers, in the audience. Upon dropping Thomas off at that half way house, he asked me if we were going to see each other again. I told him I was still trying to get over my childhood and forgiving him was the start. On occasion before the academy ended, Dajia and I would visit him. That night, my family and I had dinner at Bennigans a few miles away from Dana's flower shop. Coach Music was there with his thick chest and new facial growth, and we talked about high school, junior college, and the possibility of me ever wrestling again. I felt accomplished; remembering standing atop the victory stand at the N.C.A.A tournament, yet somehow felt the desire for more. Soon, I would be graduating from the police academy, and whatever I was missing would surely be discovered during that accomplishment.

Several nights of preparing for exams would start to really burn me out. R.T.O Hamilton busted me in line up one day for not remembering Penal Code 215 (carjacking), and I had to write a memo. That was the first time throughout the whole academy that I received a demerit. I held the third

highest rank in class as leader over platoon number two and had pride in the fact that I never scored below eighty percent in any of our learning domains. In the same week, I would receive a second demerit for not shaving. R.T.O Hamilton was keying on me. That was the first time in my life that I would even have to shave. The peach fuzz on my chin had not settled in, so whatever he saw growing down there reminded me more of dirt than anything. I had respect for R.T.O Hamilton, I figured he was preparing me for our last week of finals.

After graduating with the top physical training award, I was told by one of my instructors, Lieutenant Least of the California Highway Patrol, that I would make an outstanding officer with whichever department hired me.

Dajia was out of town for the summer, back home with her family. Coach Darling and a few of my fraternity brothers attended graduation. Living poor, not poverty stricken like most drug addicts I knew, I just had enough money for the necessities. I moved back home with my parents, while I was filling out applications to different departments. That summer my parents threw me a graduation party. With all my friends, frat-brothers, and loved ones in attendance, the surprise was Dajia flying down to spend the weekend with me and celebrate my academy graduation. A huge gift box sat in the living room of my parent's home. Dana was always full of jokes, so I figured it was a small gift placed inside this huge box. When I opened it, Dajia jumped out. Wanting to kiss her thick lips, I pulled her into the back room so we could embrace in private. My smile carried so much energy I could have lit a dark hall for hours. After realizing how

much she was missed, I thanked her for taking time off from her summer internship just to come see me.

Dajia only stayed for a couple of days, and then it was right back to being lonely and chasing interviews. I had friends to be proud of, like Yero and my fraternity brothers, but the company of a woman always captivated me. I often used that human desire as a scapegoat, still not mature enough to practice self-restraint. My girlfriend was out of town and the warm weather had girls dressing provocatively. The good thing was I lived in my parents' home, so I didn't have free rein to do as I pleased. At a church picnic, I met a young light-skinned sister, just a couple inches taller than Dana and attending U.C. Davis. Tamara McDonald wore a perm and drove a two door Honda she called Purple-Passion. After going out on a couple of dates, she truly seemed like a lovely woman with a sound family and a prosperous future. Hanging out with her let me know I could pursue a woman with good intention and her be worthy of a good man. But I wasn't about to make the same mistake again, giving myself to a woman when I wasn't over the present girl I was seeing. Plus, I was far away from being healthy enough to contribute to a relationship, so Tamara and I became plutonic friends. Knowing that Monique and I were having our issues communicating, I promised myself that Tamara and I would never compromise ourselves, leading towards a tainted romance or friendship. We spoke on occasion when she was down visiting her family and our church. Yero joined us during our outings and we nicknamed her Ms. Mack because she seemed to hold her own in the company of guys acting like idiots most of the time. Since I had graduated, my demeanor was less tense, and joking

with Yero became a regular occurrence outside Sunday dinner.

I wanted to stay home and work for Fresno P.D; however, they offered me a position as a reserve until the next hiring phase came into effect. Disappointed, I waited on interviews from Madera P.D and the Contra Costa Sheriff's Dept. The hiring process for law enforcement is extensive. First, you have a written exam. Next, is an interview with citizens from the community and officers from the department. If you score above ninety-five percent, then you're asked to take a polygraph test. After your poly-exam, an investigator is assigned and a background investigation is conducted. The next step is an interview with a psychiatrist and an exam consisting of a thousand or so questions. If you're fortunate enough to pass each of those steps, then you have your hiring interview with one of the highest-ranking members of the department. If you're given a job offer, it's conditional on whether or not you pass the physical exam given by their physician.

The whole process takes anywhere from four months to a year, depending on the department you've applied with. I traveled up and down California interviewing with different departments. I then made another mistake that would haunt me for years.

One weekend, stressed and hanging out with my fraternity brother, I caught myself flirting with a woman who was known to please in whatever way she could. Sinai wanted to sleep with me, and without effort, it happened. She was not strikingly attractive, light skinned sister, plain appearance, thin waist. Yet her aggressive sexual nature was a turn on. Weeks afterwards, I told that woman not to

call me because I did not want to see her in that fashion again. The situation got out of control when she would not stop calling me.

"Listen Tuck, you can make this easy for the both of us if you just give me some when I want it. Dajia doesn't have to know! I'm not going to tell her! Don't you know how to keep stuff on the down low?"

She was too aggressive; eventually I'd suffer for my actions. This woman was used to getting her way, and not being able to have me was a challenge for her. For months, I dodged that woman's phone calls. Selfishly wanting to control the outcome of my relationship with Dajia, I distanced myself from her, avoiding long conversations and changing the topic when asked if I was seeing other people. What I should have done was come clean, yet, Dajia was my love I was afraid to be without. Even if she was out of town, my actions were unhealthy, my insecurities just warped our relationship.

During the first week of October 1998, I received two job offers. The first was with Madera P.D and the second with the Contra Costa Sheriff's Dept. I declined the job with Madera and attended the hiring interview with Contra Costa. During the interview, Commander Young stated, he had never read a background investigation report with so many people saying such great things. I wasn't a criminal, didn't drink alcohol or do drugs, and the only thing I regretted as an adult was lying to and cheating on my girlfriend. Even though, I felt happy about being offered a job with Contra Costa, I knew when I told Dajia about my infidelity she would walk out of my life. While driving home from the Bay Area, I stopped off in Sacramento to speak with

Coach Darling's mother, Grandma Darling.

Grandma Darling is still the sweetest, older woman I know. I love her because she has always been very open and real with her conversation. If she doesn't like something, she doesn't hesitate to voice her opinion. When she is pleased, she openly shows affection. Free from color, her skin is just as pale white as her hair. To an onlooker, she appears past her prime, yet everyone in our family thinks she will out live us all. I wanted her to know about my good fortune and that she would be paid back the money she loaned me while in college. We agreed she would receive a check on the tenth of every month until paid off. While having lunch with Grandma Darling, my Uncle Darrell, who is just as tall as Coach and with a full head of hair, brought over my two cousins, Sara and Ruthy, whom I only saw on holidays. Everyone connected to Grandma Darling's genetic tree has some height. Both Sara and Ruthy are taller than me, close to six feet tall in heels. Speaking with all of them felt good. They repeated how happy they were about my new job and we discussed seeing each other more now, that I would not live as far away. I drove home to tell Yero and my parents the good news. My hiring date was Oct 19th, and I had just a couple of weeks to find an apartment and begin my life living in the Bay Area.

The following weekend, I drove back down to Contra Costa in order to find an apartment. To my surprise, everywhere I tried was rented out or had a waiting list. I drove from Antioch to Oakland looking for housing. The only places that had vacancies were either unkempt or over-priced. Across the street from the Martinez Detention Center, where I would have to serve my probation

period, was a set of studio apartments. My assumption was those units were so close to the jail, the renter's turnover rate was high. I left a desperate message on the owner's voice mail and surprisingly received a phone call. We negotiated everything over the phone and agreed to meet in person the following Friday, (Oct 16th). The expense of moving and paying rent with the security deposit totaled over two thousand dollars. I could not believe the cost of living in the Bay Area. The apartment was only 400 square feet, with a tiny refrigerator and stove that looked like toys. Also, it would be the first time in my life that I would live alone.

I asked my parents for the money and fortunately Dana's flower shop, Flowers and Sweets, was having a good month. Coach Darling loaned me the money and I rented a U-haul truck and loaded everything by myself. Nervous, I prayed the whole way. My tiny new home seemed even smaller than the first time I walked through it. After I unpacked, I drove back to Fresno the same night. Tired and nervous about my new job, I spoke with Dajia about how I would drive back home on my off days to see her.

The next night when the time came for me to leave, I waited and waited until late in the evening to make that three-hour drive. While standing on Dajia's porch preparing to say good-bye, we both cried, knowing things between us were changing. I wanted to tell her then, yet could not.

The next day, Monday morning, standing in the city council chambers surrounded by my family who came down to witness my swearing in ceremony, I knew I had finally given myself the opportunity I had worked so hard to achieve. I had a

job that would afford me security and I was so grateful to myself for hanging on for all those years I struggled with Thomas and ran from a life that would have earned me a prison bid. It was weird, because I promised myself as a teenager living with Coach and Dana, that I would not ever commit a crime and end up in jail. Now, I would have to spend my probationary period working in a jail. With all that love in the room, people like Coach Music with his girlfriend Sheila, Sherri Hall, who helped me get an interview with Mr. Lindstrom of the Fresno Police Academy, Yero who walked around with my new badge pinned upon his chest, and Zachary, Kassie, Mike, and Dana, I felt accomplished. Yet again, something was missing. I was not at peace.

I'm a cop now. I really don't feel like a cop because I'm working inside a jail. But I got a nine-millimeter Smith and Wesson and a gold star that stated, "Deputy Sheriff Contra Costa County." My partner, Mark Apley, whom I met during our hiring process, would be going through training with me. He seemed different from the other white guys I knew in the department. Mark told me about his life and his childhood was very similar to mine. Mark and I were about the same size, his five-ten 180 pounds allowed him to hold his own and he carried himself as if he could whoop ass, if he had to. Always wearing a short military style haircut, he is even more meticulous than I am. We became friends and I occasionally had dinner with him and his beautiful Hispanic wife, Sandy.

At first working in the jail was intimidating. I pictured inmates behaving negatively as they do in the movies and plotting on killing the officers and themselves. What I would soon understand is many

of the offenders inside jail were trying to get along with each other so they could be released on time. The most hardened offenders influenced the weak and only engaged in incidents from which they could prosper. Inmates do engage in activities that could endanger the lives of themselves and others. Escapes occurred, people were injured in altercations, but they weren't all performed in Hollywood fashion. I learned real fast that my ability to communicate verbally was more important than my physical capabilities. Even though the facial expressions were hardened, I wasn't going to be misled. The inmates' thoughts were not new to me. I figured they were a bunch of tough guys who made some wrong turns and poor decisions that led them to this jail. Unlike some of my co-workers, I was not going to be surprised by their actions. I was just amazed why most had not learned from their mistakes.

As soon as my phone was connected, the prank calls started. There was no cause for alarm. Only Dajia, my family and my fraternity brothers knew my number. I drove to Fresno every chance I got, hanging out with Dajia and thinking I couldn't stand the long-distance relationship thing. She would possibly be moving out of California herself for grad school. A friend of ours, who planned to attend law school after college, had changed her plans to move to Canada with her boyfriend. This guy, a good football player, was drafted by the Canadian Football League.

One day while talking about them, Dajia stated the girl was being foolish for putting off law school by running off to Canada with that guy. Her statement hurt; insecure, I found myself pulling back again. We talked about her plans, and I felt she

would apply to grad school in the Bay Area, however, no guarantee existed that she would be accepted and choose to attend a school in the Bay.

Again, the prank calls started back. On one occasion, a voice spoke up and asked me how I had been. After a few moments of recollection, I said, "Sinai, please don't call me!" and hung up.

She immediately called back. With my face distorted, eyebrows touching, "Girl, how did you get my number?"

"Alfonzo, Alfonzo, don't hang--."

She sounded excited and said she was turned on by my anger. I hung up and unplugged the cord.

A few days later, while talking on the phone with Dajia, my call-waiting signal beeped. I answered the other line, and Sinai spoke.

"Alfonzo don't han--!"

"Bitch, if you call me again. Harassment charges okay, I'll file!"

Clicking back over to Dajia, she asked me if things were fine.

"Dajia, you must know that."

"Know what? Alfonzo know what?"

Again I punked out!

CHAPTER FIVE

The After – Living With Honesty

Because the jail was across the street, walking to and from work took a minute, if that. Coming home, with my key in the door lock, I heard the phone ring. It felt eerie, like coming home after getting in trouble at school with punishment waiting on your doorstep. I didn't rush in to answer it. Moments later, it rang again. It had to be Dajia; she always called me after my shift.

When I answered the phone, Dajia's voice was filled with laughter and I could hear girls in the background. Then like a sunset her tone changed, she asked, "Who is Sinai?"

I paused, afraid to answer.

Dajia then stated, "Alfonzo, this woman

called my house and told me that you two are f--king. Have you been screwing other women behind my back?"

Still afraid to answer, the next couple of minutes I lied. Dajia was too smart for that -she knew my words weren't true.

"Yes, we have been together. I wanted to tell you months ago but was too afraid of losing you."

My world stopped rotating that night. Not only did Dajia know about my infidelity, but also Sinai embellished the affair to the second power. She was telling Dajia that I was her man, giving her money and taking her out places. It seemed like everyone I knew was involved. Dajia questioned my friends and my parents, searching for the truth. I told Dajia the situation with Sinai was purely physical and I did not love her.

"So what Alfonzo, does that make it okay? With all these viruses running around here, you're having sex with me and other people I know nothing of!"

I wanted to find Sinai and give her as many curses as possible. Then I realized that I had dug my own grave and should have been sincere enough to tell Dajia long ago.

Surprisingly, Dajia agreed to continue our relationship until the end of her school year, under the conditions that I take an S.T.D & H.I.V. test. Even though I had used condoms, taking that H.I.V. test was scary. Condoms are not one hundred percent effective so I dreaded taking the test and walked around in a daze for two weeks waiting for the results. When the second week finally came, I contemplated what would happen in the worst-case scenario. Death could be imminent not just for me but Dajia as well.

With the non-reactive test and clean bill of health, I drove to Fresno thinking I had good news. Not only had I ruined our relationship, but I had also disappointed the woman I asked to be my mother and was setting a bad example for my sister. I couldn't look Dajia in the eyes without feeling guilty. I spoke with Kassie and explained to her my behavior was not acceptable and that she should never accept that type of behavior from a man. I apologized to Dana for disappointing her and didn't know what to say or do for Dajia. An apology just would not suffice.

Our relationship ended with me not being able to forgive myself. Dajia wanted to give me another chance, but I worked more and overtime was a refuge.

After several months of long thoughts about my actions, I believed I could trust myself and tried to persuade Dajia to return to my life, but she felt differently. That year, I averaged close to seventy hours of overtime a month. I concentrated on paying off my bills and did a lot of soul searching. Since I lived alone, no excuse existed for me not to focus on myself. I finally came to the understanding that my actions were common and many men before and after me would struggle with infidelity. The difference being, some would learn from their mistakes and be honest with themselves afterward and others would not. What was more important, a night of lust or a relationship of honestly and pure love?

I have chosen to never lie to another woman again and never cheat on another woman again. I have made this decision for my own personal sanity so that I will never experience heartache due to my own infidelity. I know for the rest of my life, I will

be attracted to other women. Whether I'm in a committed relationship or if I am blessed with a loving wife. I have made a choice for the betterment of my future and whomever I share it with. Honesty will rest alongside my demeanor, guiding me when situations present themselves.

With the amount of overtime I accumulated, my bills were paid off, and with the extra money saved, I bought myself a little home and a new car. While waiting for escrow to close, my short brown haired friend Mark Apley, and his lovely wife, allowed me to stay with them. Because I had been cooped up in that tiny studio for a year, it felt good to socialize outside of that cave. Mark's wife, with her long straight brown hair and olive skin tone, was spoiling me with her Mexican meals and I was shopping to decorate my new place.

Late one afternoon, Mark, Sandy, and myself were planning to go see a movie. Mark asked to see my off-duty gun (Walther-ppk/s auto 380). After unloading it, Mark showed his wife and later gave it back to me. The gun had fingerprints all over it, so to avoid rust and dirt; I used a cloth to wipe it off. Holding the gun away from my torso as I'd been taught, I slid the magazine into the butt and pulled the slide back to have a round in the chamber. Then, I removed the magazine and loaded it to capacity. Again, I slid the magazine into the butt of the weapon. When I leaned forward to conduct a press check, I didn't have a strong grip on the gun. So I adjusted my grip, holding the gun tighter with my right hand and my index finger against the trigger guard. I pulled the slide back, viewed the bullet in place, and released the slide back into position.

A loud bang sounded. Even though I didn't

grip the trigger, my right index finger had to have been close enough to press against the trigger, allowing it to engage the firing pin.

I looked out the window and knelt to the ground for cover, thinking someone outside was shooting. Then I felt a tingle in my left shoe. Mark ran into the room and asked his wife if she were okay.

Sandy replied, "I'm okay, but I think Tucker's gun went off."

I looked down and saw an entry and exit hole in my shoe.

"Tuck, what have you done to yourself?" I set the gun down beside me and proceeded to remove my shoe. Mark picked up the gun and took it into the back of the house. Sandy was on the phone asking someone for the number of an ambulance service. I told Sandy I was all right and could drive myself to the hospital. The bullet struck my left index toe and shattered the second knuckle.

I looked up at the ceiling and said, "Lord, what have I done."

Mark asked, "Tuck, you alright?"

I asked Mark for the phone and he handed it to me. I told Mark I was sorry for the accident in his house and I did not mean for that to happen.

Mark again asked me if I was okay. "Yes, I am fine." I used the phone to call my supervisor, Sgt. George Wright. When he answered, I told him exactly what happened and I was on my way to Kaiser. Sgt. Wright, five-eight, couple of extra pounds in the mid section, short, very thin red hair, and a very strong family man, invoked policy and told me someone would interview me at the hospital.

Mark and Sandy, arguing over the quickest

route, drove me to the emergency room where the orthopedic surgeon cleaned and stitched up my wound. At the hospital, my African-American supervisor, Lieutenant J. Devaull questioned me to determine whether it was indeed an accident. The whole department was bound to find out, so there was no need to sugarcoat my situation. Attentively, my elder supervisor listened as I explained the details for a third time.

I was out of work for one week and on light duty for two weeks. Most of my co-workers laughed at me and left comical notes on my locker. Even though I understood the shooting was accidental, my ego suffered greatly. Determined to put the accident behind me, I concentrated on rehabilitating my toe. My co-workers and supervisors respected my work. I just wanted everyone in my department to know I was an above-average employee and would be back, ready to work even harder. While trying extremely hard to uphold my duties, I realized my accident would always be in my file and no matter how many extra details I pulled, history would not change. I stopped trying to impress others and worked on impressing myself. As long as my respect was given to others, then their treatment of me was their prerogative. Fortunately, work ethic spoke volumes and my co-workers made me feel welcome.

On October 22, 1999, I closed escrow and moved into my own home. Yero drove down from Fresno and helped me load up the U-haul truck. I was so happy I couldn't stop smiling. I couldn't believe a mortgage note was reality and I would actually be able to come home after work to something that was all mine. The city of Hercules seemed so peaceful, and deer ran around when the

weather was nice. Monique and I had reconciled, and she invited me to the San Francisco Jazz Festival to see Gerald Wilson's Orchestra and Louie Bellson's Big Band. On cloud nine with all my achievements, I still felt as if something were missing.

One month to the day after my accident, on November 13, 1999, I scored a touchdown in a passing league football game with some of the guys from my department. It was not just any ol' touchdown either. It was a go route with me striking down the sideline. To this day that was the most excited I've ever been after scoring a touchdown.

Loving life more and more, I was still working a lot, but cut down to about thirty extra hours of overtime instead of close to seventy. I had more time on my hands and began doing more public speaking. Not losing a step since college, I was invited to speak at several different venues. One held at Diablo Valley Jr. College, with one of my supervisors, Sergeant. J. Sidemen. We spoke to the basketball team about issues on campus and opportunities after basketball. Most of the brothers on the team wanted to know why I chose to work in a profession that historically has issues with people of color.

"I have chosen to make a difference in law enforcement. This profession needs more people of color so the minority public has representation. Myself, along with other African-Americans want the same security in life as Caucasians, peace, prosperity the American Dream, why not be a cop? As long as you have good intentions, your race should not dictate your profession."

I started dating again, nothing serious, and my parents often questioned when they would

become grandparents. I figured I would enjoy being single and allow that love stuff to happen on its own.

After several nights contemplating sharing my writing, I attended an open mic at the Black Repertory Theater of Berkley. That night, I read a poem I wrote several months after Dajia and I stopped seeing each other.

Untitled

BEFORE WE MET

I WAS LIVING BUT I WAS NOT ALIVE!

FEAR HELD BACK THE LOVE I NEEDED TO

SHARE WITH YOU

NO EXCUSES, I ENJOYED THE ATTENTION

OTHER WOMEN FLAUNTING THEIR

WOMANHOOD, ENTICING MY SENSES.

PHYSICALY, I COULD NOT FIGHT TEMPTATION

MENTALLY, I WOULD SUFFER EVERY TIME I

ACCEPTED THE SWEET SATISFACTION OF

ANOTHER WOMAN'S FRUIT

MY LOSS OF YOU, WOKE ME TO SUFFERING

EACH SUNRISE.

EVEN THOUGH I REGRET MY ACTIONS

MY LUSTFUL WAYS, I KNOW THAT THOSE

EXPERIENCES WERE NECCESSARY

BECAUSE IF IT WERE NOT THEN,

THEN HEARTACHE WOULD BE NOW

AND I WOULD NOT BE PROUD TO BE ALIVE

AND LIVE AS A HEALTHY, MATURE,

AND UNDERSTANDING BLACK MAN.

The performance went well. One of the directors hosting a play, in the weeks to come, asked me to play the part of a bartender in *Blues Café*. I accepted the role and performed after work, three nights a week for two weeks. I really enjoyed myself and wanted to be a part of the cast in several other plays. But the Police Olympics were approaching, and I made plans to win a gold medal for my department.

Before I knew it, the games were upon me, and I was headed to Los Angeles for my first "California Police Olympics." Even though I would play for my department's football team, I was more focused on wrestling. I trained at the Concord Youth Center and figured if everyone else was working at least forty-hour weeks, I shouldn't have any competition. I won that year easily and enjoyed hanging out with my family and co-workers.

Just like in high school and college, Dana was in the stands yelling my name. Only this time, bystanders would assume she was my girlfriend instead of my mother. Whenever I was in public holding Dana's hand, people would look at us differently from when I was a kid in high school.

On one occasion, I took Dana out to eat at the World's Sports Café Bar and Grill in Fresno. While waiting for our table, I ordered Dana a white wine. A Caucasian gentleman sitting next to us struck up a friendly conversation and mid-way asked me what my girlfriend thought of his comments.

"Sir, this lovely young lady is my mother!"

Dana went a step further stating, "His father is white, too."

The guy jokingly offered to buy our drinks, continuing with his small talk. I've gotten used to the looks people give me when I'm alone in public with Dana or Kassie. On average, black women either frown at me or try not to stare at me. I have even heard derogatory comments and chose to ignore them. My first thought was, would they look at me the same way if they knew Dana and Kassie were my mother and sister as opposed to a girlfriend? But it's not worth the time to explain my relationship to people whom I'll never know in my life. Why would I even care to ponder the thought of wanting to explain my relationship with Dana and Kassie? As a Black male in this American society, I grew up knowing there are White people who hate Black people and vice versa. Because of those conditions, Black people have a bond that is beyond explanation. Some Americans feel you are selling out your race if you form a pair bond with a person outside your own ethnicity. I cannot challenge those thoughts. Even though I have never sold out my race, I have loved women outside of it. As human beings, we have an innate desire for companionship. Are you fighting natural desires to date outside your race and never consider a relationship?

On Sunday March 19th, 2000, 9:30 am, I decided to attend church. Driving, not knowing exactly where the church was, I stopped at the grocery store and asked the first Black person I saw if they knew of a church nearby. The woman I spoke with knew of a church called Keys to Life and gave me directions. The church was holding service out of an elementary school's cafeteria. That reminded me of my home church in Fresno, Family Community Church. We held service out of the

Kastner Middle School's cafeteria.

While standing in the third to last row, I saw Ra-Ra for the first time. She wore an off-white full-length dress with sleeves. Her natural hair was braided into four bobs atop her head. I had never seen a woman with a more beautiful face. She was not athletic, yet she had a very soft feminine physique.

Not comfortable with asking her out after my first visit to her church, I figured I'd wait until I became more comfortable with the congregation. That Tuesday, the 21st of March, after I had bought a sweater from Banana Republic, I noticed Ra-Ra walking out of Bed Bath and Beyond. As she walked toward the elevator, I stopped her, and we had our first conversation. I asked if she remembered me from church that past Sunday, and she said she remembered the goofy smile on my face when the first-time visitors were asked to stand and introduce themselves to the congregation. The conversation was brief and I declined to ask her for her number. We said goodbye and agreed to speak to each other the following week at church. As she rode the elevator to the second floor, her still posture reminded me of a healthy, chocolate mannequin. She seemed so calm and pleasant. Intrigued, wanting to know more about her, I raced up the stairs and caught her just outside the exit doors. I politely offered her my number and figured if she called me then she was interested. I recited the number as she wrote it down on the bag she received from Bed Bath and Beyond. As she walked away, her hips didn't sway like a sprinter nor did her thighs flex with each step. She moved slowly with grace not physical power, but an alluring power, the aura around her. She wore no

make up and had the prettiest white teeth I had ever seen. Her smile afforded her many second glances from admirers.

Two days later, we spoke on the phone, and I learned that her mother was an English professor at the local junior college. Her father was approaching retirement as a construction contractor and she was the youngest of six children. My reply was that her mother must be a powerful woman to have had six children teaching English. Ra-Ra spoke very highly of her family, which was important to me being very close with mine. She went on to tell me her father was a deacon at a local *Baptist Church* and her mother was close to finishing her second Masters Degree in Divinity.

We went on our first date that Saturday, March 25th, to see the movie *Romeo Must Die*, with the singer/actor *Aaliyah* and *Jet Li*. After that, we spoke on the phone more often and went on a couple more dates. April 8th just a few weeks after meeting her, we shared our first kiss. That night when I took her home, I wrote her a poem and mailed it to her house the following day.

"YOUR KISSES"

EUPHORIC

MY HEART COULD NOT PACE ITSELF

BECAUSE YOUR KISSES CONTROLLED

ITS RHYTHM

SOFT, YET FIRM ENOUGH TO FEEL YOUR

CURVES. SWEET, ARE YOUR LIPS

SO INTOXICATING I FELT LIKE A

DRUNKEN MAN

WITH NO INTENT TO BECOME SOBER

AS YOU PRESSED YOUR LIPS AGAINST

MINE MY EYES WATERED

MY SKIN BECAME MOIST

THE WEIGHT OF MY BODY RESTED AT

MY TOES

IF YOU FELT, FEEL, AND LONG

FOR something serene

I PROMISE MY KISSES

WILL HAVE YOU SING

After a few more conversations that month, we shared each other physically for the first time. Ra-Ra seemed to embrace my patient touch and sensual attentiveness to her likes. Yet, at the point of penetration, she felt uneasy, maneuvering closer to the headboard. Was I hurting her? She reminded me it had been a while; she wasn't a virgin, yet needed me to be very gentle with her. Even though I felt as if I were loving her timidly, she still seemed distant. Without pressuring her sexually, we began enjoying each other's company more and more. We attempted lovemaking again with the intent to share one another physically in a monogamous relationship. The same energy was expressed.

However, on May 30th, Ra-Ra told me that because of her moral and religious beliefs, she felt guilty about having premarital sex. I was impressed with the fact she felt strong enough to explain herself openly. I had wondered what was holding her back physically. I explained to her that I have faith in our higher power as well; however, I knew I would not be willing to remain abstinent until marriage. In addition, I didn't want her to compromise herself or her level of faith to please me. We agreed to remain friends and continue seeing one another outside the commitment of a relationship and the pressures of sex.

For the next three months, on occasion Ra-Ra would approach me sexually. Her actions confused me. I thought she wanted to remain

abstinent. I also thought that temptation was getting to her, and she had a need to be sexually satisfied. I would then become more confused when she would ask me to make love to her, then behave as if she couldn't perform the act. I assumed that guilt would occupy her thoughts or she cared for me and felt as if she had to give me sex in order for me to care for her.

I told her I had a very strong sex drive, but I was not foolish. I explained that I had cheated on my last girlfriend in college, allowing my hormones to get the better of me and had promised myself I would never lie to a woman or cheat on another woman as long as I lived. I went even further and explained that I respected her decision to remain abstinent until marriage, and I felt that if she compromised her decision without a clear conscious, then she would live with regrets that were unhealthy. For the next ten months, we dated platonically off and on and I understood her more from a friendship perspective.

During that time, I witnessed Yero place fifth at the U.S. Olympic trials and my little brother, Zack get expelled from Clovis High School. Zack got into a fist fight off campus at the Texaco gas station on Shaw Ave. across from Dana's Flower Shop in Clovis. Zack had an aggressive side to his personality and would not take smack from anyone, but that fight came at a bad time. Kassie was always responsible and a little more mature for her age, so my family gave more attention to Zack. But Zack had quit the wrestling team and the football team because of his grades and poor attitude. All the conversations I had been having with him were only paying off in the crime and drug area. Zack was not going to be a criminal or a weed smoker. Zack was

going to be the laziest, party-and-get-drunk-on-the-weekend guy he could be. My parents were frustrated to the second power and undecided on what to do.

One weekend, I went back home to speak at a charter school where Monique was teaching and to accompany Zack to his expulsion hearing. That Sunday night at dinner, Zack raised his voice at Dana.

"Zack! If you speak to our mother that way again, I'll kick your ass!"

Coach Darling told me there was no need to make threats. I felt as though we had run out of options concerning Zack's behavior. He did not appreciate the blessing of being born into a lifestyle that provided him with love, food and shelter that is free from violence and misery. Then again, I was living in the Bay Area away from home, so I felt like my obligations as a big brother were not being kept. I promised myself to try and build a stronger relationship with my little brother. I loved him and did not want to visit him in jail or on the street corner some time in the future. Zack just caught some bad breaks and needed someone in his corner.

My fraternity brother, Oliver had been working for the Fresno Police department for about two years. I had been given a new position with my department working within the classification bureau and loved it. On top of intelligence gathering, I worked as a liaison with every local, state, and federal agency associated with law enforcement. Moving further and further away from the world of competitive wrestling, I found myself in the gym more, gaining muscle mass. I now weighed one hundred and eighty-five pounds, fifteen more pounds than what I weighed in college.

After more and more conversations with Yero, I opened up about something being missing from my life. I felt as if I needed something more, yet could not place my finger on what "it" was. I'd speak more with Monique, who would encourage me to write. I figured I would either pursue a graduate degree or apply to a federal law enforcement agency. During this time, I started to attend more open-mic sessions on Wednesdays at the *Jahva House* in Oakland. The poets spoke with so much heart and passion that I felt my writing wasn't good enough to be heard. At times, I would grab the mic, but my energy was solemn. The content of my writing reflected a self-inflicted broken heart and a troubled childhood. I would always calm the crowd and it seemed like the majority wanted to hear more high-paced lyrics with an afro-centric flair. So I would only speak on occasion.

Ra-Ra and I started having conversations associated with marriage and children. She would tell me how scared she was of gaining weight from pregnancy; she even showed me pictures of her adolescent years as an overweight child. Ra-Ra had just finished junior college and would need a couple more classes to transfer to a university. I had become close with her family and shared many conversations with her mother, who is a published author and poet. Enjoying Ra-Ra and her family, I felt,, as though they had accepted me. Learning more about Ra-Ra while we hung around her family, I observed in her an unprecedented level of femininity, not associated with clothes and make up. Her nature was warm and inviting like her hugs and kisses.

Coach Darling came down to visit me, and I

accompanied him to one of his ex-student's graduation from Saint Mary's University. That day, I asked Coach Darling, "When does a man know he is ready for marriage?"

My father figure told me he believed a commitment to marriage could be made at anytime by anyone. However, when you believed that you could conform to the sanctity of marriage and live no longer as one person, then that helped with your decision. He also said you could deny a good woman forever, but good women were rare.

I knew I was in love with Ra-Ra and was amazed that it was not based on physical lust. After more conversation, I told Ra-Ra, as a friend, I had thought of marriage with her and felt as though I could live the rest of my life with her, but part of me was running from her. I wanted and needed to do some self-reflection and soul searching. I asked her not to worry about me, but I needed some time alone.

We didn't talk for two months. That whole time I asked myself several questions of why marriage, why Ra-Ra, and I came up with answers that made me feel as if I had found what had been missing from my life. For example, I had forgiven Thomas, yet was still disgusted with him as a man and his behavior with me. Realistically, he had not truly been forgiven. I had to let that go because that emotion would interfere with my life and my spouse. I feared commitment within relationships, love, friendships and family, protecting myself and hoping not to be mentally destroyed and emotionally broken. I wanted to eliminate the possibility of heartache associated with hard times that, for the most part, were inevitable. I would never drink alcohol in fear of becoming an

alcoholic, maybe even inheriting a low tolerance for drugs like Thomas. My perfectionist ways were not being expressed in a healthy fashion. I had fully avoided accepting my past and remembered pieces of my childhood associated with understanding and comprehending my behavior and my ability to think my way through any situation. I cannot control the outcome of every step in my life. If I fail, then so be it, as long as I have good intention and try in a positive fashion, then those risks are no longer risks, they're lesson of life.

Could I actually be faithful within a relationship? I promised myself I would, but I had not been presented with that option since my last relationship with Dajia. How important was sex to me? I answered honestly: "Very important! If I thought otherwise, then that was not healthy." I felt strong enough to resist temptation within the confines of marriage. And, most of all, from a healthy perspective, sex wasn't the ultimate reason I was in love.

At my little home, I was so emotional, happy and proud of myself. I answered questions I had been pondering for years. Then I asked myself, why Ra-Ra? The answer was easy. She was honest, loving, nurturing, and I felt she could never hurt me. I would never have to work a hundred hours of overtime to please her financially. She was not materialistic, and she loved me for me, not because she felt I had a nice body and drove a nice car. I knew she would love me if I were overweight and had no teeth. Now, would I love her just the same? Yes. Ra-Ra was the most honest and caring woman I knew. I felt lucky that she was in love with me. She would never be as fit as me, she would never want to discuss my writing, and she was going to

put on weight in the years to come. But, I loved Ra-Ra for all she was and that made me feel secure with her. I wanted to marry Ra-Ra for her, not just to be married. Not love for the sake of love solely, but love in its purest form, honest and unconditional.

When those thoughts came to mind, I called my family and told them I would ask Ra-Ra to marry me. I told Yero I had discovered what was missing from my life after spending years searching for answers. The time I had crossed Kappa feeling like I needed more knowledge to know what made my belated fraternity brother Arthur Ashe such a great man. Also, standing atop the All-American podium at the N.C.A.A. tournament, the night I graduated from college, the day I graduated from the police academy, my swearing-in ceremony with the Contra Costa Sheriff's Department, and knowing that I would never be a world champion had all come into perspective.

I spoke with Ra-Ra's mother, who not only gave me permission to marry her daughter, but also agreed to be our minister. My conversation with Ra-Ra's father was more in-depth, as I figured it would be. He complimented me, telling me that he would be honored to have me as his son-in-law.

On November 19th 2001, I invited Ra-Ra to my small home, in which she had never spent the night. I cooked her baked chicken with lemon and decorated the home, in which she would eventually live, with roses of all colors representing love, romance, and friendship. I adorned the dining table with mementos from our first date, and after I fed her, I presented her with a tritium diamond. After explaining the three points of the diamond represented God, herself and me, I asked her to

become my wife.

With tears in her brown eyes, she nodded and asked me if I was sure. I said yes and told her I needed to hear her say yes.

"YES!"

That very night we prayed together and asked each other questions concerning the other's needs and wants. She told me she did not want children right away because she wanted to finish school. With that, I told her that the M.B.A. program I was in would be put on hold to save money for the wedding and her schooling. She asked me what I needed and I told her, "I just need your love, both mentally and physically, for the rest of our lives."

We agreed to marry on March 9th, 2002, ten days before the first day we met two years earlier. I took my fiancé home that night, though I wanted to keep her with me and make love to her. We thought it best that she return home.

Along with spiritual counseling from our minister, Ra-Ra's mother, we attended another counseling session with a marriage counselor. During that session he asked us questions concerning why we were choosing to marry each other. When he asked us what our differences were, I was eager to state that she was committed to abstinence before marriage and I felt like we could have sex. The counselor asked me if I respected my fiancé's wishes. I sternly answered, "Yes."

He then asked Ra-Ra what her reasons were for wanting to remain abstinent. She calmly told him that her moral and spiritual beliefs would not allow her to engage in sexual activity before marriage. The counselor probed further and asked her if she had ever been molested as a child or raped

or had any negative experience associated with sex.

Ra-Ra calmly stated, "No," and then jokingly said, "He can wait, the wedding is only a couple months away."

The counselor asked how I felt about that.

I replied, "I don't like it, but I love her."

As we finalized the plans and waited for our day to arrive, I invited Monique down to meet Ra-Ra's mother, they had a lot in common. Both had master's degrees in English, and both taught English as a profession. That was the first time I ever thought Ra-Ra behaved in a jealous fashion. I had told Ra-Ra when we first met that Monique and I were just friends. I even explained in detail about our sexual experiences and how that ended our friendship for some time. I was proud of the fact that I had a female friend whom I loved and cared for outside of anything sexual. That night Monique slept in my guestroom, and Ra-Ra complained of bad health and slept in my bed with me. I teased Ra-Ra and told her she was being insecure.

Yero and Oliver took me to Las Vegas for my bachelor party. That whole weekend I was scared, hoping I would not give into sexual temptation. I remember telling Ra-Ra before leaving that I wanted to have fun with my boys and come home with no regrets. Ra-Ra was very understanding and thanked me for my honesty.

Her advice: "Keep your %#@& in your pants until March 9th."

I enjoyed myself and felt fortunate to have friends who could share that moment with me. I came home proud that I hadn't had sex with those women. At the same time, I felt seriously sexually frustrated.

March 9th, our big day. Ra-Ra only wanted

our immediate family in attendance. I wanted a huge wedding with all of my friends, fraternity brothers, and loved ones there. Yero would be my best man. I wanted Oliver to be my best man as well, with my partner Mark Apley and my fraternity brothers as groomsmen, but Ra-Ra only wanted her second oldest sister as her Matron of Honor with no wedding party. I figured she could have the wedding she wanted and decided not to make a fuss of it. Since she had such a large family, we agreed I would invite the same number of people as in her family (twenty five). Squeezing in a few more guests, the wedding was bigger than we thought. Oliver had his wisdom teeth pulled, and his mouth was too swollen to recite scripture. Ra-Ra's oldest sister filled in nicely. My mother did the floral arrangements. The ceremony Ra-Ra's mother put together was amazing, I was very impressed with her choice of words and her actions throughout. The music was spirited and unconventional along with our entrances and exits.

At our reception, friends and family spoke, sharing thoughts and feelings that were both comical and sincere. Afterwards, we danced and laughed with intentions of sharing a loving and fruitful life together.

After the reception ended, I drove my bride out to Napa Valley, and we lodged at the Candle Light Inn. I figured we would both be worn out from lovemaking and unable to wake the next morning, only to become exhausted again after indulging ourselves with each other once more. I was so disappointed, I literally felt like crying. That night, as we held each other, I never felt so at peace. There was no rush, and I knew she would no longer have the baggage of unwed sex occupying her

thoughts. Every inch of her body was now mine and free from inhibition. I wanted her to enjoy every moment of our first married night together. When I felt her body ready, consummation would be an understatement. Moments later, her shoulders and neck twitched, she was weeping. I asked her what was wrong, and she asked me not to stop. Feeling uncomfortable, I stopped and asked her what was wrong. She cried aloud and hugged me tightly, "don't stop Alfonzo." Then she kissed me and said, "I'm making love to my husband." I could feel her vagina tighten and lose that natural form of lubrication. I stopped again and then she asked me to cum.

I told her, "Ra-Ra, I'm only going to enjoy this if you like it as well, you know this. That's why we've waited so long."

She said, "I do, I do, cum for me, I want to feel you cum." At that point in my life, I had never experienced anything like that. It was as if her body was rejecting me rather than welcoming me.

CHAPTER SIX

Lies And Deceit

Two days later, we would make love again, but this time it was far from lovemaking. While we were engaged in the sexual act, I focused on reading her facial expressions more than her body movements. I could not see any pleasure within her eyes. The best way to describe it was the opposite of pleasure, even associated with emotional pain. I noticed that moments after sexual penetration, her body would again lose any form of natural lubrication. This became extremely frustrating, and Ra-Ra would tell me that she was hurting. I stopped and held her while she cried. I couldn't understand what was wrong and it would be another week

before we would attempt to make love again. I already knew my sex drive was more active than hers. I also knew I would not be able to make love to my wife as often as I would like. There was a problem and I was determined to discover what it was. We talked about everything that may lead to any emotional obstacles. She told me she was considering quitting her job at Magic Johnson's 24 Fitness in Richmond, California. I suggested she give her boss a two-week notice and a letter of resignation to avoid burning any bridges and still be able to receive positive recommendation for future employment. She told me that she had no issues at work and just wanted to concentrate on marriage and school. I was already independent, so she would not have to worry about cleaning up after me. I prepared my work clothes and things of that nature. She loved to cook and I felt like that trait of hers was a perk to the relationship because I had been cooking for myself for years since living on my own.

She returned home from the hospital one evening stating she had a yeast infection and suggested I change my diet because she was having allergic reactions to my semen. I had no issues with that. Figuring anything that would afford us having a healthy sex life, I would do. Ra-Ra was allergic to fish. She was also a vegetarian; eliminating meat from her diet so as to monitor her weight. Due to this problem, all I would eat was poultry, thinking it would help.

We tried using condoms again, and she came home stating she had an allergic reaction to those as well. I began asking her questions about her sexual past and first experiences. She told me that the first time she had sex was when she was

seventeen working at Champs shoe store at Hilltop Mall, in Richmond, California. Then she said that she did not enjoy the experience and felt no pleasure from a sexual aspect.

" Ra-Ra, What part of the encounter did you enjoy, and why did you choose him to share your virginity with?"

"Well, I did not enjoy any of it, there was no foreplay and my sister kept paging me so I had to leave. I liked him and he was fun to work with."

"Ra-Ra, were you even attracted to the guy?"

"Alfonzo, you are the first man I've ever been attracted to physically."

With more conversation, she told me about two other men she had sex with. One was in high school and the other as an adult (her boyfriend prior to me). I knew she had been in a relationship with her ex-boyfriend for close to two years. I was shocked when she said they had only had sex three times.

With that information, I began studying our sexual behavior. I had logged and written in my journal every time we had ever had sex, clear back to when I had first met her before our ten-month period of abstinence with each other. On average, we were having sex on Sundays and Mondays. Later, I would discover why.

April 21st, I was asked to be the guest speaker at my fraternity's annual "Diamond Ball" in Fresno. At that event, not only did I focus my speech on accomplishing one's goals, but I stated my goals were to write my autobiography and be the best husband I could possibly be. During my speech, I thanked Dana, who was in attendance, for being my mother, and Ra-Ra for being my wife, and

my friends for supporting me over the years.

That evening, Dana complimented me on my speech and asked how Ra-Ra and I were doing. I told her we were having trouble sexually and it was extremely frustrating. I went on to tell Dana about altering my diet because of her allergic reactions to my semen and condoms. She asked me if the situation had gotten better after I changed my diet and I answered, "No." I told her about Ra-Ra's bone disease, Melariostiosis, a rare long bone disease that only affects a small percentage of the world's population. The affected bone has the appearance of candle wax dripping along its side. It could be very painful in extreme cases. To my knowledge, Ra-Ra didn't have an extreme case and only took pain medication when necessary.

"Dana, she does not have a natural desire for sex."

"Oh Fonzie, I feel so sorry for you. I wish there was something I could say to make things better for the both of you. Sex is extremely important within a marriage. When Mike hasn't --."

"Please Dana, You're the mommy, remember? I can't picture you and Coach, you know."

"Fonzie, how do you think you got here? What, did you just show up under our Christmas tree one year?"

"Yeah Dana, 1990!"

"Ha-Ha. Seriously though Fonzie, love making between husband and wife is a part of every marriage. I couldn't image not being able to show your love physically. Hang in there son, this situation will work it self out."

A couple days later, Ra-Ra's father gave us some mats for the kitchen. Ra-Ra told me because

our little home was built on a concrete base, her legs were hurting from walking around the home. She said her father's house was built on a wood base and that would better absorb the shock of a regular walking pace. Even though it sounded odd, I accepted her thoughts and continued working with her. Our sexual sessions were still unpleasant, and I could not continue the act when she would cry and apologize during. I asked if she knew why she did not like sex. If her legs were not hurting her and she were not having allergic reactions, why?

Then she stated, "I just don't like sex!"

I began having conversations with Ra-Ra's mother, who suggested that her daughter might possibly be frigid. I told her that Ra-Ra had never had an orgasm with me. We invited Ra-Ra into the conversation, and she spoke openly about her dislike of sex, period. Within the days to come, Ra-Ra would tell me she liked foreplay, but the penetration aspect of sex turned her off. She described the lubricant associated with the in and out motions as gross and went on to state that the semen left inside her body afterwards made her feel ill. I felt sorry for her and I was upset she had never before told me her true feelings associated with sex.

That night she apologized. The next day, she made arrangements to visit with a sex therapist. Before the first session with the therapist, we had dinner at her parent's home where her mother prayed for us, then we all prayed together. We tried to make love that night, and it seemed worse than the times before. I could tell that Ra-Ra was making an effort to enjoy the act, but could not find pleasure in it. She asked me to change positions several times, and I thought to myself that our pleasure had nothing to do with performance; she

just plainly disliked sexual intercourse with me.

We were invited to have dinner with a black couple, who are friends of Ra-Ra's mother, which seemed pleasant enough. This was the second marriage for both of them, and the woman was suffering from osteoporosis. At first, I felt like we could relate with them and their issues, however the woman would break off on these long tangents that had nothing to do with our situation. She would mainly speak of herself. To make things worse, she wanted more sex than her husband was capable of giving, so he had to use Viagra. I thought to myself, I'm too young and healthy to have a need for Viagra. To top it off, I felt like they were upset with me for wanting to have a regular sex life with my wife. That night I told Ra-Ra that she never had to be the best sex partner I ever had. I just wanted to be able to make love to her and have both of us enjoy it because her pleasure would arouse me.

Ra-Ra started coming home with books that her therapist gave her. Ironically, I was familiar with a couple of them from college. I think Ra-Ra started catching on that I was having major issues associated with our sexual relationship, because she would ask me to just have an orgasm when we were together. I would explain to her that sex for me was more than just the orgasm, and her attraction to me was important. During this time, we started arguing with each other regularly. I recall telling myself to calm down and refrain from yelling because I wanted us to solve our situation rather than belittle one another due to frustration. This is when I witnessed major changes and contradictions within Ra-Ra's character and some of her statements. She would get in my face almost to the point of

challenging me physically. I would remind her that if the police came and I went to jail, I could lose my job and subsequently we would lose our home. Either that or she would go to jail because California law has changed concerning domestic violence. No longer is the victim given the options of filing charges, the state now files in all matters of arrest. Her next statement floored me; my heart stopped.

"If my husband were to cheat on me, I would not like it, but I would deal with it."

That statement broke my back. I thought we were working together concerning a problem within our marriage, now I felt as if she was giving me a subliminal message, to go out and have sex with some other woman. I did not want to believe my ears. I questioned her about the statement and asked her if she was trying to encourage me to seek sexual gratification elsewhere. I felt I knew her too well for her to say that. When she took too long to answer, it didn't matter what her reply was. I asked her to be honest with me and tell me if she knew she had no sexual desires before I asked her to become my wife. She couldn't even look at me. I asked her what the deal was with being allergic to my semen and condoms, still no answers. I then asked her if her bone disease really affected her sexual desires and if she had discussed that with the sex therapist. With hesitation in her voice, she told me she should have some results for me shortly concerning her sex therapy. I told her she should want the therapy for herself not just me.

I went home that weekend to speak with my parents and Dave Hill, the counselor I went to when my parents were first given custody of me. I saw another counselor through my medical coverage. I

was looking for answers, but I already knew that Ra-Ra had lied to me. Her honesty and caring nature was the basis of my attraction for her. Before we married, I felt there was no hurdle that we could not jump over together. Now, I knew she lied to me and had me running through an endless obstacle course. I had no words for Ra-Ra. We slept in the same bed, yet I would not touch her.

On Thursday, May 30th, I called Linda Reaves (the woman who took care of me during my first foster-care placement). I needed to hear a black woman's perspective concerning our situation. She was very real and asked me several questions concerning my treatment toward Ra-Ra, sexually and otherwise. I told Linda everything I knew.

Then Linda asked, "Is the girl gay?"

"No Linda, she can't be."

Before Linda got off the phone, she said, "Alfonzo, I think your wife is gay."

That night I told Ra-Ra I could not be a celibate husband under the present conditions.

She told me she was not asking me to be celibate, and I could have sex with her anytime I wanted to, it didn't matter to her if she liked it or not.

"Alfonzo, I learned how to have sex with my boyfriends. Even though I did not enjoy it, I did it to please them!"

"Ra-Ra, you're not a masturbation tool, pleasuring you arouses me. And if you're still wanting me to have sex with some other woman, I'm not! I won't disrespect myself ever again. I told you about my ex back in college!"

With a trembling voice and tears ready to fly, I told Ra-Ra that she had the option of seeking an annulment with me or just signing papers after I

had spoken with a lawyer.

She hit the ceiling, fussing, screaming and yelling. Her beautiful long, black hair tangled and scattered. I was sure the police were going to knock on our door. Later, we lay in bed as I held her in my arms. She told me she loved me. All I could think of was why she would behave so selfishly, knowing that I respected her and thought that she was practicing abstinence because of moral and religious beliefs. If spiritual reasons were the case, at least she failed to mention any other reasons.

Wanting to clear my thoughts, I secluded myself in the shower. Was I really ready to leave this woman? Stepping out of the shower, I started a puddle at the foot of our bed.

"Ra-Ra, there has to be more to this. I am contemplating ending our marriage, and I know I love you."

Watching her shoulders tremble and her knees shake, I wanted to hold her, but I needed to hear what she had to say. With a weak voice she said, "Alfonzo, I lied to you and I'm sorry."

"I know, but why, just to be married? I thought we loved each other beyond the fallacy of marriage?"

She didn't answer me and after a few moments of silence, she spoke again. "Remember when I told you about my first sexual experience?"

"Yes, when you lost your virginity to that guy you worked with at Champ's."

"Well, that wasn't my first sexual experience. My first was with a woman."

My breathing stopped. Before I could remember to breathe, her words answered the questions I had. Then, in denial, I inhaled.

"How old were you when this took place?"

I hoped to hear something associated with childhood experimentation, anything to justify her actions.

"The first time, I was in the sixth grade."

"The first time, how many times were there?"

She said the first woman she was with in the sixth grade was a few years older than she was, and it happened regularly.

"How many women have you been with?"

"Three."

I began asking her questions, and she just started screaming. I asked her not to yell, and she shouted, "You can help me change!"

"Help you change, how? Did you like having sex with those women?"

With her face contorting like a power lifter trying to set a world record, Ra-Ra said, "I hate feeling guilty for enjoying sex with women and not men!"

I asked when was the last time she was with a woman. She didn't answer. Crying enough to flood our bed, her words were stuttered.

"I've never told anyone about this, I don't want to discuss this. The only people who know are those I've been with."

I wanted to know more, yet she kept avoiding my questions.

I held her and stared at a dark ceiling for the next few hours, contemplating what to do. Five A.M. showed on my nightstand clock, and my alarm started the radio. As I dressed for work, Ra-Ra sat up in the bed and asked me not to leave her. She apologized for lying to me and again said I could help her change. I said nothing out loud, yet thought while on my way to work.

"How can I possibly change this gay woman to my heterosexual wife? Who she is and who she wants to be are two different people!"

After conducting a few interviews, my sergeant suggested I take the rest of the day off. I didn't want to go home. I felt like I needed to stay at work. Sergeant Wright then asked me to take a couple of days off so I wouldn't become a liability to the department. I understood his reasoning and knew his request was in my best interest. I told him a small portion of what was taking place.

Then I called Ra-Ra's mother and told her I was going home to my parent's house in Fresno for a couple of days and suggested she speak with her daughter. Her mother asked me what had happened the night prior, and I told her I would allow her daughter to give her that information. I felt she needed to know what emotions Ra-Ra was struggling with and hear them from her own mouth. I didn't want to express how hurt and angry I was over the phone. Did Ra-Ra's mother know all along that her daughter was gay?

In my car during that three-hour drive home, I realized I had not slept the night before. Angry and disgusted with my wife, driving on pure adrenaline, I was concerned that I wouldn't make it to Fresno safely. I said a prayer and realized Ra-Ra may have been hiding within her religious faith to cover her sexual frustration. Her father was heavily involved in the church, and her mother was a minister. My pastor, Pastor McGenzie, at *Family Community Church* in Fresno, delivered sermons against homosexuality. Even when I was a child listening to my Uncle Bishop Archie, he spoke of homosexuality as being a sin. I figured Ra-Ra had married me thinking I would somehow help her to

become a heterosexual woman and she would live secretly desiring a female. Her inner turmoil had to be worse than my childhood. I found the power to overcome childhood depression, but how does one struggle within their own sexuality? I felt used, like she coerced me into a marriage. I was deceived and lied to in the worst way. Why me? Was this karma? Was I being punished for cheating on my college girlfriend, Dajia? I was not the only person in pain. Ra-Ra was also hurting.

Could homosexuality be cured? Was it a learned behavior or innate? Confused, I pondered if I could have sex with a man. The thought alone disgusted me-genetically how would one find satisfaction? That question is answered by the number of homosexuals on this planet. But, what about procreation? No answers, I was still disgusted! Was that how Ra-Ra felt? She was clearly disgusted with heterosexual intercourse. I could only perform a sexual act with a woman because that is where my sexual interest dwells. Right or wrong, men who could perform sexual acts with other men were sexually aroused by them. The same goes for women. However, a woman does not need to be sexually aroused or stimulated to perform sexual intercourse with a man.

Because I had no answer for homosexuality being caused by nature or nurture, I spoke with a couple of women in my department. One of the ladies, who was married, told me about her lesbian exploits. She explained to me that she was bi-sexual and found enjoyment sexually within both sexes. She also stated if Ra-Ra were fighting her desires, it would be a lifetime struggle. The next lady was in a committed relationship with another woman and had no qualms concerning her lesbianism. She had

always known herself to be gay and only felt at ease with her sexuality when she expressed it openly. She said, "The woman you're with is gay and is afraid of giving into it." She explained Ra-Ra possibly became dry within sexual penetration because she could not deal with the fact that she'd rather be with a woman. Then she said not all gay women go both ways; many *only* like other women. I told her Ra-Ra was extremely feminine and carried no masculine traits. She told me I carried an uneducated view of homosexuality.

I stayed at my parent's house, listening to the same morning sounds I heard growing up in high school. Only this time Kassie was older and more in control of her schedule. Dana hadn't changed a bit. She was still scurrying around the house like when I first came to live with them on Christmas Eve, 1990. Zack was still in bed as if he had just fallen asleep, and Coach Darling was now an administrator, so he was wearing ties to work. I spoke with my parents and asked them not to give me advice on whether I should leave Ra-Ra or stay with her. I just wanted their support.

Sunday, June 2nd, 2002, only eighty-six days into our marriage, I asked Ra-Ra to leave. Instantly the temperature in the house rose twenty degrees.

"Why? Alfonzo, why? You can help me change!"

"How Ra-Ra, by having sex with you until you eventually like dick? You lied to me, had me jumping in hoops and climbing though obstacles. Why have you been lying to me all this time? Are you really allergic to my semen, or was that another lie so we wouldn't have to make love? Have you told your sex therapist about your guilt for liking women instead of men?"

Slam-Slam-Slam-Slam-Slam-Slam-Slam.

"Girl, if you break that bedroom door and the police show up here!"

"F—k you, F—k you, Alfonzo, we're married now!"

"Why didn't you tell me this before I asked you to marry me? Why? Answer me, Why? Why did you allow yourself to go through with the wedding? Answer me?"

"F—k you, you're my husband now!" With her arms reached out, her hands slammed into my chest. "We're married; you're supposed to be here for me!"

She steps towards me again, deja vu, I'm back in college with a crazed woman putting hands on me! With my left arm, full of her clothes, and my right hand holding the phone to my ear, her father answers the line.

"Sir, your daughter has become violent, and I'd like you to come and get her!"

"I'm on my way!"

While waiting for Ra-Ra's father to show up, I locked myself in our bedroom, bathroom, sitting on the stool talking to her through the door.

"Ra-Ra, your acting crazy right now, why all of a sudden you want to become violent with me?"

"Alfonzo, baby I'm so sorry. Sorry, I pushed you. Sorry, I lied to you."

"Girl, an apology does not fix a situation of this magnitude! You are my wife who I cannot make love to because you would rather be with a woman!" Bang, the thin wooden door shakes. "Don't say that Alfonzo! Please come out here and talk to me."

"Why, so one of us can go to jail? I'm

surprised our neighbors aren't knocking on the door!" Ding Dong, Ding Dong. "See, tell them to go away and mind their own business!"

After a couple minutes of silence, I walked out of the bathroom and peered down the hallway. Ra-Ra's father was embracing his little girl. Watching him hold her, awkwardly made me want to join in. Then I thought, "Good, she needs some affection right now, but I can't give her any." I stayed in the room and walked out on the patio anticipating him poking his chest out. Approaching retirement, he was well past his prime, however years of construction work afforded him enough size not to be mistaken for and older weak man.

"Alfonzo."

"Sir."

"Let's talk."

Before I could come inside the room, Ra-Ra locks the patio door. Her father opened it and directed me inside. While we both stood outside in front of my little place, he spoke to me kindly. "She says you're ready to leave her. Called her crazy, told her she would never get better."

"Sir, I told her she was acting crazy, and I never even mentioned anything about her not getting better. I don't know where that came from."

"Well, she's upset right now. Women tend to say things when they're hysterical. Can you two work this out? I like you; I'd hate to see you go."

"Sir, do you know everything that's going on? Maybe your wife didn't tell you everything or maybe Ra-Ra hasn't told your wife everything."

"Well, I just know about her situation in the sixth grade."

"Apparently, she and your wife haven't told you everything! I'll help you with her clothes and

things." At that point I spilled the beans, telling him everything that I knew about his daughter, her likes and dislikes."

"Alfonzo, if I had known, then things would have been different when we talked about you two getting married."

A couple hours later, after the last of Ra-Ra's things were loaded into her father's work van, she asked me to speak with her in private. While standing in the doorway of our bedroom, she apologized again.

"Ra-Ra, do you even know what you're apologizing for?"

"Alfonzo, I know it took an awful lot for you to give yourself to me. I love you, I do. You're a good man with so much to look forward to. Whatever you do, don't close up, there is a woman out there for you. Who knows, maybe we'll get married again."

A few days later, Ra-Ra phoned me, asking me what we were to do. I suggested an annulment, yet warned her she would have to testify in court and her deceit would be recorded. She asked if there was any other way. I said a regular divorce; however, we'd leave with everything we had in the beginning.

Agreed.

NOESIS

Dear Heavenly Father,

Forgive me for I have left the woman I married.

However, I believe that we were not meant to be one.

How can marriage have a foundation of lies and deceit?

If I was used to help her discover herself then fine,

I accept that with no disbelief.

And if she never understands

Then continue to guide her with your own hands

I have loved

So, I thank you for allowing me to be

An honest man kneeling at your feet

Be with me, Lord, because I have yet to be complete

And I thank you for allowing me to live free

I am a sinner

And will never be perfect

So I thank you again for love, peace, and my family.

CHAPTER SEVEN

We All Deserve

Not knowing if I would recover from the trials and tribulations of my life, I faltered into a depression that was worthy of midnight tears and isolation from my peers. Remembering my first years of employment, and the overtime with seclusion in my cave, that was not the route to take to find brighter days. My thoughts were that my wife and I would be together for life, the freedom to explore other women was sour, yet I found myself

buried under new faces and different scents. My mind was closed to the future and satisfaction was not underneath the skirts of woman who would never know my last name. My workouts were still there, a weight room to press away the pain. New goals relieved moments of psychological strain. Never training as a sprinter fueled the possibility of a gold medal at the Police Olympics 100 meter dash. Work, then workouts, recalling the satisfaction of victory, hoping that would release my misery. Bang, 11.1 seconds later, I was the fastest cop in California. My joy was not heavenly, but I smiled, took pictures, and figured I find some in wrestling. Slam, crack, pop! Remember your opponents are merely cops, again smiling for the cameras, receiving my props. Tired, lonely, drained emotionally, maybe my cure was velocity. Bought and paid off a 2000 Super Sport Ducati. Wow yeah, how could I not enjoy the speed of 120mph? Then I remembered when I was two years old, having drowned and how blessed I am to be thirty. A block away from my home, being safe, riding cautiously, suffering only scrapes, my bike was totaled. Lord, why the blessing? What are you trying to tell me? I lost myself in writing. A few showers later and even less grooming, THE POWER OF THOUGHT (NOESIS) reminded me that I could still love me and the blessing of security had been accomplished already. Writing allows me to understand and comprehend my meaning, and if this reading has not inspired you, know that life is meant to be lived peacefully, in harmony, free from unforgiving hate, allowing yourself to learn from your mistakes. Start with yourself. Learn why you wake up in the morning and if that is not pleasing, then set your goals, so as to create, the environment within you, a

healthy mind state. Excuses are tools of incompetence, as human beings we are all capable of great aspirations. My biological mother Sue Ann, I may never meet. Even though, she was and may still be a prostitute, if I could, I would wash her feet. My biological father, Thomas Tucker, is a drug addict who has killed, his decisions haunt him, and his vision is skewed. I have loved, lied, deceived, then turned around and had all done to me. Where went my childhood, suffering without a mother's love. These will never be excuses, this is me, and they are constantly hovering above. So, hopefully these words allow you to preserve growth, because that is what We All Deserve.

Acknowledgements

Father-Christ- Holy Sprit, Thank you for all your inspiration.

For my friends, family, and loved ones, I would like to thank you for all of your support over the years. To every coach I ever had, thank you for providing an outlet, helping me maintain my sanity during times of stress. Dana-Mama, thank you for being my mother. Nancy Cisneros, thank you for demanding I see a counselor during my custody hearings (and thank you for being a friend and mother figure). Linda Reaves, thank you for being the first positive black woman in my life (you will always mean more to me being my first foster mother). Monique Williamson-Frasier (Nicole), thank you for being my friend. Dajia (you know who you are); I apologize for my behavior back in undergrad. I have and always will love you. My little brother & sister, Zachary and Kassie, I am very proud of you both. Zack, keep your head down while you're defending our country. Kassie, continue being the strong independent woman you are, just know I'll always provide for you. My sands, Proverbs eight, It will be healing to the flesh and satisfying to the bones. (1) Rick McCaster, (2) Oliver Baines, (3) Myself, (4) Damian Ruffin, (5) Reuben Parrish, (6) Jeremy Guidry, (7) Charlton Spurlin, (8) Nathan Moore. Coach Darling (silver back), thank you for taking care of me and leading me in a positive direction, I still cannot understand why you picked me up Christmas Eve, 1990. Yero Akil Washington, thank you for being such a

special person, my brother, I love you. Ra-Ra, if you were honest with yourself and asked me openly to help you at the time of my proposal, we would have never married. However, because I love you, we would have been able to maintain a relationship geared towards accepting and understanding your sexuality. I've prayed for your happiness and hope you live in peace with yourself.

This book is dedicated to every person who reads it and finds inspiration!

www.ALFONZOTUCKER.com

P.S. I have wanted to be a writer since my first trip through the second grade! Unfortunately, my childhood did not allow me to pursue this goal. On February 12th, 2003, I finished the first draft of NOESIS and felt like I'd been touched by our higher power. The next month, March 15th, I attended my first writer's conference hosted by Mary B Morrison in Oakland California. At that very conference, Ms. Morrison awarded me with my very own publishing deal that allowed me to obtain all legal rights to NOESIS. Again, I was touched by our higher power! Ms. Morrison set up my editorial with Susan Mary Malone, who not only used up all the red ink in her pen but is teaching me how to become the writer I know I'm capable of being! At this point, my ability to thank you two women within writing has not been reached, so please accept this for what it is and look forward to my growth!